BATMOBILE

MANUAL

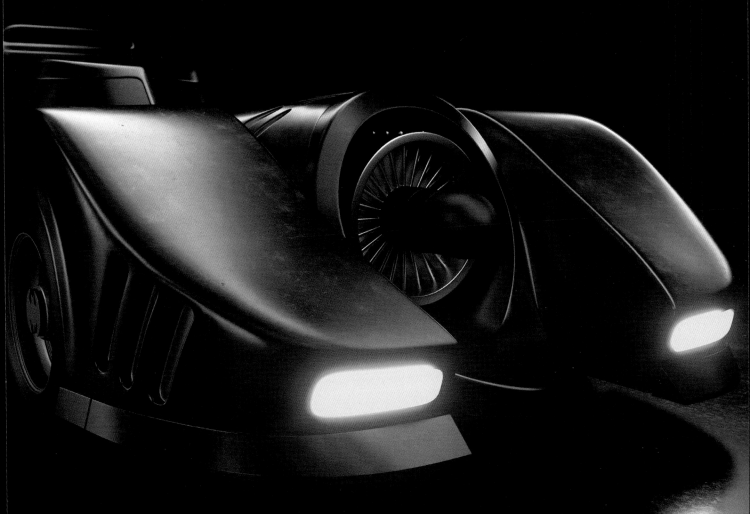

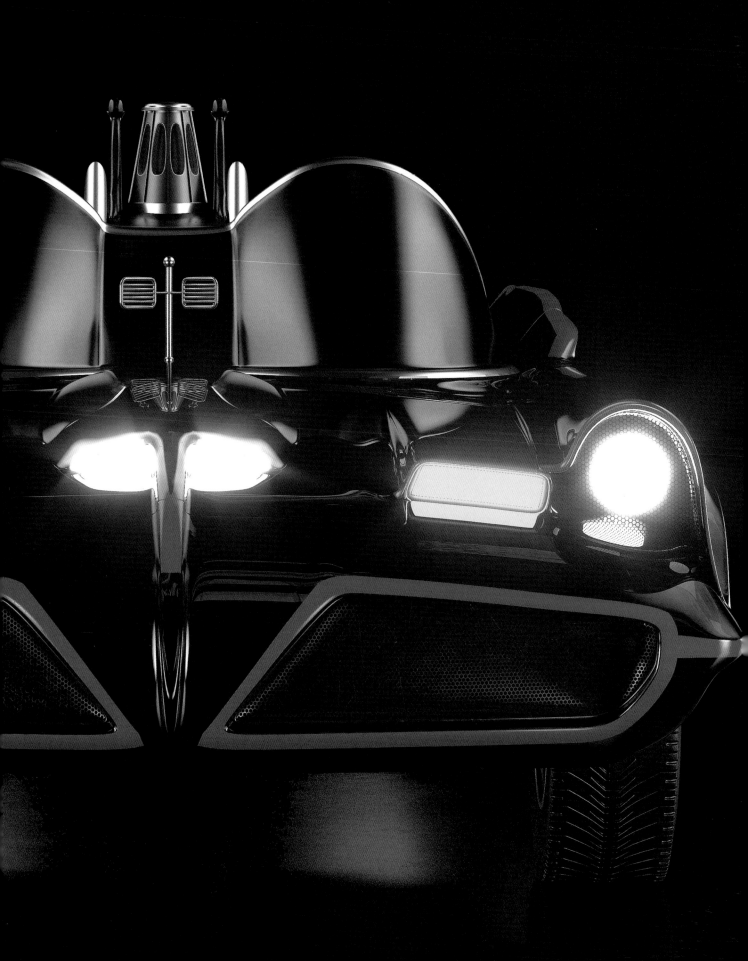

BATMOBILE
MANUAL

— Written by —

DANIEL WALLACE

With illustrations by

ŁUKASZ LISZKO

INSIGHT
EDITIONS
SAN RAFAEL • LOS ANGELES • LONDON

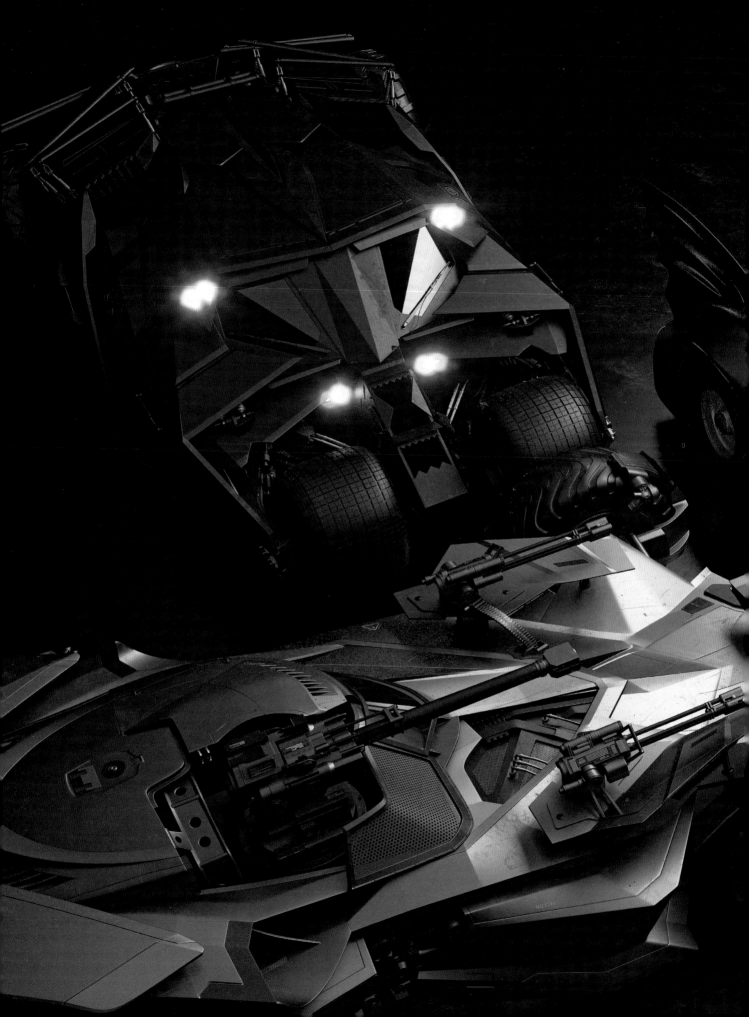

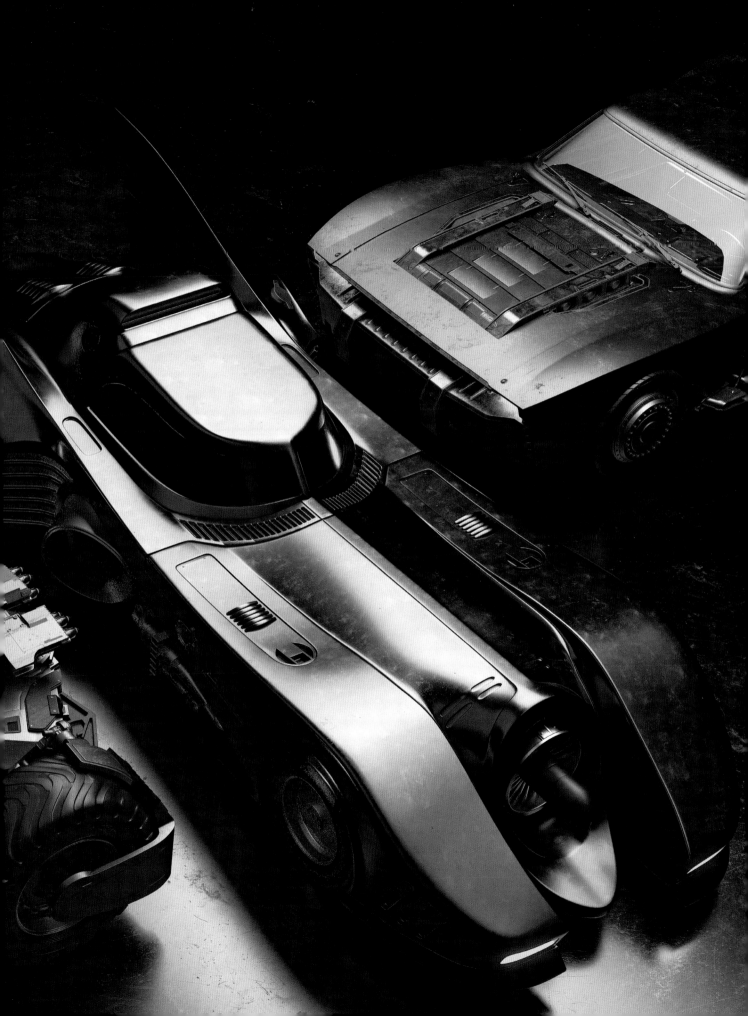

CONTENTS

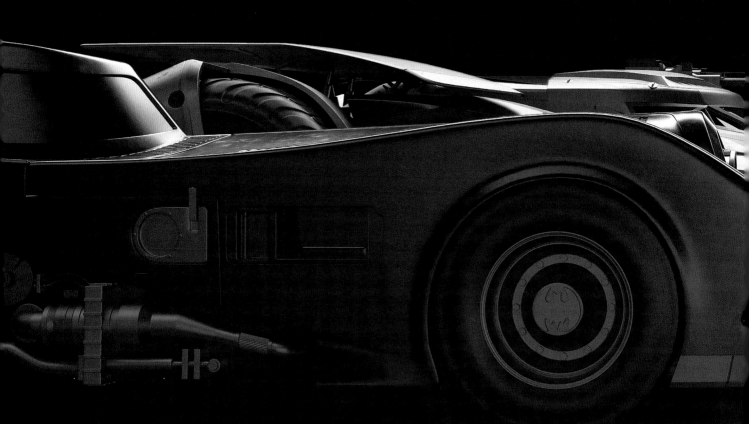

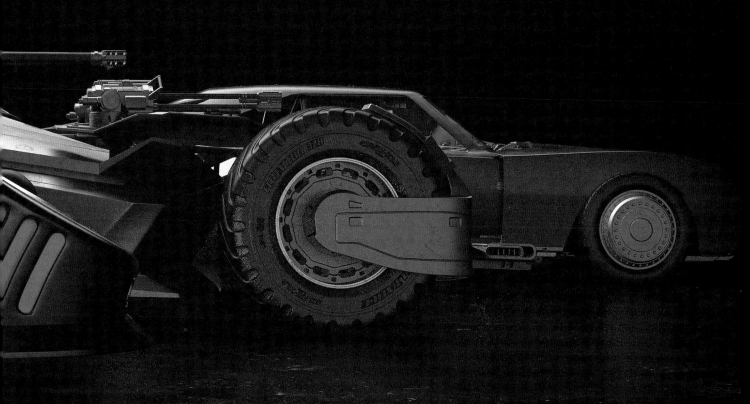

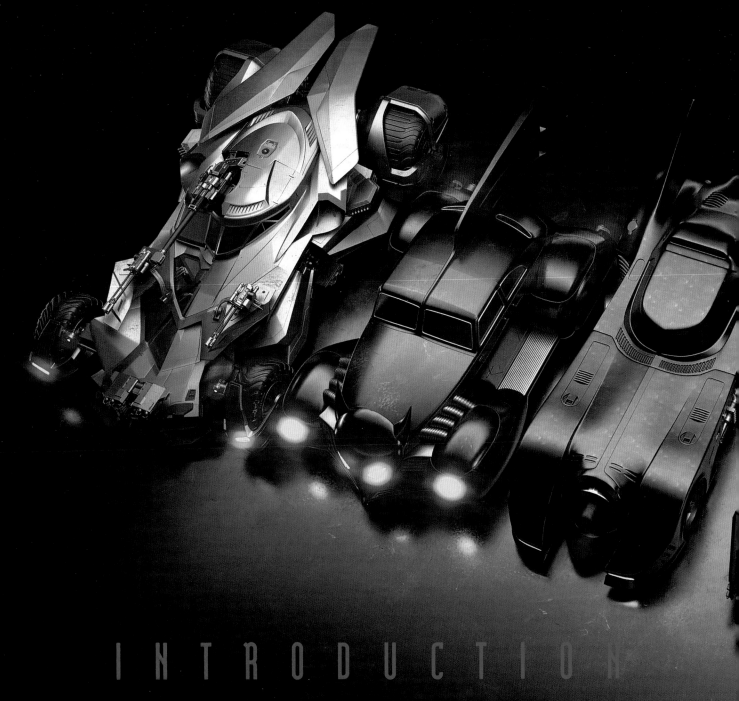

INTRODUCTION

Though our universe appears to be endless, in reality there are realms that exist far beyond the infinite! In almost all these realities, Batmobiles prowl the moonlit streets of Gotham City under the control of the formidable costumed crime fighter universally known as the Batman.

Hidden weapons and a powerful engine allow the Batmobile to chase down fleeing lawbreakers and neutralize any threats they present. Criminals who have been laid low by its antipersonnel deterrents can easily be collected by the officers of the Gotham City Police Department and thrown into lockup.

A closer look at the differences between the vehicles found in each of these parallel dimensions reveals how each Batmobile is perfectly tailored to assist Batman in his crusade against injustice. Some vehicles stress pure speed, while others offer raw offensive power. A few Batmobiles are capable of remarkable transformations, enabling them to escape from near-death situations or to operate in hostile environments. In addition, each Batmobile is optimized for a number of factors—including street performance and psychological impact—to suit the surrounding environs of Gotham City.

So get ready—you've been granted unrestricted access to a multidimensional garage stocked with the greatest Batmobiles ever created. Strap in and hit the accelerator. It's time to take the fight directly to Gotham City's criminals!

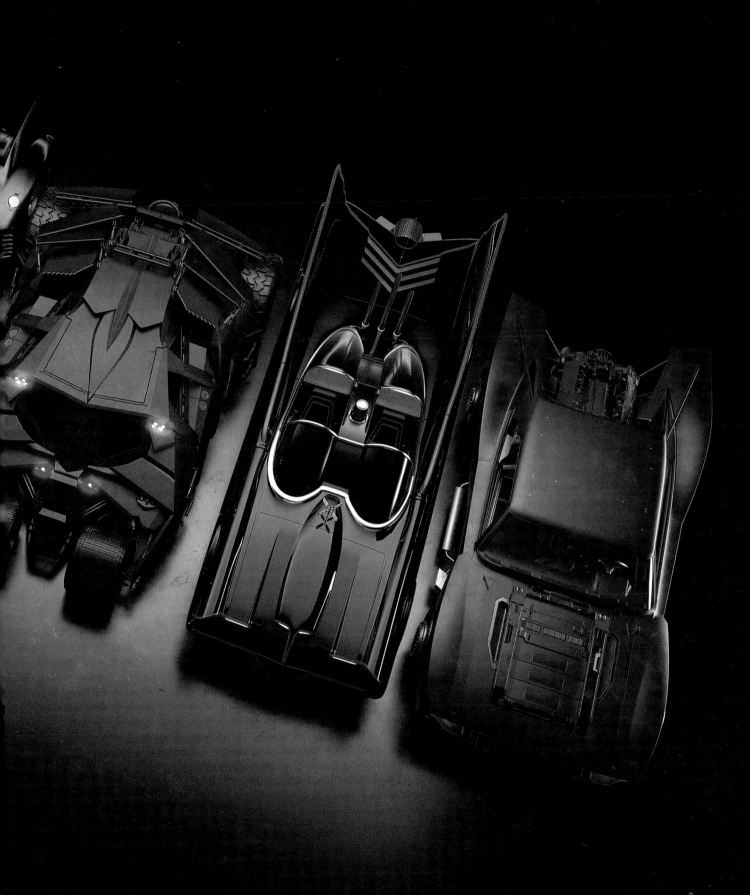

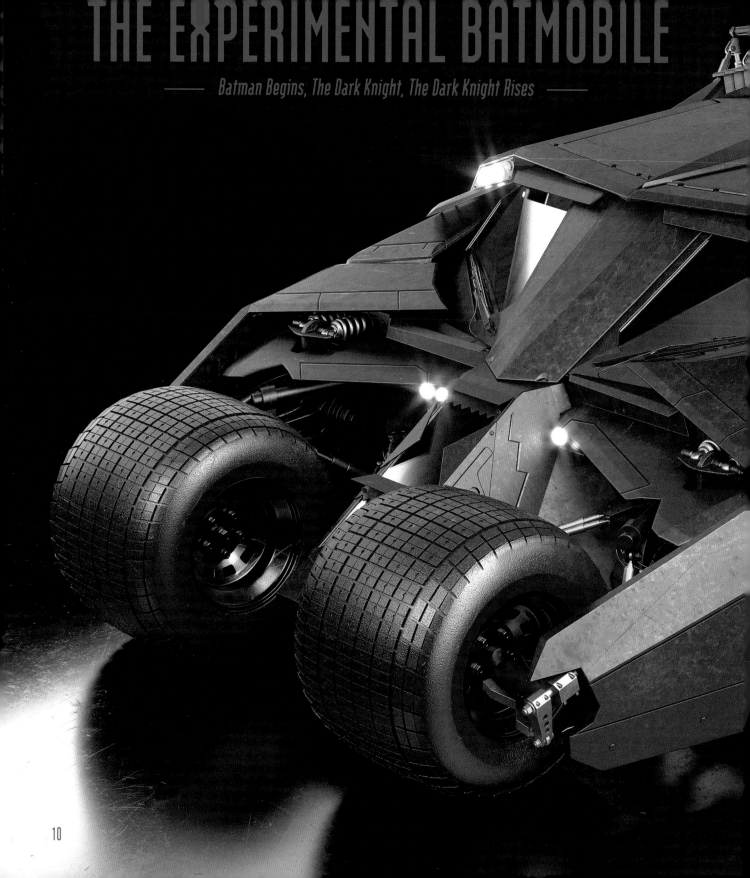

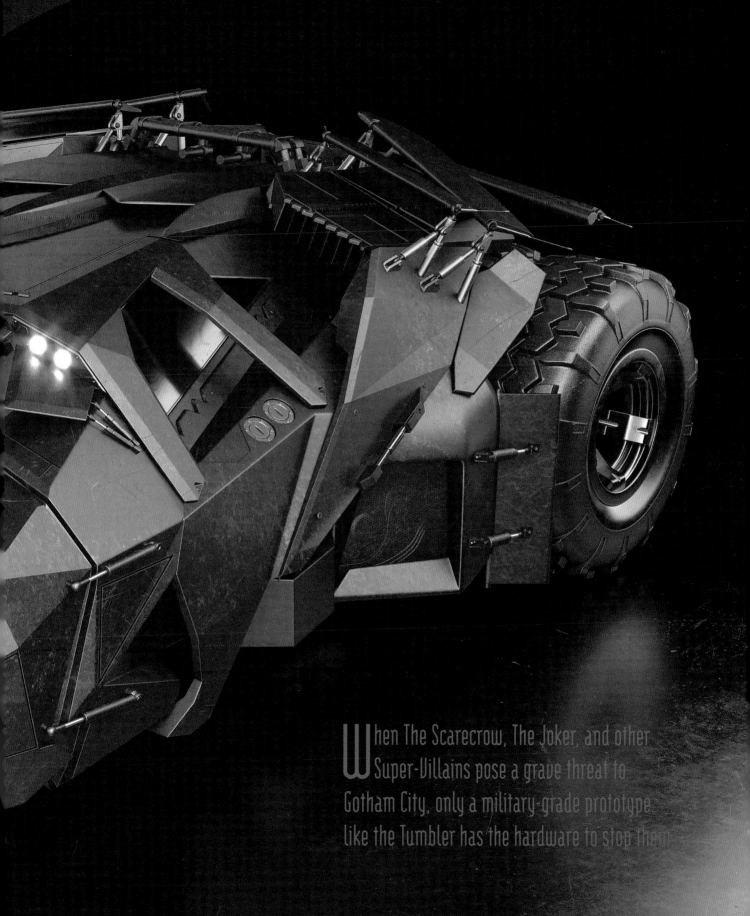

When The Scarecrow, The Joker, and other Super-Villains pose a grave threat to Gotham City, only a military-grade prototype like the Tumbler has the hardware to stop them.

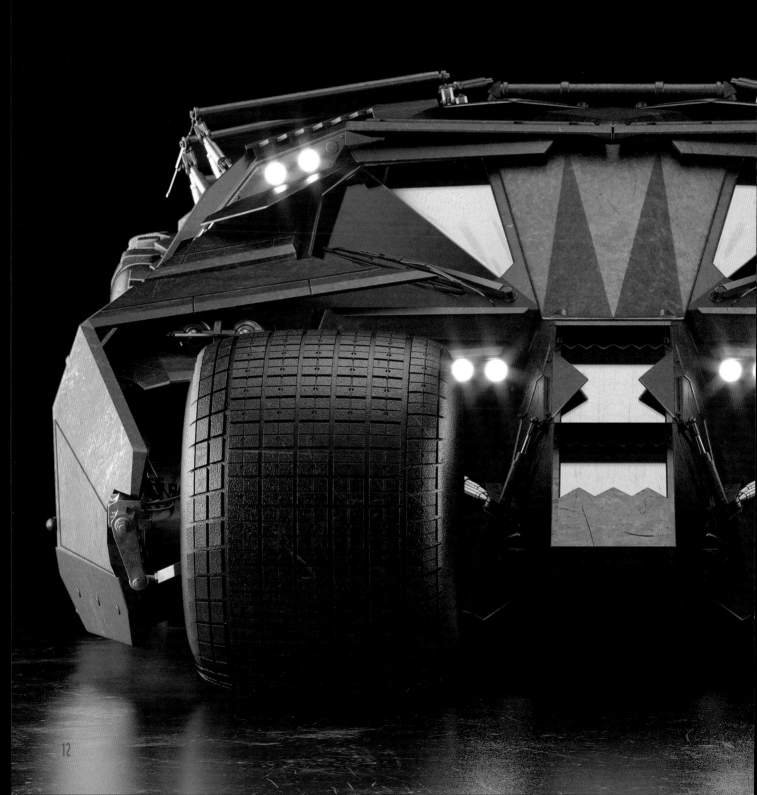

"The Tumbler combined the best qualities of a muscle car and an all-terrain utility vehicle."

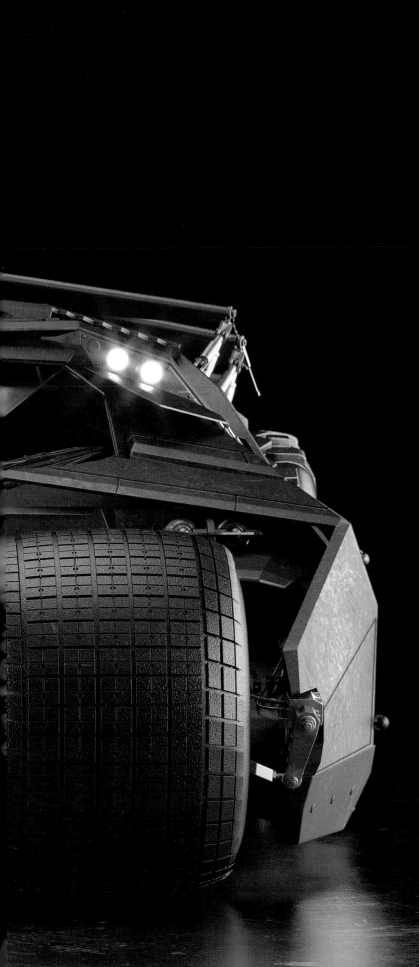

The billionaire heir to Wayne Enterprises, Bruce Wayne was forever changed when he witnessed a mugger gun down his parents, Thomas and Martha Wayne, in cold blood, a tragedy that sent him down the path of vengeance. After years of training with Ra's al Ghul and the League of Shadows, Bruce became Batman and set out to create an all-purpose assault vehicle he could use to bring the streets of Gotham City under control.

The Dark Knight's armored, jet-black Batsuit was sufficient to intimidate criminals, but Batman needed a machine capable of dominating the streets, plowing over anything that got in its way. He found his solution in the Tumbler, a prototype military vehicle constructed by Wayne Enterprises' experimental engineering division.

Assigned to Lucius Fox—a brilliant engineer who helped Bruce's father, Thomas Wayne, build the Gotham Monorail—the Applied Sciences Division of Wayne Enterprises is a hands-off skunkworks where mechanical engineers can indulge R&D flights of fancy. But, with few breakthroughs to show for its efforts, the Applied Sciences Division was quietly dismissed as a dead end.

Bruce Wayne, however, recognized that the division's military prototypes could provide the edge he needed as a costumed vigilante. After bringing Lucius Fox into his confidence, Bruce raided the division's archives to obtain a prototype US Army vehicle called the Tumbler, which had been built to rocket across gaps while towing a cable that would form the support structure for an improvised military bridge.

The Tumbler combined the best qualities of a muscle car and an all-terrain utility vehicle while also incorporating experimental features sourced from stealth bombers and light tanks. Because the Tumbler had been designed as a bridging vehicle, it could achieve jet-propelled acceleration and astonishing rampless jumps.

Once Bruce Wayne chose the Tumbler as his new Batmobile, he made very few alterations besides covering its camouflage exterior with multiple coats of black paint.

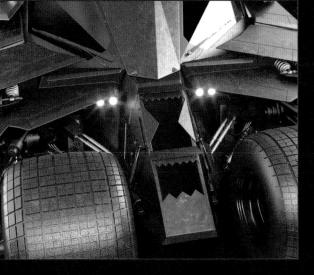

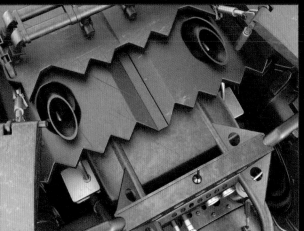

The Tumbler Batmobile was a formidable sight on the streets of Gotham City. It could crush cars under its wheels while shielding its driver behind a bulletproof canopy. Machine guns and missile launchers gave the Batmobile an offensive punch intended for property destruction and intimidation rather than physical injury, while a programmable autopilot allowed the car to self-navigate.

The Tumbler's aerodynamic angles and adjustable, drag-inducing flaps helped direct airflow at high speeds. Furthermore, the cockpit was gyroscopically balanced to keep the operator in a steady position when encountering rough terrain or if the vehicle should be upended.

Bat-themed symbolism is a vital component of Batman's dark mystique. As a child, Bruce Wayne fell down a dry well while exploring his family's estate, and a swarm of bats engulfed him, leaving him with a lifelong phobia of the creatures. When outfitting himself as Batman, Bruce channeled his fears into the design of his armored suit, pointy-eared cowl, and a cape that could be snapped into a rigid framework that resembled membranous wings.

The Batmobile shared in that rebirth. Even though the exterior of the Army-built Tumbler was not altered significantly (other than its matte-black paint job), criminals who have seen the Batmobile in action often swear that it resembled a gigantic bat, noting how the forward arm struts curled up around the small "head" (or weapons cockpit) like a bat caught in mid-glide.

"The Tumbler's aerodynamic angles and adjustable, drag-inducing flaps helped direct airflow at high speeds."

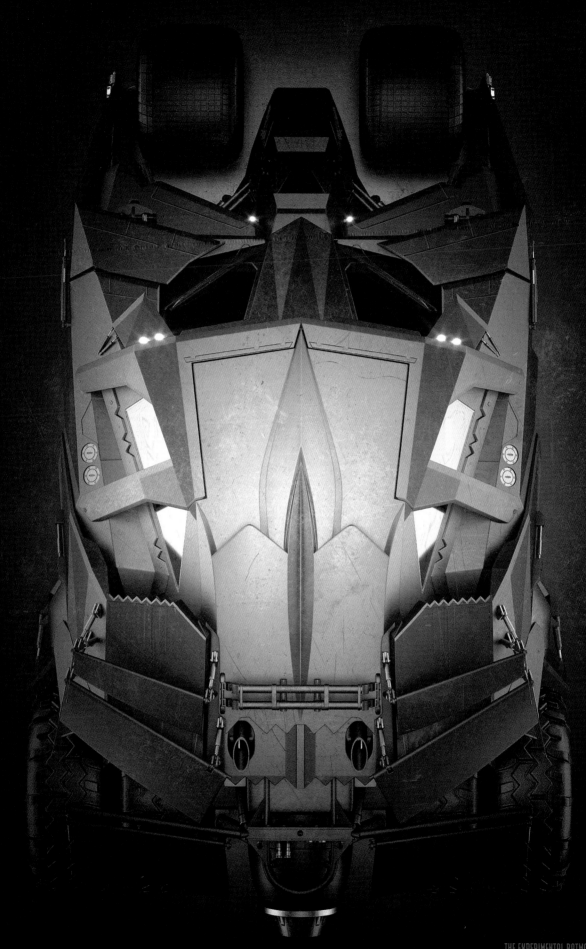

OPERATIONAL HISTORY

The Batmobile first saw action in response to the mayhem unleashed by psychologist Jonathan Crane, aka the Scarecrow. It was Crane's use of fear toxin that threatened to tear down Gotham City, fulfilling the destructive visions of Ra's al Ghul. As the city's costumed protector, Batman forged an alliance with Sergeant James Gordon of the Gotham City Police Department and entrusted Gordon with operating the Batmobile while Batman fought Ra's al Ghul on an elevated monorail. Gordon fired the Batmobile's cannons and collapsed a section of monorail track, saving the city's reservoir from contamination by the Scarecrow's hallucinogenic fear toxin.

The Batmobile continued to serve as the primary tool in Batman's arsenal as Batman and Gordon joined forces with District Attorney Harvey Dent to combat Gotham City's crime families. When the anarchic mastermind known as the Joker disfigured Dent and turned him into the deranged villain Two-Face, Batman took the blame for Dent's crimes to preserve the district attorney's reputation. Batman became an outlaw, and the Batmobile, destroyed during the Joker's rampage, survived only in the form of prototypes stored at Wayne Enterprises' Applied Sciences Division.

The rise of a dangerous terrorist calling himself Bane changed the equation once more. For the first time in eight years, the Batman prowled the streets of Gotham City, relying on high-tech solutions to thwart Bane's fleet of stolen Tumbler prototypes.

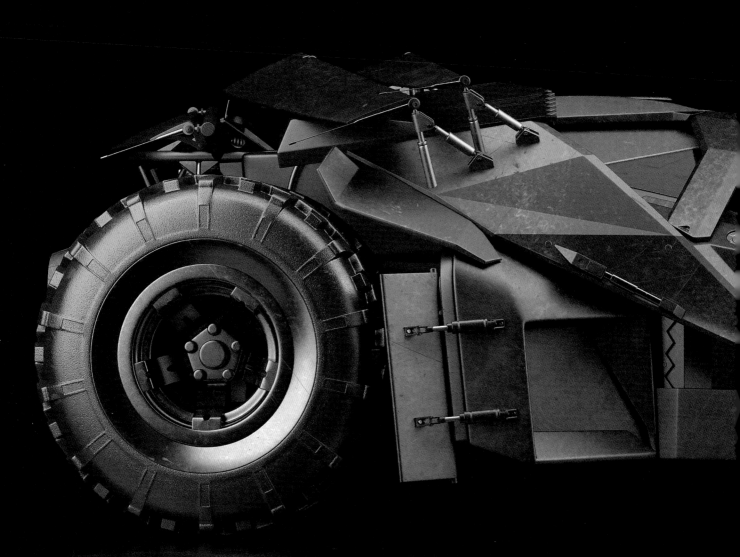

ARMOR

The Batmobile's armor was printed in the form of interlocking panels, which were easy to replace in case of damage. This approach to modular design originated with Lucius Fox and the Tumbler's original military role, inspired by situations where explosive-reactive armor panels (which burst outward, expelling themselves when struck by rockets to offset the impact damage) could be quickly swapped out for intact panels by Army mechanics at a forward operating base.

Armor panels also were required to insulate the volatile fuel tanks against ignition during explosive attacks. In emergencies, Batman could temporarily block the Batmobile's fuel lines via cockpit commands, and if a propane canister was ruptured it could be forcibly ejected from the vehicle. Hydraulic shutters and airfoils on the top and sides of the vehicle helped direct airflow in a manner that kept the Batmobile glued to the road for optimal traction.

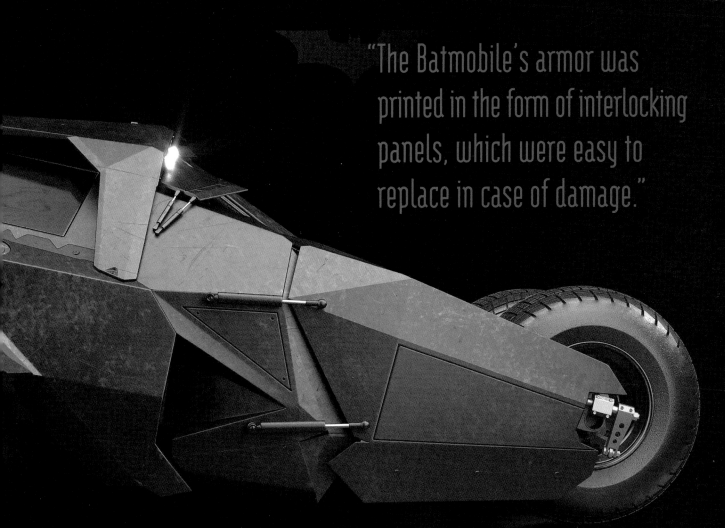

"The Batmobile's armor was printed in the form of interlocking panels, which were easy to replace in case of damage."

TO: BRUCE WAYNE
FROM: LUCIUS FOX

Bruce, if you've read the most recent annual report, you already know the official Wayne Enterprises narrative. But once such things aren't high on your priority list, allow me to quote: "From shipping to pharmaceuticals, we play a vital role in every industry that underpins the global economy," and so forth. Vague bromides might be enough to reassure most investors, but I want to stress to you that some corporate ventures will never turn a profit. Exhibit A? How about the Wayne Enterprises Applied Sciences Division?

The suits and ties view everything through the lens of raw capital. And under that accounting, the Applied Sciences Division is an expensive failure. Despite the engineering breakthroughs produced during my tenure, I couldn't drum up contracts from military or corporate buyers. Given my history with your father, the board of directors didn't have the authority to remove me, so they defunded me instead. I stayed on as head of the Applied Sciences Division, but with vastly reduced funding, I was

essentially the caretaker of a museum of lost technology. You know what happened next. How you persuaded me to uncrate a few of our mothballed prototypes: armored memory fabrics, machine-balanced shuriken, and jet-propelled all-terrain vehicles. By freely sharing experimental tech, the Applied Sciences Division jump-started the Batman's personal arsenal.

As for myself, I can't complain about what happened next. I appreciate how you outmaneuvered the board by purchasing a controlling stake and named me as CEO by executive order. The Applied Sciences Division is now Batman's primary supplier, and I have willingly become the first person Batman calls when he requires a tech solution.

Bruce, let me be frank. The Batman has brought order to Gotham City, but he is an ungovernable force. Without oversight, anyone is capable of overreach, and I don't know if I'm capable of reining in this figure that you've created. We may have order, but at what cost?

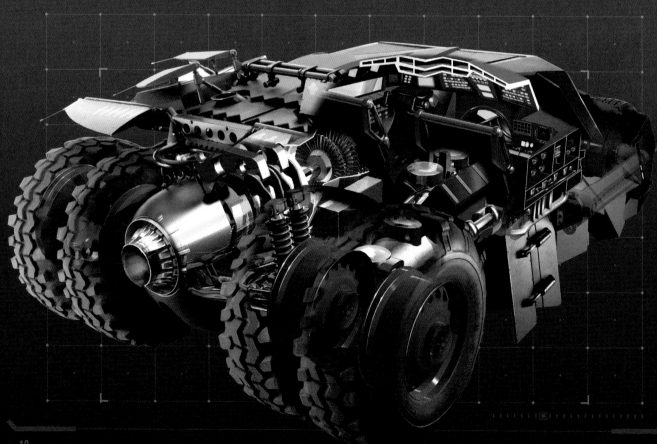

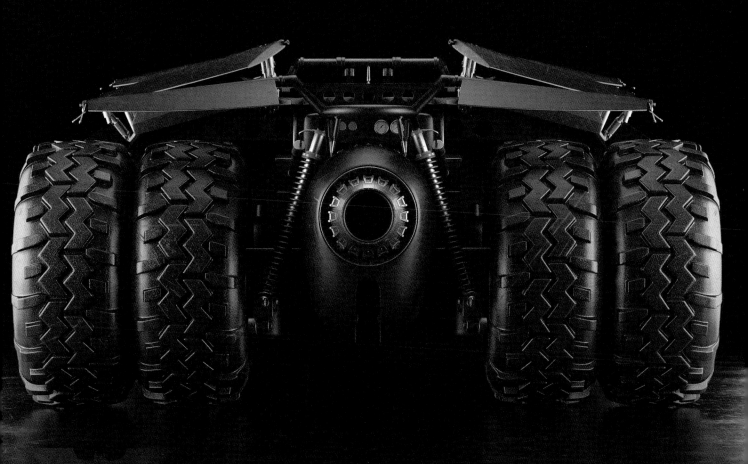

"Its secondary propulsion mode (built for military use, not urban conditions) was a propane jet engine capable of 3,000 pounds of thrust."

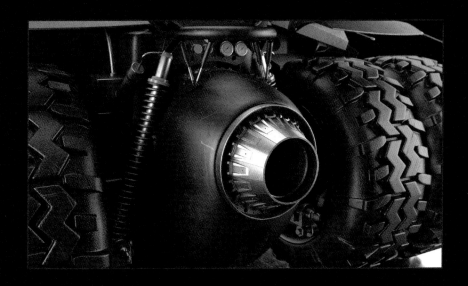

DRIVETRAIN AND WHEELS

The Batmobile used a 500-hp V-8 engine as its powerhouse, fine-tuned for efficient acceleration in the grid-like streets of Gotham City. Its secondary propulsion mode (built for military use, not urban conditions) was a propane jet engine capable of 3,000 pounds of thrust. To achieve rampless jumping, the Batmobile reared up on its front suspension as its rear jet nozzle used vectored thrust to launch the car on a controlled arc of up to 12 meters.

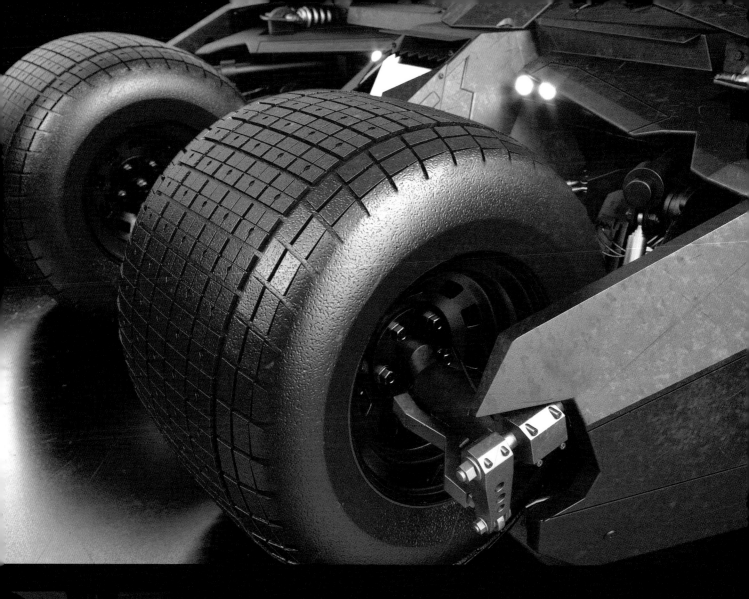

"The Batmobile's wheels were independently controlled and able to lock up on either side to facilitate extremely sharp turns."

WHEELS AND SUSPENSION

The Tumbler also featured a highly responsive shock-absorption system. When the vehicle reached the apogee of a boosted jump, its front wheels extended 30 inches below the suspension on its underbelly to provide extra cushioning for the landing shock.

The Batmobile's wheels were independently controlled and able to lock up on either side to facilitate extremely sharp turns. The front end of the vehicle had no axle at all, with each front wheel bolted onto an independent arm strut to assist in maneuverability and to accommodate the central pod used to fire guided missiles. The two forward tires had slick road-gripping racing treads, while the four rear tires were massive deep-treaded tractor designs built to handle muddy terrain. The doors, roof, and cockpit of the Batmobile used hydraulic pistons to slide and unfold with intricate mechanical movements.

DEFENSE AND WEAPONS SYSTEMS

The angles of the Tumbler's armor plating formed a precise, radar-scattering silhouette rendering the vehicle nearly invisible to electronic detection. To maintain an even lower profile, Batman could switch the engine over to a fully silent mode that ran on an electric power cell, while dousing all exterior running lights and relying only on night-vision readouts for navigation.

The Tumbler was programmed with two modes—"loiter" and "intimidate"—to help sell the illusion that the vehicle was being piloted when the cockpit was empty. In loiter mode, the Batmobile passively monitored pedestrians and vehicles while parked or slowly patrolling a perimeter. In intimidate mode, the Batmobile fired guns or missiles to create spectacular, nonlethal property damage guaranteed to frighten aggressors. When properly applied, these automated states enabled Batman to divert attention from his true objective or to provide extra muscle during combat engagements.

The Batmobile's weapons included machine guns and variable-armament nose launchers (equipped with ballistic missiles, tear gas canisters, fire-retardant gel, and compressed adhesive foam that solidified upon exposure to air). In firing mode, the driver's seat shifted from an upright position to a center-mounted, face-down configuration, with Batman's head positioned between the front wheels of the vehicle.

From its rear undercarriage, the Batmobile could drop explosive mines to disable pursuers or to render the roadway unnavigable. The vehicle also could deploy plastic strips embedded with metal spikes designed for shredding pneumatic tires. A reel-mounted landing hook could be used as an offensive weapon or as a braking assist.

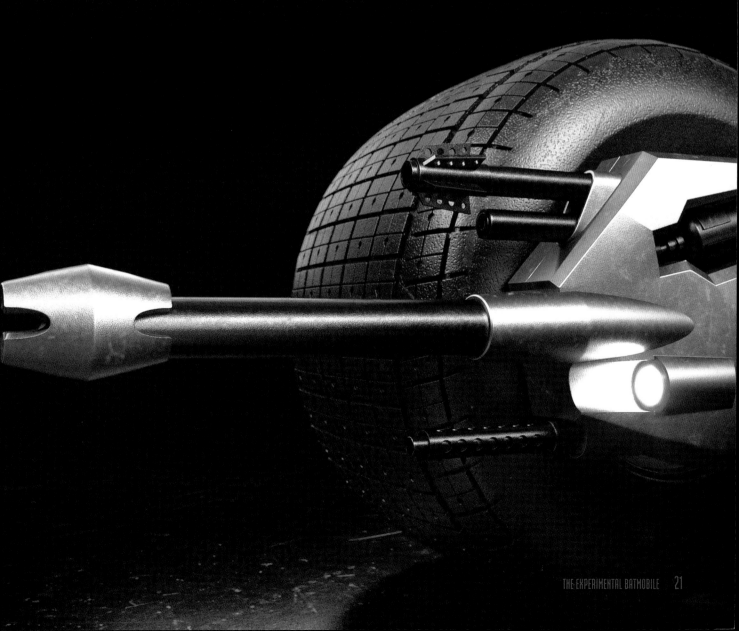

5.7-LITER (350 CUBIC INCH) V-8 ENGINE
CAPABLE OF 500 HP

TWIN DRAG CHUTES
FOR RAPID BRAKING

PROPANE JET ENGINE FOR
BOOSTS OR RAMPLESS JUMPS

SHOCK ABSORBERS

EXPLOSIVE REACTIVE ARMOR

ROOF-ACCESS CANOPY FOR QUICK ENTRY

POLARIZED/UNPOLARIZED BULLETPROOF GLASS

BLAST SHUTTERS

BATPOD EXIT PORT

GRAPPLING HOOK

SPECS AND FEATURES

LENGTH: 15 feet, 2 inches

WIDTH: 9 feet, 2 inches

HEIGHT: 4 feet, 11 inches

WEIGHT: 2.5 tons

ACCELERATION: 0–60 mph in 5.6 seconds

MAXIMUM SPEED: 220 mph

MAXIMUM JUMP DISTANCE: 30 feet

AIR-COOLED MACHINE GUNS WITH VARIABLE AMMUNITION

GUIDED-MISSILE LAUNCHERS

TUMBLER VARIANTS

In Lucius Fox's own words, the Tumbler was a failed design, unable to fulfill its original role as a military bridge layer. Work nevertheless continued on the Tumbler design, but the focus changed to adapting the vehicle for a variety of military needs. At the time of Bane's attack on Gotham City, several Tumbler variants were under development, but none had progressed beyond the prototype stage.

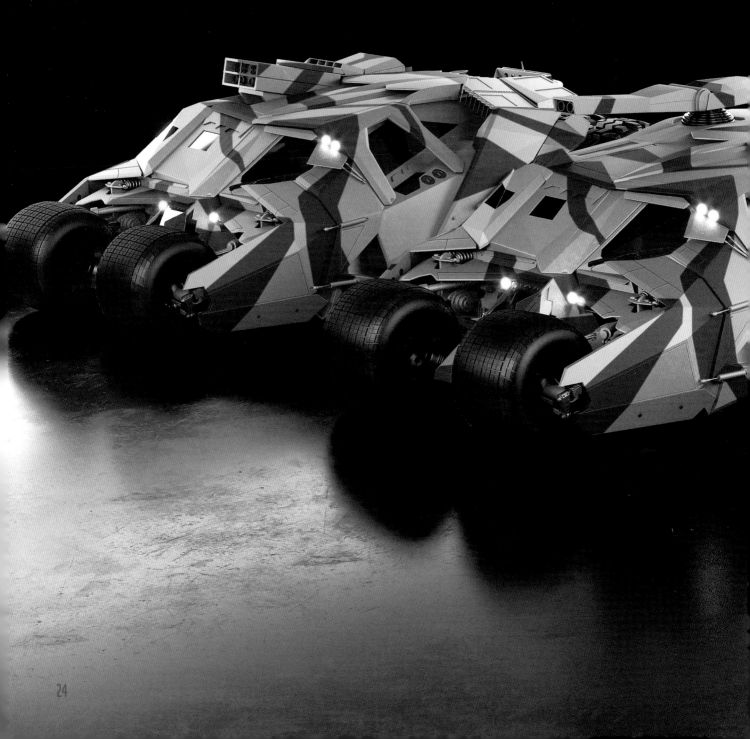

"At the time of Bane's attack on Gotham City, several Tumbler variants were under development, but none had progressed beyond the prototype stage."

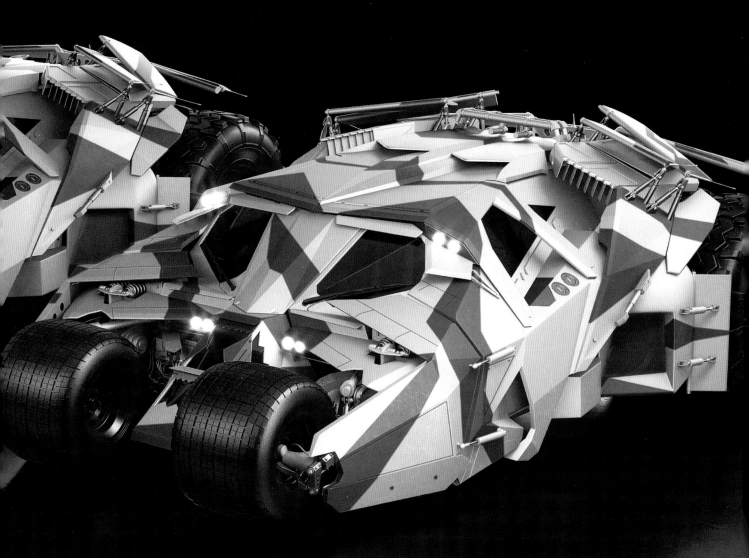

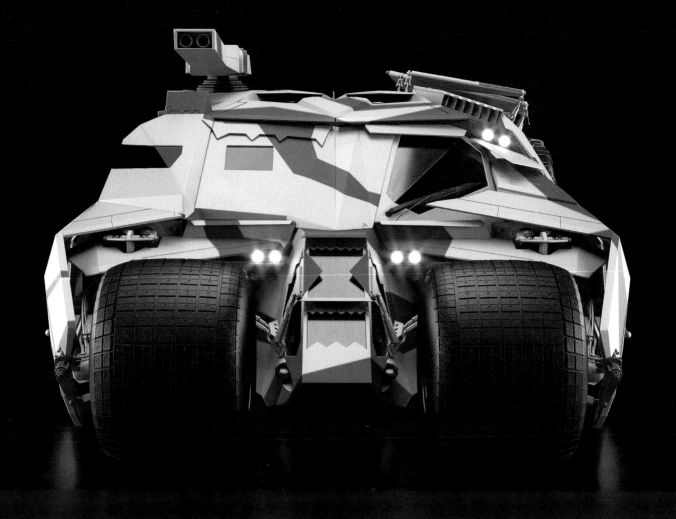

RECONNAISSANCE TUMBLER
A stealthy variant built for battlefield scouting, this Tumbler featured lighter armor and could travel extended distances without refueling. Equipped with autocannons and anti-tank guided missiles, it also was packed with electro-optics and multi-spectrum eavesdroppers for intercepting enemy communications.

TECHNICAL TUMBLER
A tactical variant built for versatility in the face of changing combat needs, this vehicle featured universal weapon mounts for the rapid installation and removal of machine guns, autocannons, anti-tank guns, artillery cannons, mortars, rocket launchers, and other munitions.

EW TUMBLER:
Built specifically for electronic warfare, this vehicle was outfitted with directed-energy generators to disrupt enemy communications and technology, plus countermeasures for detecting and blocking hostile electromagnetic (EM) assaults.

LIGHT UTILITY TUMBLER
A stripped-down model with lightweight armor and four-person carrying capability, it was equipped with retractable panels around the cockpit to allow for open-air maneuvering in the manner of a military jeep. Fox built this vehicle for maximum versatility at a low cost, speculating that it could be used for ferrying command staff, hauling equipment, or evacuating the wounded.

ANTI-AIRCRAFT TUMBLER
Equipped with surface-to-air guided missiles and a twin-barreled autocannon, this Tumbler was classified as a SPAD, or self-propelled air defense system. Its weapons were mounted on quick-rotating pivots controlled by cockpit trackers calibrated to lock onto fast-moving aircraft.

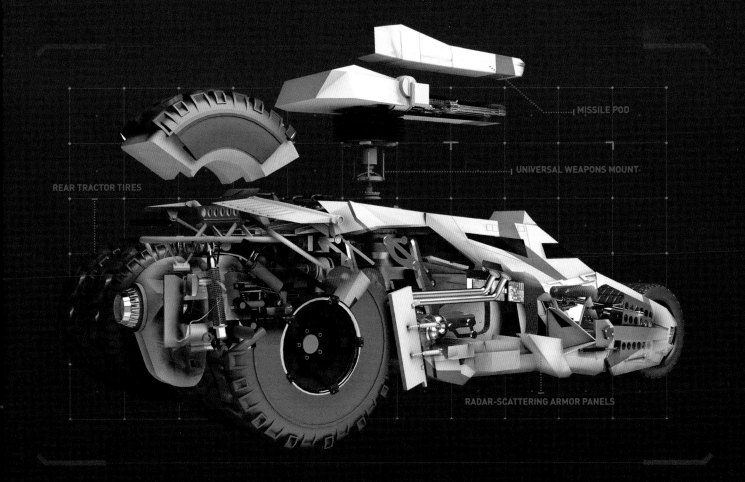

REAR TRACTOR TIRES

MISSILE POD

UNIVERSAL WEAPONS MOUNT

RADAR-SCATTERING ARMOR PANELS

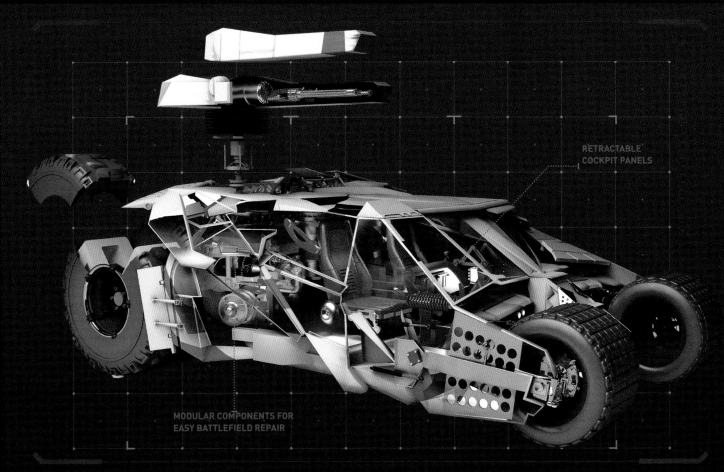

RETRACTABLE COCKPIT PANELS

MODULAR COMPONENTS FOR EASY BATTLEFIELD REPAIR

BAT-POD

The Bat-Pod was a two-wheeled motorcycle built into the framework of the Tumbler itself, intended for use in emergency escape when the primary vehicle had suffered catastrophic damage. Activating the Bat-Pod's ejection sequence also initiated a self-destruct countdown that incinerated the Batmobile and ensured that none of its secrets would fall into hostile hands.

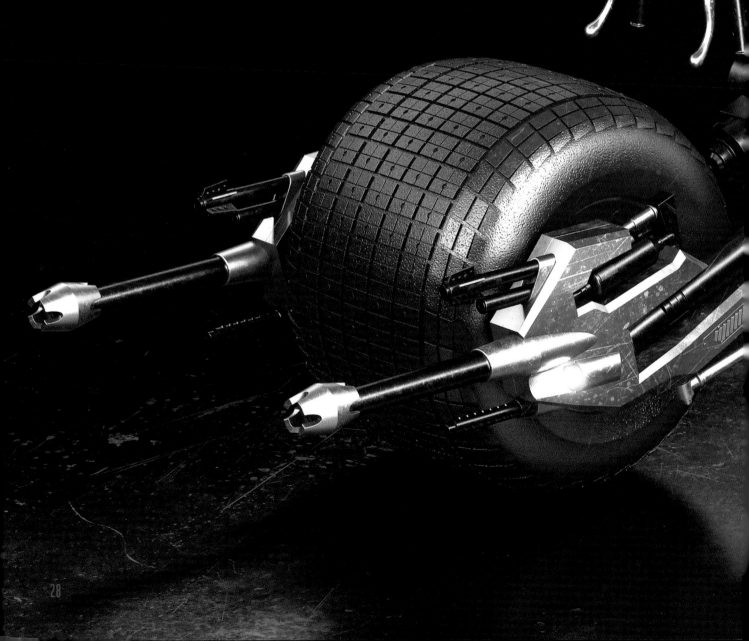

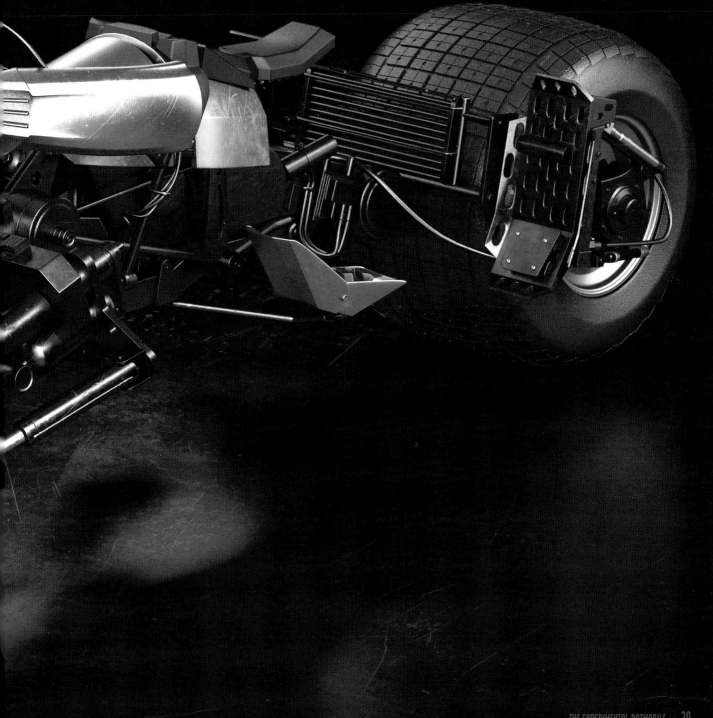

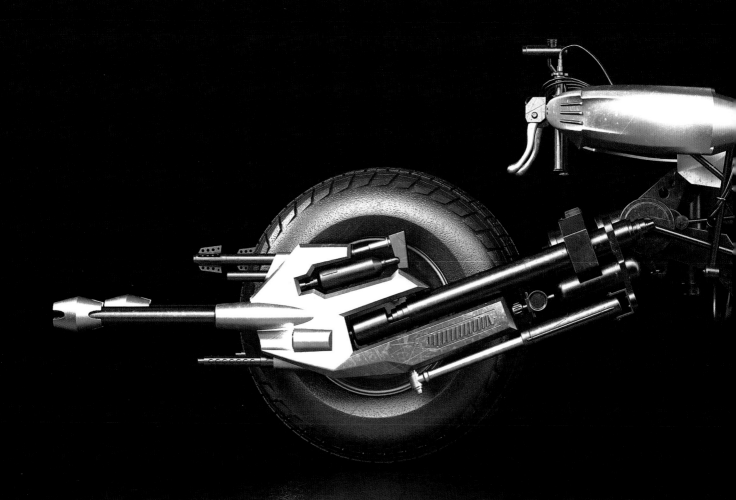

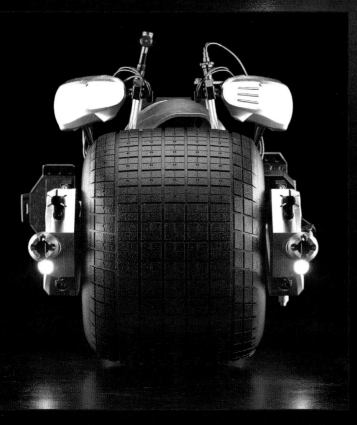

To release the Bat-Pod, Batman pulled forward on a bank of overhead levers, snapping an array of weapons into position around the Batmobile's left front wheel. An explosive ejection sequence followed, which rocketed the Bat-Pod forward and away from the blast radius of the self-destruct charges that scuttled the Batmobile.

The essential components of the Bat-Pod are borrowed directly from the Batmobile, including its front wheel and suspension. The Bat-Pod's rear wheel (equipped with a similarly slick street-racing tire) remains hidden behind the Batmobile's rear armor plating, coming into view only after explosive ejection.

A pair of electric motors mounted in the wheels deliver power to the Bat-Pod, their rotational speeds governed by an onboard computer that provides readouts on speed, braking, throttle inputs, and energy consumption. Batman steers the cycle with his shoulders, and the Bat-Pod is set so low to the ground that it can pass under the trailer of a semitruck with inches to spare. The Bat-Pod's weaponry includes machine guns and explosive launchers.

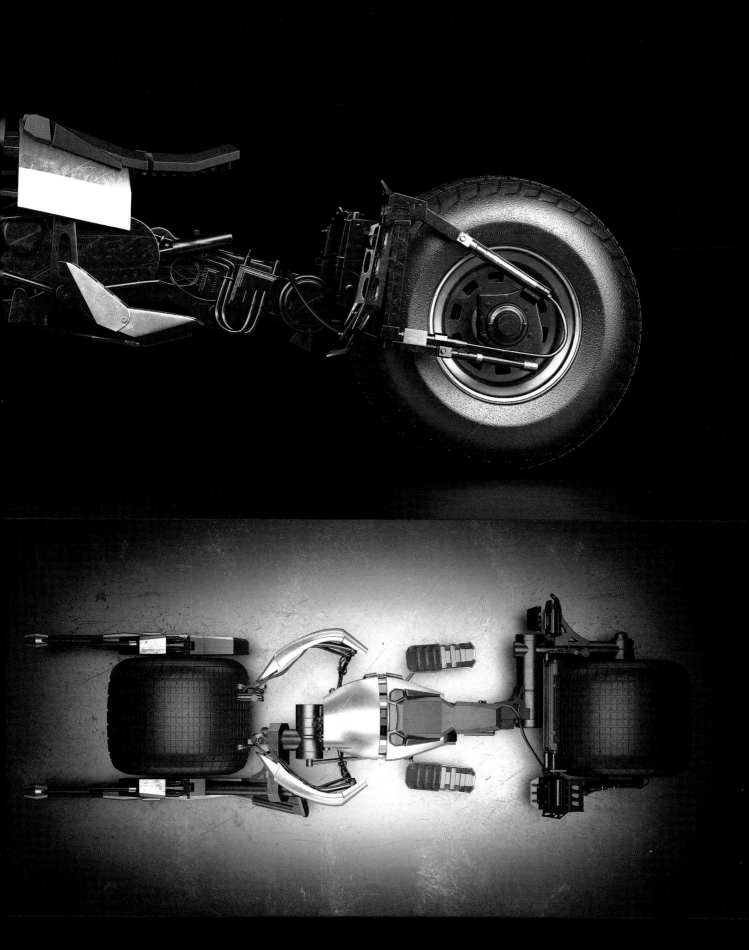

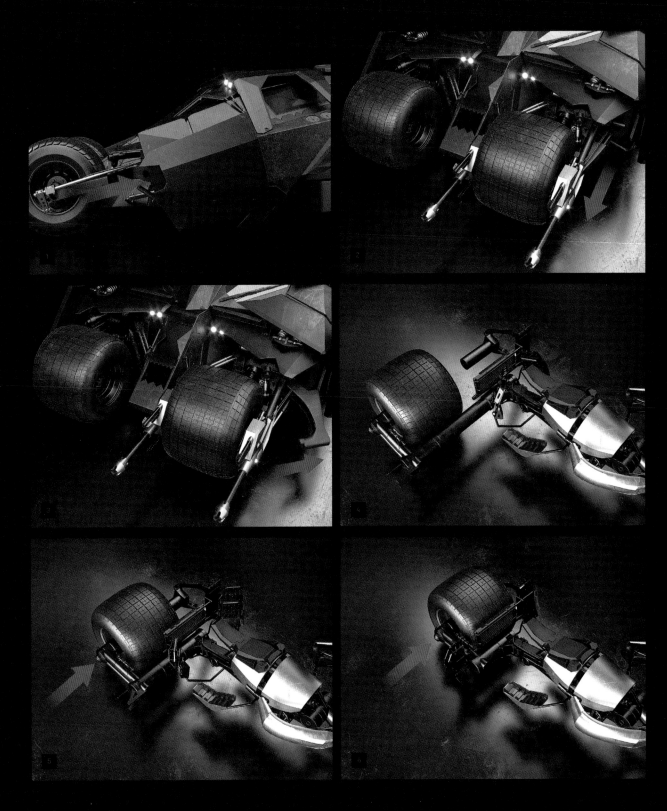

01 FRONT ARMOR PANELS RETRACT

02 WEAPONS EXTEND

03 HOLDING BAR RELEASES

04 BATPOD IS EJECTED FROM VEHICLE BODY

05 FRONT WHEEL SLIDES ALONG AXLE

06 FRONT WHEEL LOCKS INTO INLINE CONFIGURATION

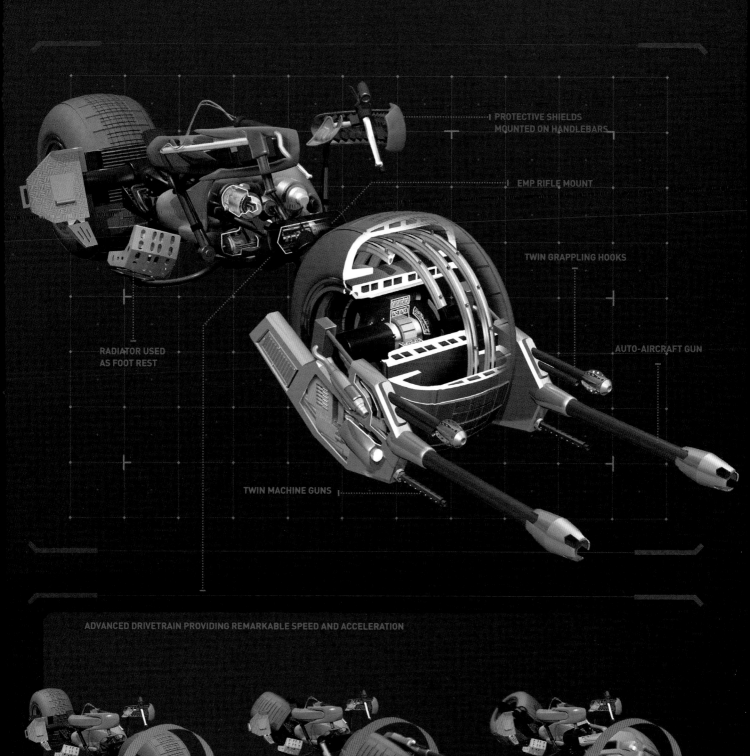

PROTECTIVE SHIELDS
MOUNTED ON HANDLEBARS

EMP RIFLE MOUNT

TWIN GRAPPLING HOOKS

AUTO-AIRCRAFT GUN

RADIATOR USED
AS FOOT REST

TWIN MACHINE GUNS

ADVANCED DRIVETRAIN PROVIDING REMARKABLE SPEED AND ACCELERATION

THE BAT

An experimental aircraft built by Wayne Enterprises for the US Department of Defense, this radical reinterpretation of a traditional attack helicopter was commissioned to fill the role of "tight-geometry urban pacification" during occupation of enemy cities or in response to domestic terrorist threats. Capable of precision maneuvering in three axes of movement, the Bat relies on twin rear rotors for propulsion, achieving lift by channeling air downward through vents in the craft's dorsal surface. The Bat requires very little energy for a craft of its size, giving it a smaller thermal footprint, an advantage when evading sensors or shaking off missile locks. The vehicle is also armed with machine guns mounted on the front pods on either side of the cockpit.

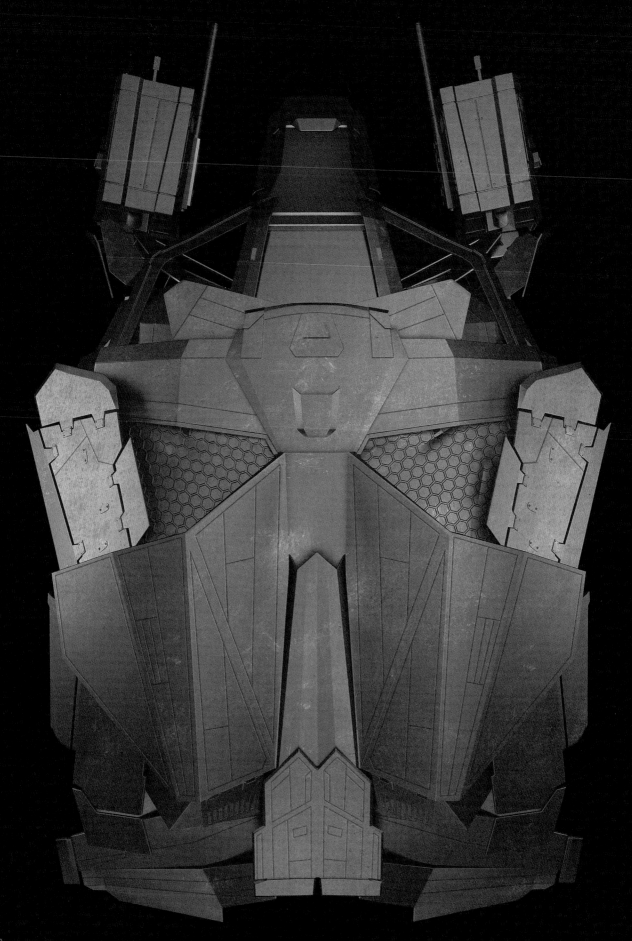

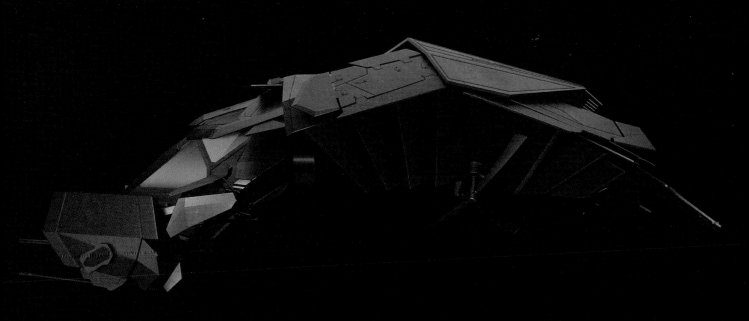

"Capable of precision maneuvering in three axes of movement, the Bat relies on twin rear rotors for propulsion, achieving lift by channeling air downward through vents in the craft's dorsal surface."

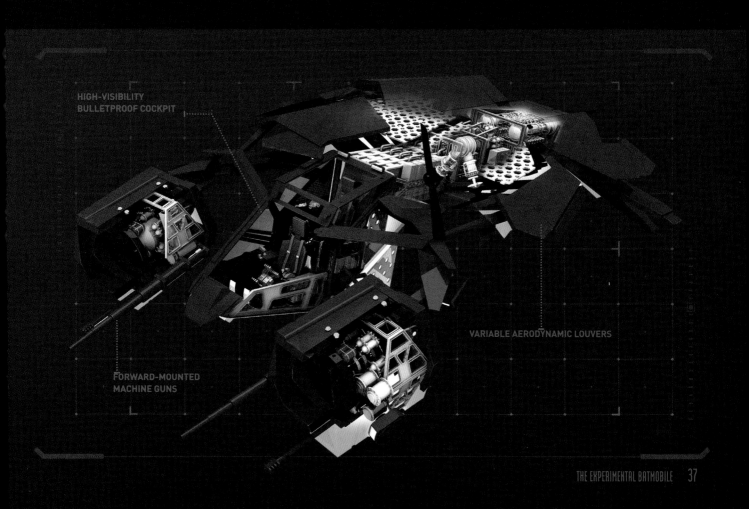

HIGH-VISIBILITY
BULLETPROOF COCKPIT

VARIABLE AERODYNAMIC LOUVERS

FORWARD-MOUNTED
MACHINE GUNS

THE UNCOMPROMISING BATMOBILE

Batman v Superman: Dawn of Justice, Justice League

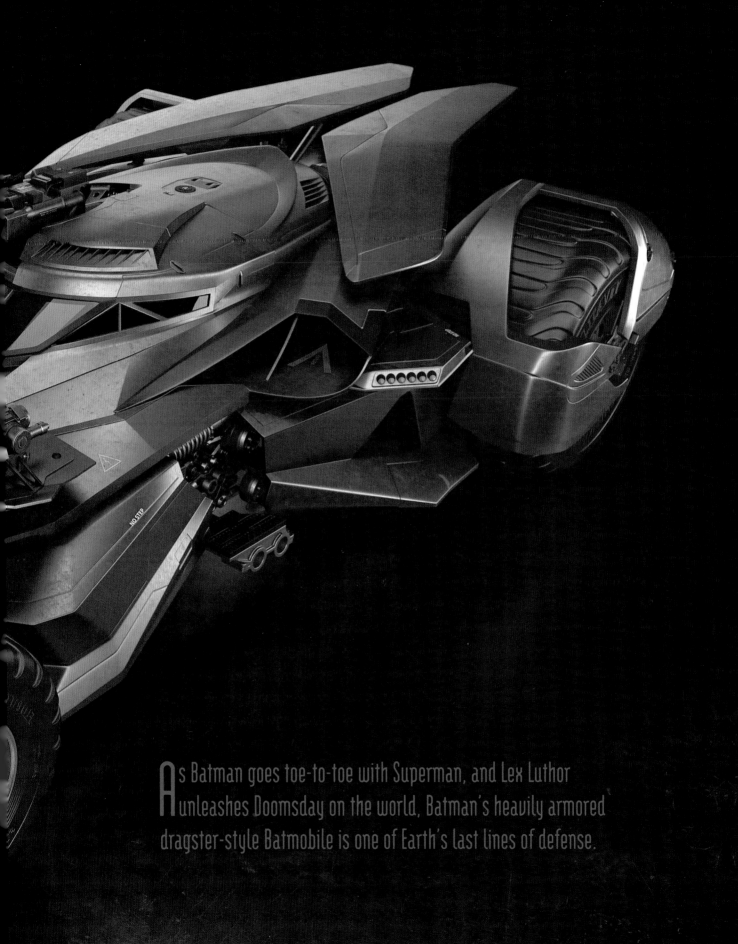

As Batman goes toe-to-toe with Superman, and Lex Luthor unleashes Doomsday on the world, Batman's heavily armored dragster-style Batmobile is one of Earth's last lines of defense.

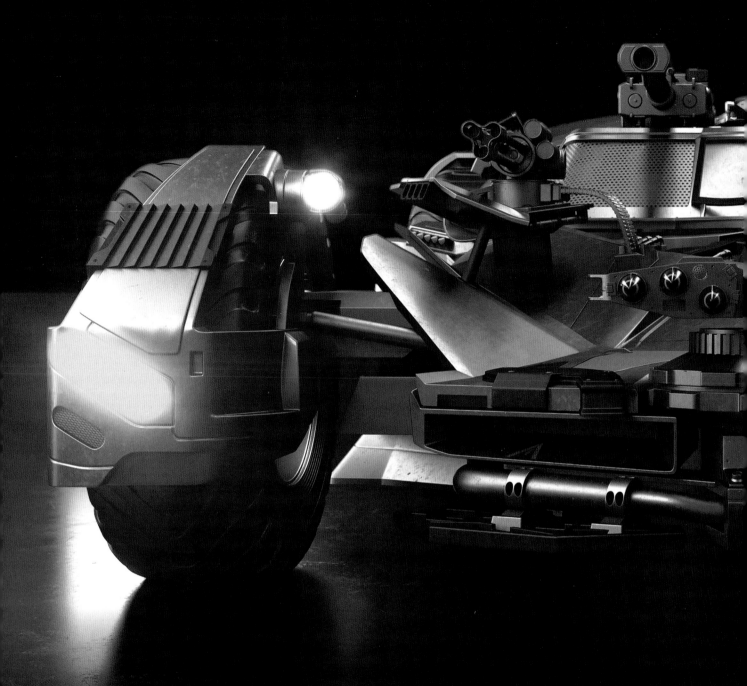

Even though Bruce Wayne sank millions into becoming a formidable crime fighter, the sudden appearance of Superman convinced him that humanity was powerless against what he perceived to be a unique alien threat. Batman had designed his Batmobile to stand up to villains like the Joker and Harley Quinn, but he knew his armored vehicle had no hope of defeating a bulletproof Kryptonian who could fire heat beams from his eyes. Fearing Superman's power, he immediately set to work making upgrades to the Batmobile's design.

Until this point, the Batmobile had performed exceptionally well against street gangsters and cartel thugs. It was built for combat, with a low-riding, wedge-shaped nose that allowed it to overturn enemy vehicles. The Batmobile is an utterly original creation, constructed from 3D-printed parts combined with components sourced directly from Wayne Enterprises' aerospace and advanced technology divisions.

The Batmobile's armored shell is practically undetectable by electromagnetic scans thanks to sensor-baffling bodywork.

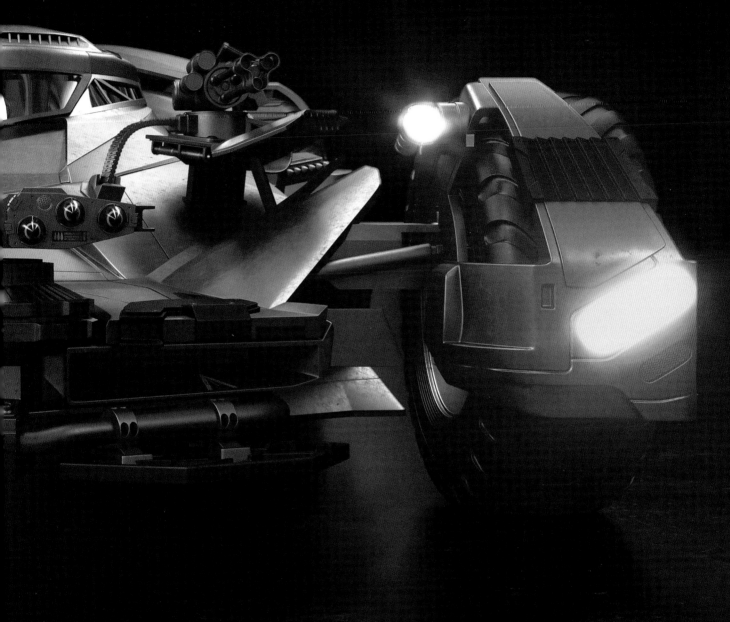

Other onboard devices can scan the air for toxins or intercept secret transmissions across the full spectrum of electromagnetic wavelengths.

For inspiration when designing the Batmobile, Batman studied multiple high-performance vehicles including off-road racers that had survived Mexico's annual Baja 1000 endurance contest. The Batmobile is specced for resilience and performance under stress, and every system is overbuilt with redundancies and fail-safes.

The Batmobile has a stripped-down, utilitarian appearance that extends to a cockpit that features heavy switches and chunky toggles instead of slick touchscreens. Despite its pragmatic appearance, the Batmobile exhibits a few subtle bat motifs. The hard line atop the vehicle resembles Batman's billowing cape, while the rear fins and pivoting cockpit doors are designed to evoke bat wings.

OPERATIONAL HISTORY

Batman spent years fighting Gotham City's villains from behind the wheel of the Batmobile. But a hugely destructive battle between Superman and fellow Kryptonian General Zod made Batman realize that humanity needed to achieve an evolutionary technological leap if it hoped to survive the imminent age of superpowers. This philosophy extended to not only the Batmobile but also related vehicles in Batman's arsenal.

Later, while using the Batmobile to pursue Russian mobsters, Batman rammed his car straight into Superman. The collision didn't scratch the Kryptonian but left the Batmobile in ruins, requiring Batman to assemble the damaged pieces into a replacement vehicle.

Batman continued his crusade by improving the Batmobile and constructing several new bat-themed vehicles, including the Knightcrawler and the Flying Fox. These upgrades appear just in time for the rise of the Justice League and their battle against the New God Steppenwolf.

"Later, while using the Batmobile to pursue Russian mobsters, Batman rammed his car straight into Superman."

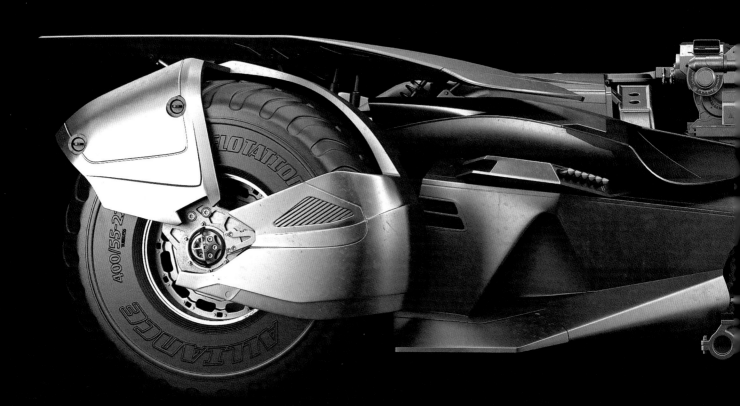

SUSPENSION AND TRANSMISSION

The Batmobile's variable suspension incorporates airbags that inflate or deflate as needed to keep the vehicle's body level relative to the ground and to reduce frame stress caused by the weight of the vehicle.

Batman uses a manual transmission to shift between gears, arranged in a dog-leg gearbox pattern as used by classic dragsters. Many of the dashboard instruments are installed directly on the steering wheel in the manner of Formula 1 performance cars.

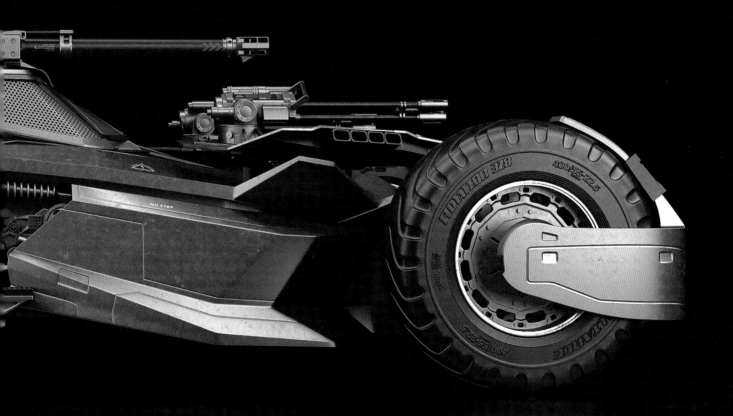

DRIVETRAIN AND WHEELS

The Batmobile relies on an experimental turbo-thrust kinetic ion pulse engine, which generates electric propulsion through the innovative use of ion acceleration. This technology, adapted from Wayne Enterprises' research into rocketry and the maneuvering jets of geosynchronous comm satellites, creates an electrostatic force that can be harnessed to operate all vehicular systems without the need for burning fossil fuels. An AI program installed at the Batcave runs diagnostics on the ion drive and suggests calibrations and repairs.

Additionally, the Batmobile possesses a miniature nitro-methane jet engine that incorporates an afterburner mechanism for boosting thrust, injecting fuel into a combustor behind the turbine to ignite the exhaust gas. Used only in rare cases, the afterburner is prone to breaking down due to its tendency to overheat the valves that govern the operation of the fuel injectors.

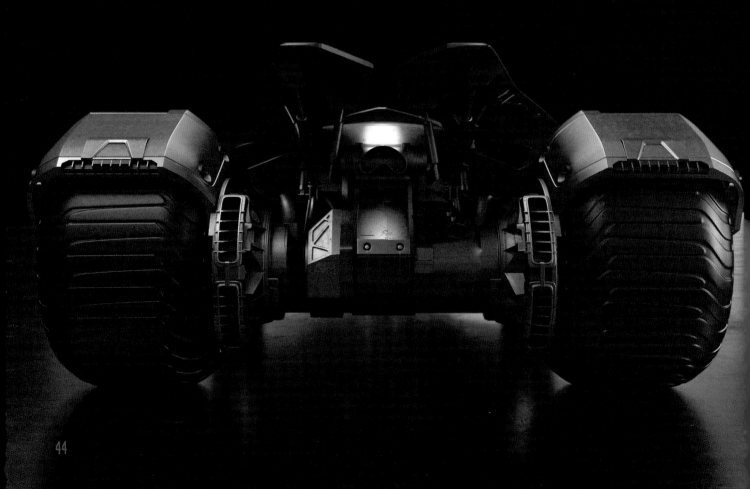

DEFENSE SYSTEMS

The antiballistic armor plating of the Batmobile renders it bulletproof against attacks from most handheld weapons, with a similar layer of protection extending to the polarized cockpit canopy and the belted, bulletproof tires. A roll cage surrounding the cockpit helps keep Batman safe should the Batmobile flip over at high speeds.

The Batmobile features a suite of electronic countermeasures that includes a devastating electromagnetic pulse (EMP) that can block hostile sensor scans or knock them out at their source. Additionally, the Batmobile can deploy an impenetrable smoke screen in its wake, or emit a shrieking sonic irritant calibrated to upset the inner-ear balance of attackers in its range.

When parked, the Batmobile can activate an electrified deterrent across all exterior surfaces, jolting anyone who gets too close with a charge that can be calibrated on a scale of discharge that runs from painful to incapacitating.

Batman prefers to let his Batmobile wear its scars, repairing functional components only and letting the exterior bodywork show the evidence of previous battles.

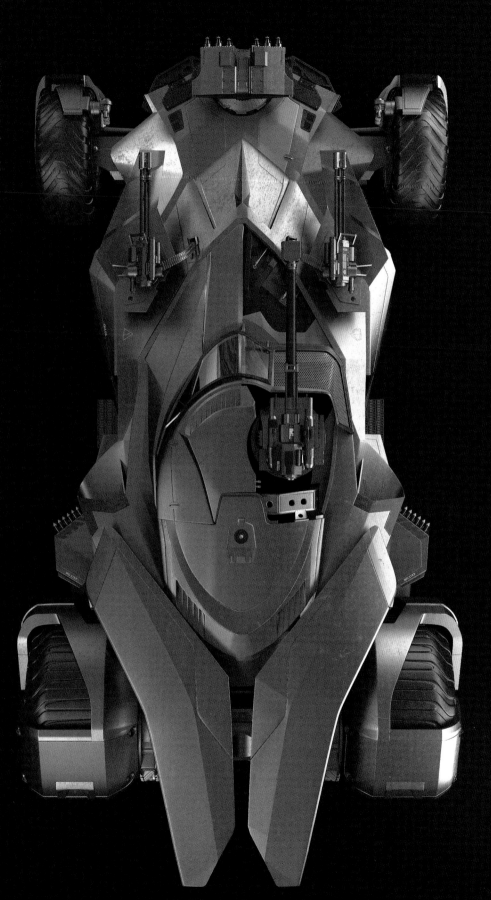

ARMOR-PLATED PANELS

MINIATURE JET ENGINE
AFTERBURNER

VARIABLE HEIGHT AIRBAG SUSPENSION

ANTI-MATERIAL MISSILE LAUNCHERS

MONSTER TRUCK TRANSMISSION

ARMORED TINTED WINDOWS

NO STEP

BALLISTICS

NONLETHAL SONIC COMPLIANCE SYSTEM

ELECTROMAGNETIC PULSE (EMP)
GENERATOR

TWIN .50-CALIBER RETRACTABLE
MACHINE GUN TURRETS

THERMAL IMAGING AND
NIGHT VISION CAMERAS

GYRO STABILIZATION
ASSEMBLY FOR
WEAPON MOUNTS

SPECS AND
FEATURES

LENGTH: 20 feet

WIDTH: 14.4 12 feet

HEIGHT: 48.4 feet

WEIGHT: 7,000 pounds

MAXIMUM SPEED: 205 mph

ANGLED COW CATCHER

HELICOPTER LIFTING HOOKS

PIVOTING HEADLIGHTS, XENON
STUN/SPOT SEARCHLIGHTS

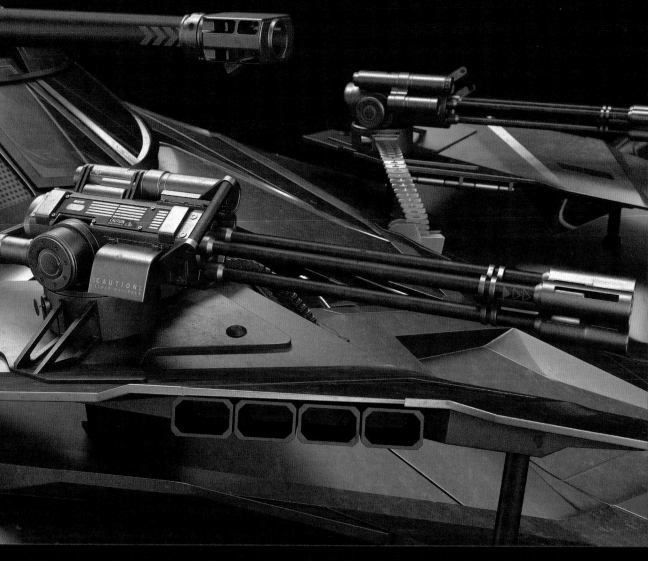

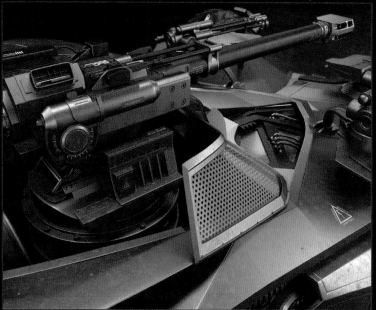

WEAPONS SYSTEMS

For Batman, Superman's existence provided sufficient evidence that humanity needed to be ready to neutralize alien invaders. But in truth, Batman's outlook had become increasingly merciless since the death of Robin—Batman's loyal comrade in arms—at the hands of The Joker several years earlier.

As a reaction to his grief, Batman replaced the Batmobile's passenger seat with a weapons locker stocked with grapple guns, Batarangs, smoke grenades, and grenade launchers.

Other weapons were installed directly into the Batmobile. These include a swiveling gimbal mount at the front outfitted with twin M2 .50 laser-tracking machine guns as well as an experimental heat ray. Sliding panels conceal launcher tubes that can fire explosive chaff for intercepting guided missiles.

In the rear, a harpoon launcher can fire a grappling hook attached to a spool of heavy cable, allowing the Batmobile to drag enemy vehicles in its wake, bashing them into buildings and parked cars. Weapons bays in the rear contain spiky coils that can be dropped onto road surfaces to puncture the tires of pursuers, plus tanks of chemical irritants, similar to tear gas, that can be sprayed into hostile crowds.

When Batman decided to take the fight directly to Superman, he modified the Batmobile to carry anti-meta-human countermeasures including Kryptonite gas grenades. In addition, Batman laced the Batmobile's exterior coating with microscopic infusions of Kryptonite.

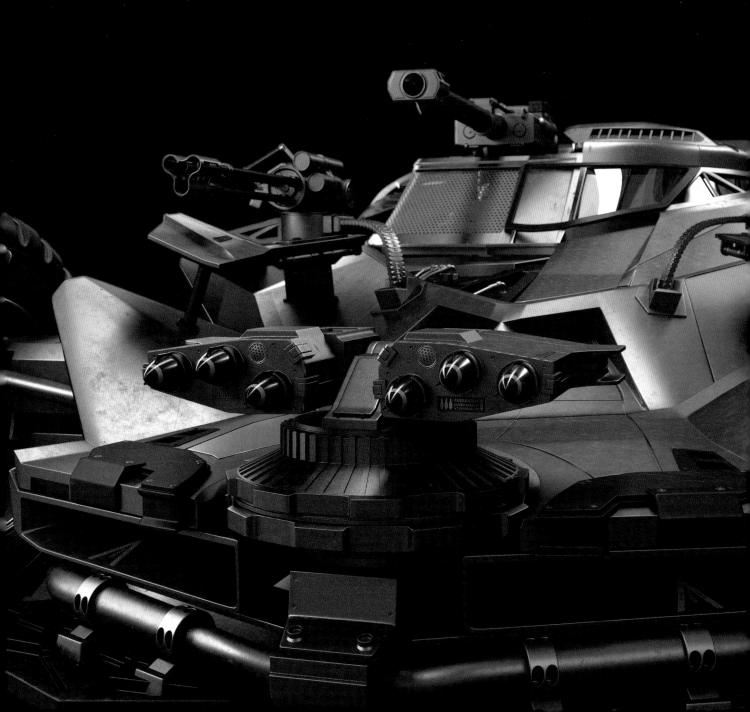

BATWING

Sinking millions into a personal project with no clear hope of financial return, Bruce Wayne successfully modified a Wayne Enterprises aerial combat prototype into a versatile, armed interceptor.

The Batwing can launch and land from a vertical position or maintain an indefinite low-altitude hover. It can also achieve blistering supersonic speeds enabling rapid cross-continental transit.

The wings of the Batwing connect in front of the cockpit and can fold vertically when the craft has touched down, a feature inspired by Navy fighter planes that are designed to share space on aircraft carrier decks. When the Batwing is not needed, Batman drapes it in a protective tarp, the folds and wrinkles of the cloth giving the vehicle the look of a giant bat lurking in the shadows of the Batcave.

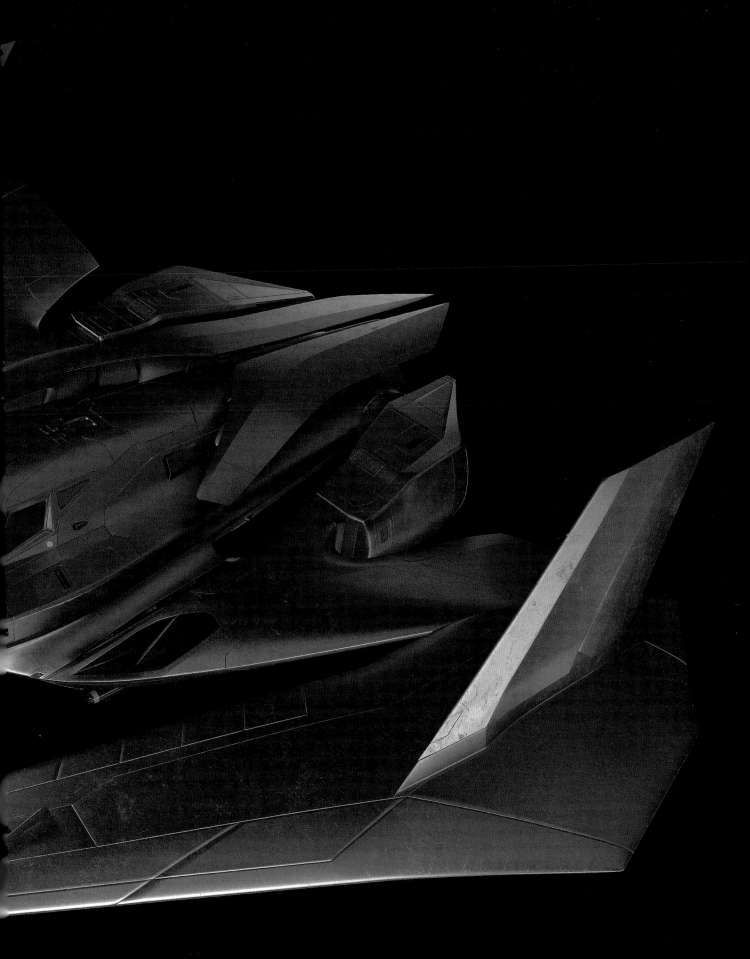

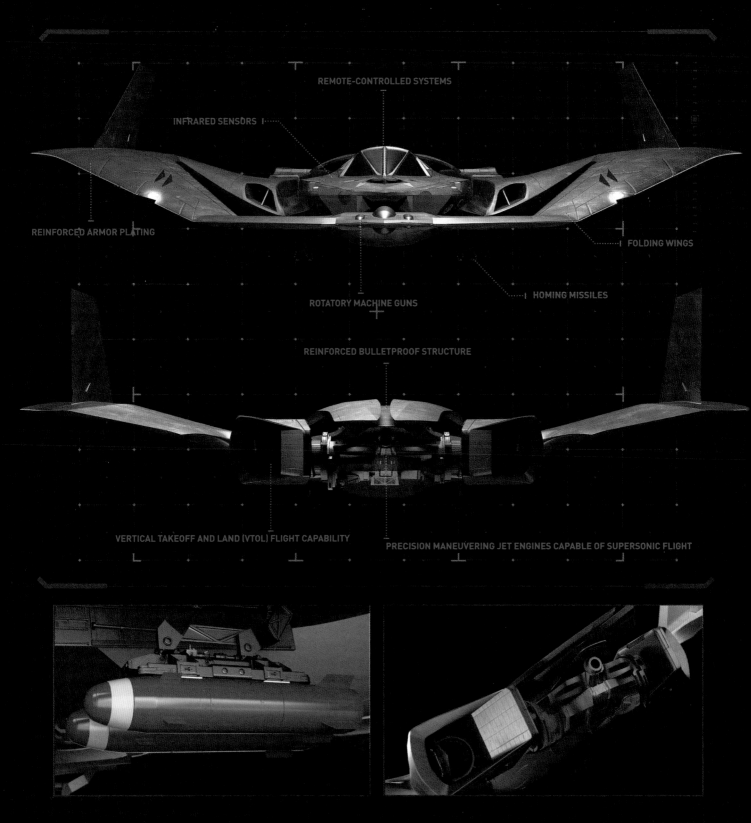

REMOTE-CONTROLLED SYSTEMS

INFRARED SENSORS

REINFORCED ARMOR PLATING

FOLDING WINGS

HOMING MISSILES

ROTATORY MACHINE GUNS

REINFORCED BULLETPROOF STRUCTURE

VERTICAL TAKEOFF AND LAND (VTOL) FLIGHT CAPABILITY

PRECISION MANEUVERING JET ENGINES CAPABLE OF SUPERSONIC FLIGHT

Using twinjet engines, the Batwing can reach speeds approaching Mach 2.5. It can also be operated remotely from the Batcave using joystick controls and linked sensor readouts. The Batwing's surveillance system incorporates thermal imagers for distinguishing living beings behind walls and barricades. If Batman chooses to engage ground-based enemies toe-to-toe, he is able to eject from the pilot's seat, launching himself directly into the fray.

The Batwing's weapons are similar to those fitted to the Batmobile, including machine guns and guided missiles. Its weapons pod is positioned in the direct center of the forward airfoil behind a retractable cover that shields the guns from debris.

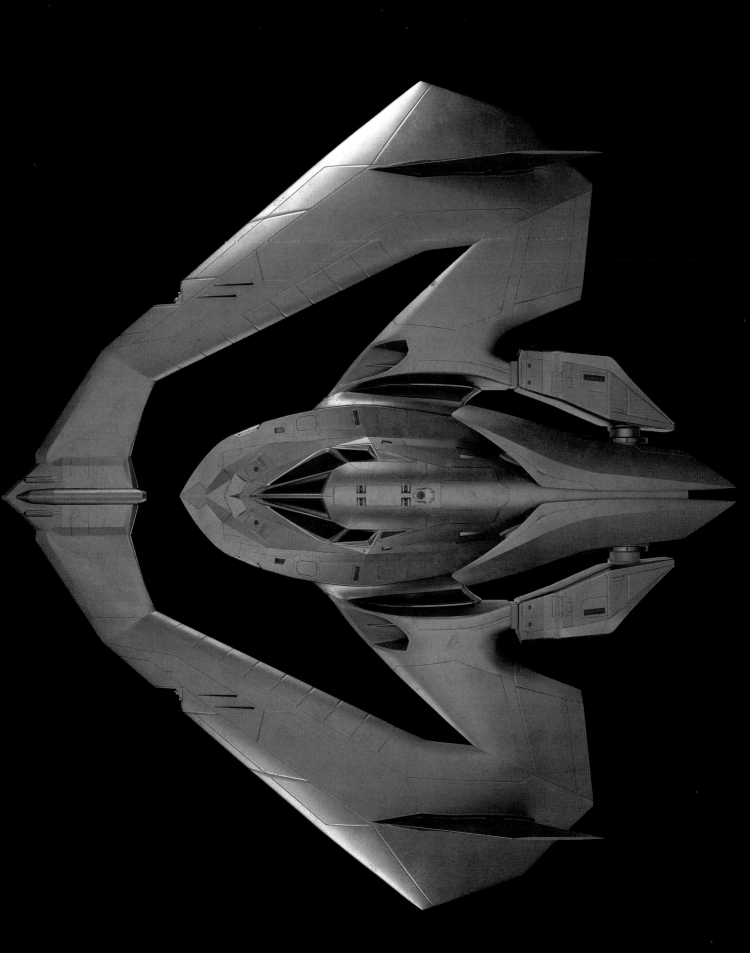

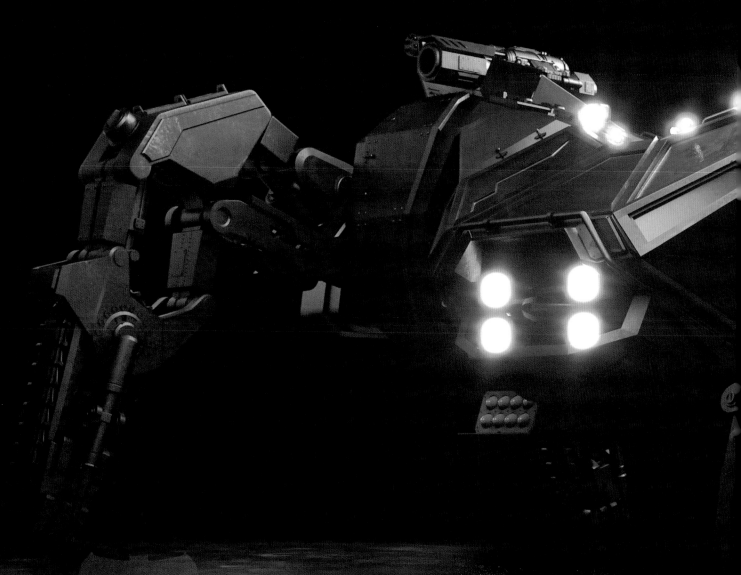

KNIGHTCRAWLER

The Knightcrawler is a crab-like military prototype vehicle built by Wayne Enterprises for use in traversing extreme topography.

The Knightcrawler moves on four jointed limbs, with each leg ending in a treaded foot, allowing the pilot to seamlessly switch between all-terrain clambering and quick, tank-like locomotion. Extendable spikes on the legs, similar to the crampons used in ice climbing, can jab into a vertical surface and expand laterally on mechanical joints to secure a foothold. Through the sequential expansion and retraction of these leg spikes, the Knightcrawler can scale the side of a skyscraper or the icy face of a glacier.

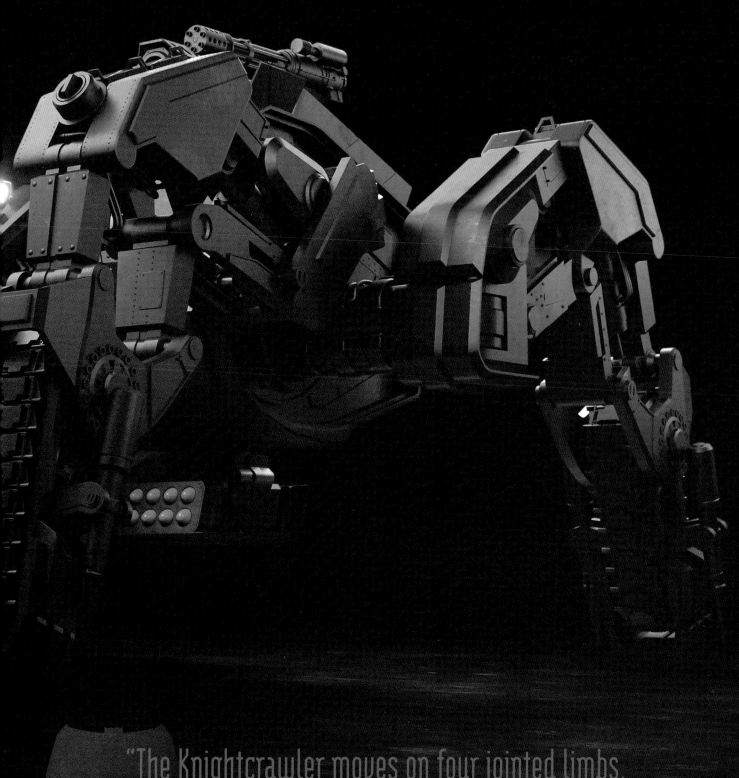

"The Knightcrawler moves on four jointed limbs, with each leg ending in a treaded foot, allowing the pilot to seamlessly switch between all-terrain clambering and quick, tanklike locomotion."

Batman controls the Knightcrawler's functions from a single seat located behind blast-proof panels. The vehicle's construction emphasizes practicality over aesthetics and features the exposed pistons and dull metallic sheen common to forklifts and industrial drillers.

In response to the incursions of the New God Steppenwolf, Batman signaled his trusty butler, Alfred Pennyworth, to activate the Knightcrawler. In a confrontation beneath Gotham Harbor, the Knightcrawler's machine guns made short work of Steppenwolf's Parademon henchmen.

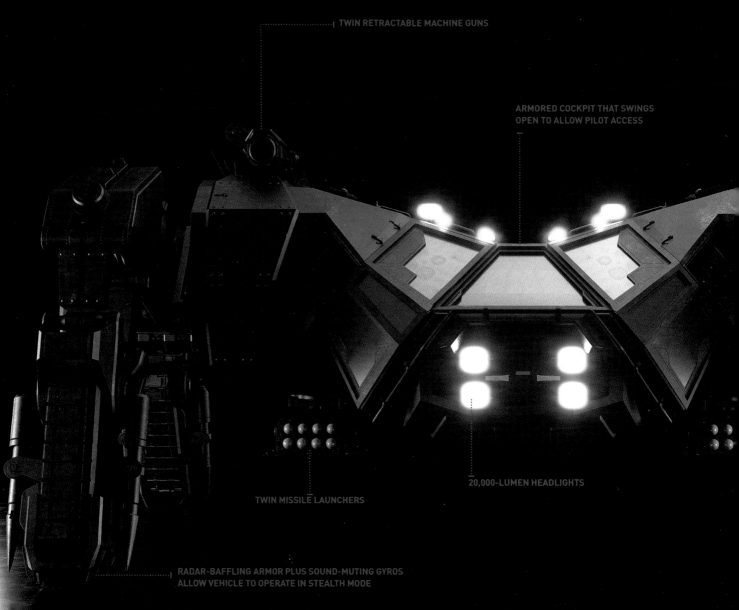

TWIN RETRACTABLE MACHINE GUNS

ARMORED COCKPIT THAT SWINGS OPEN TO ALLOW PILOT ACCESS

20,000-LUMEN HEADLIGHTS

TWIN MISSILE LAUNCHERS

RADAR-BAFFLING ARMOR PLUS SOUND-MUTING GYROS ALLOW VEHICLE TO OPERATE IN STEALTH MODE

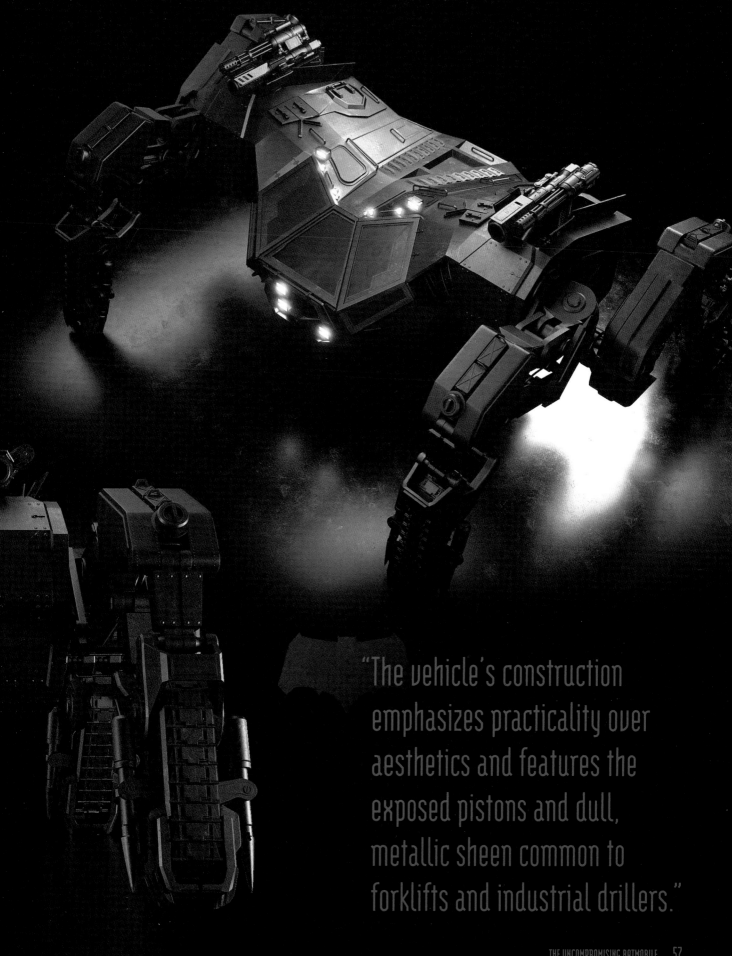

"The vehicle's construction emphasizes practicality over aesthetics and features the exposed pistons and dull, metallic sheen common to forklifts and industrial drillers."

FLYING FOX

Built in secret by a division of Wayne Enterprises, this three-story cargo carrier made its debut carrying the Justice League to their showdown with Steppenwolf—a journey that took them from Gotham City to the Russian city of Pozharnov.

The Flying Fox is defined by its triangular wings and four horizontal stabilizers, two angled downward for flight stability and two curved upward for lift. The cockpit is located far to the rear of the craft, and most of the airframe is devoted to a voluminous cargo bay. Missile launchers on the wings and a dedicated gunnery station give the craft its offensive punch.

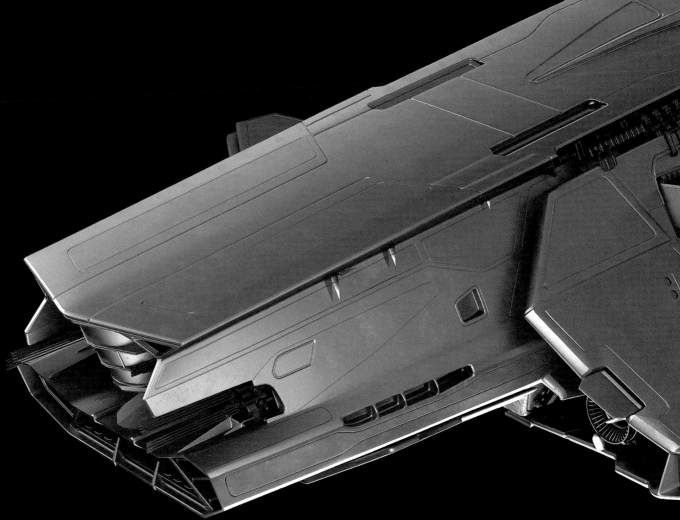

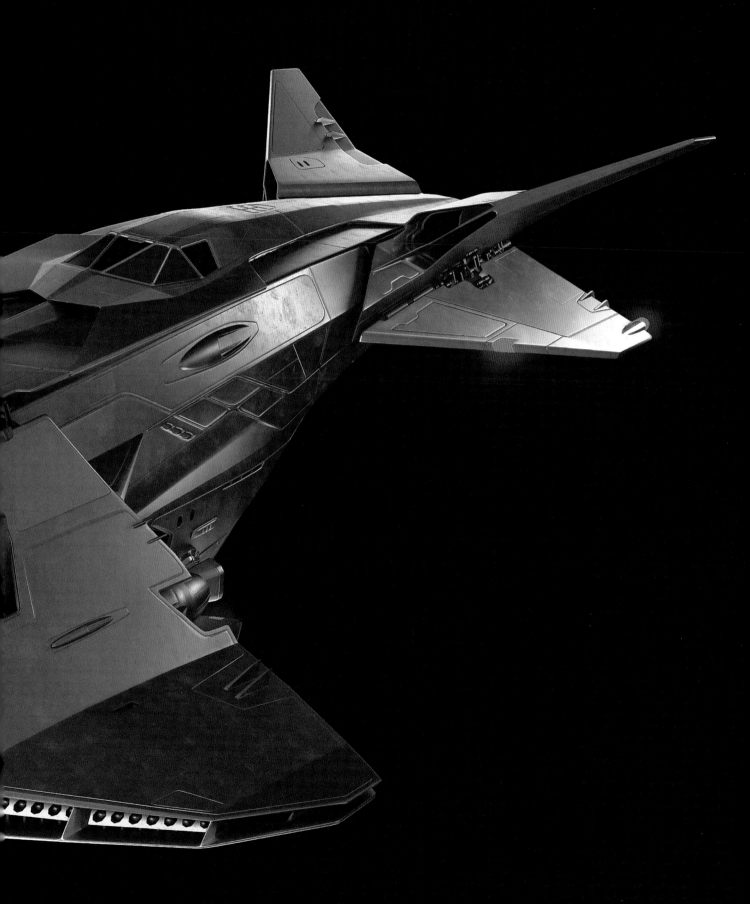

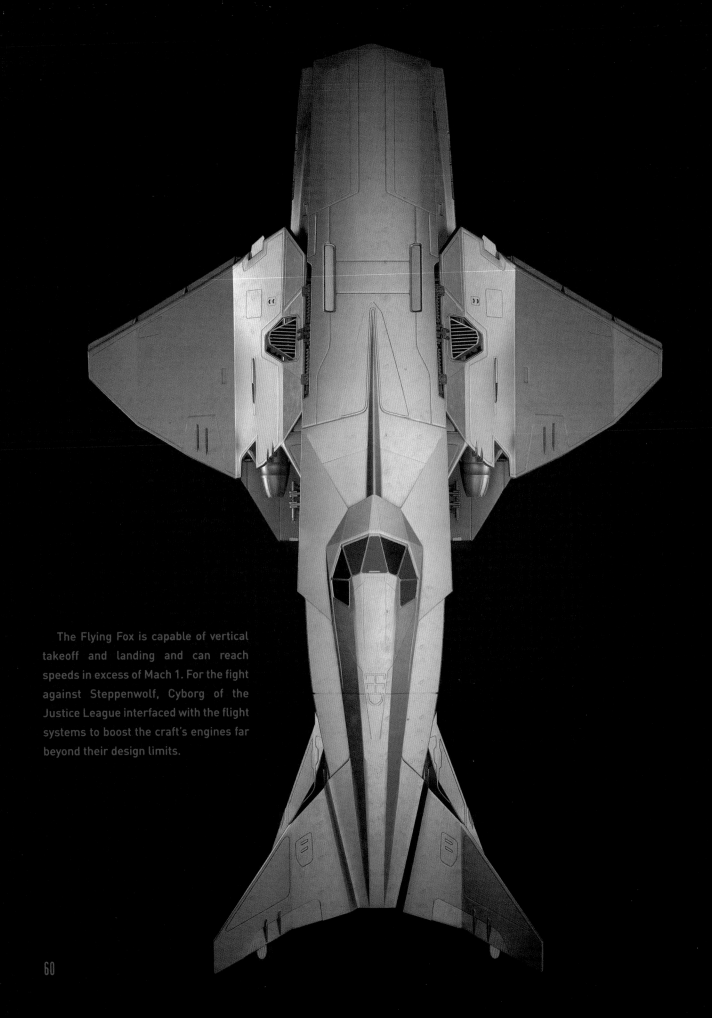

The Flying Fox is capable of vertical takeoff and landing and can reach speeds in excess of Mach 1. For the fight against Steppenwolf, Cyborg of the Justice League interfaced with the flight systems to boost the craft's engines far beyond their design limits.

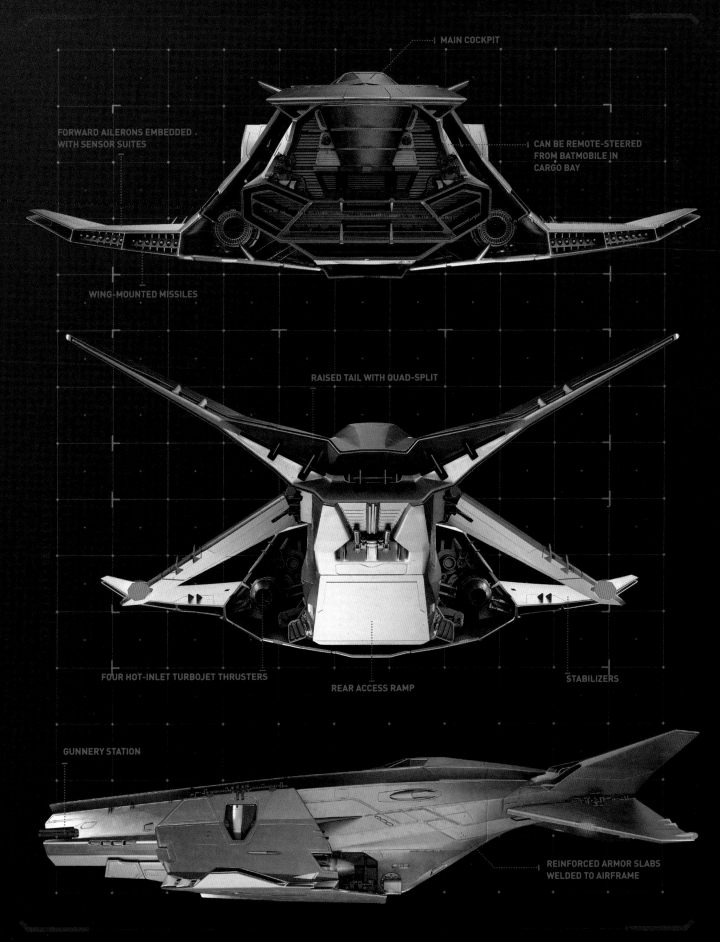

MAIN COCKPIT

FORWARD AILERONS EMBEDDED
WITH SENSOR SUITES

CAN BE REMOTE-STEERED
FROM BATMOBILE IN
CARGO BAY

WING-MOUNTED MISSILES

RAISED TAIL WITH QUAD-SPLIT

FOUR HOT-INLET TURBOJET THRUSTERS

REAR ACCESS RAMP

STABILIZERS

GUNNERY STATION

REINFORCED ARMOR SLABS
WELDED TO AIRFRAME

THE BULLET-NOSED BATMOBILE

— *Batman* and *Batman Returns* —

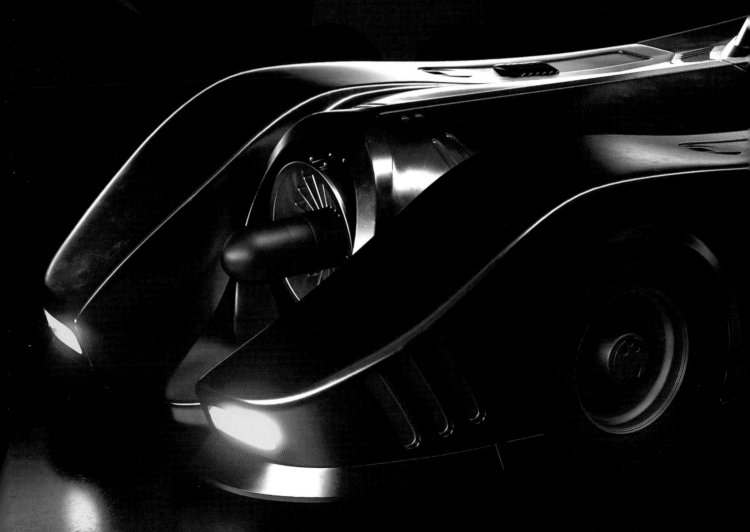

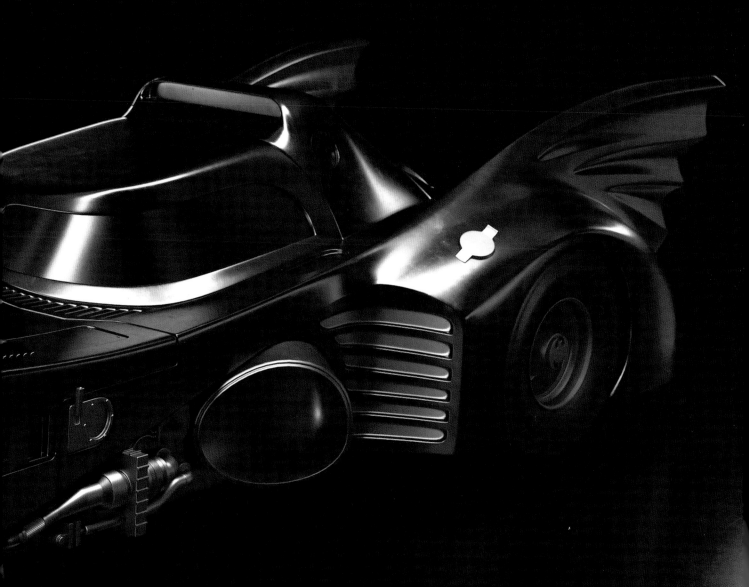

Only one vehicle is a perfect fit for the Gothic noir aesthetics of Batman's home city. When The Joker emerged on the criminal scene and unleashed the deadly Smylex chemical on innocent civilians, the Batmobile was put to the test.

The haunting environment of Gotham City is dominated by slab-like brutalism and the ornamental curves of art deco. It is a city seemingly suspended in time, where the technology of the late twentieth century coexists alongside visual styles borrowed from the 1930s. The Batmobile that Bruce crafted to patrol this crime-ridden cosmopolis has a long, low profile encased in molded armor and is propelled by a jet engine. Despite its careful styling, at its core it is a weapon of brute force.

The purpose-built Batmobile is an original work of engineering, not a modified stock vehicle. Among its most distinctive features are the rounded intake of its jet turbine and the swooping front fenders that resemble a predator's paws.

Inspired by the designs of cars famous for breaking land-speed records at the Bonneville Salt Flats, Bruce Wayne studied the gas turbine–powered Fiat Turbina and the jet-propelled British Thrust2, among many others when researching Batmobile concepts. The final blueprints incorporate a turbine that powers a rotating air compressor and a variable jet nozzle to provide jet-boosted, white-knuckled thrust.

An elongated front end became a design necessity once Batman decided to house an oversized, aircraft-grade jet engine beneath the hood. The cockpit is set far to the rear, crowned by a scoop that redirects cooler air to the engine to improve performance. Vehicle stabilization at high speeds is aided by elongated rear fenders that taper into scallop-edged fins. Inside the cramped cockpit, Batman can control the machine guns, release spherical bombs through the wheel wells, and fire cable-connected grappling hooks.

"The purpose-built Batmobile is an original work of engineering, not a modified stock vehicle."

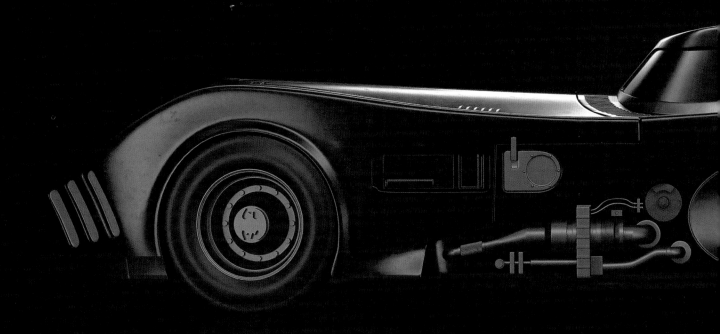

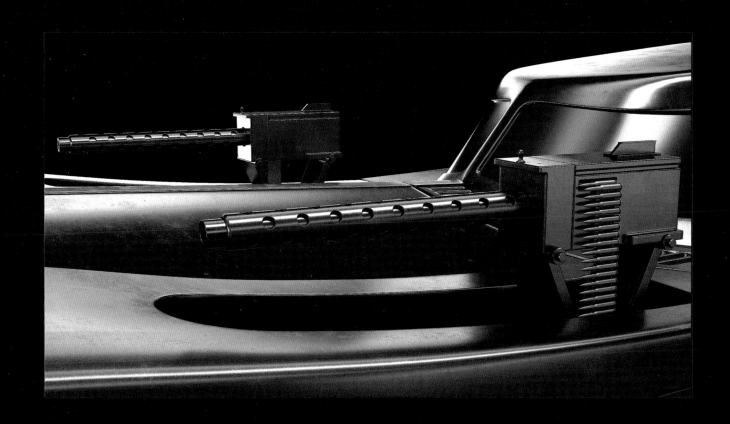

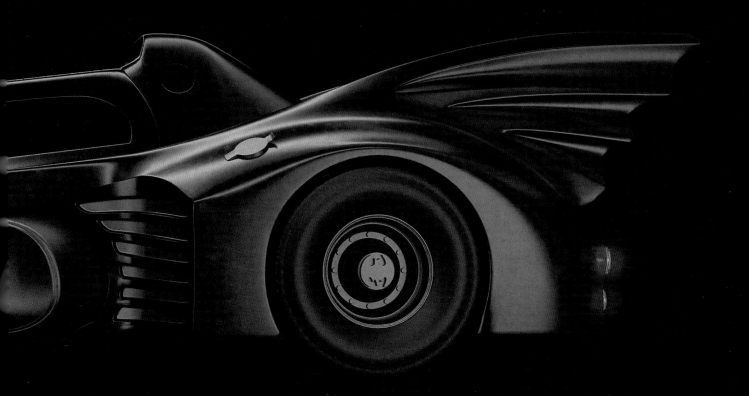

During The Joker's crime spree, Batman drove the Batmobile to Gotham City's Flugelheim Museum to rescue journalist Vicki Vale from the villain's clutches. With Vale safely aboard and armed thugs in hot pursuit, Batman trusted in his car's armor to deflect bullets while he looked for a way to escape the city's downtown grid.

In a later confrontation with The Joker's forces at the villain's Axis Chemical factory HQ, Batman used the Batmobile's explosive arsenal to trigger a chain reaction in the volatile mixing vats and engulf the entire facility in a fireball.

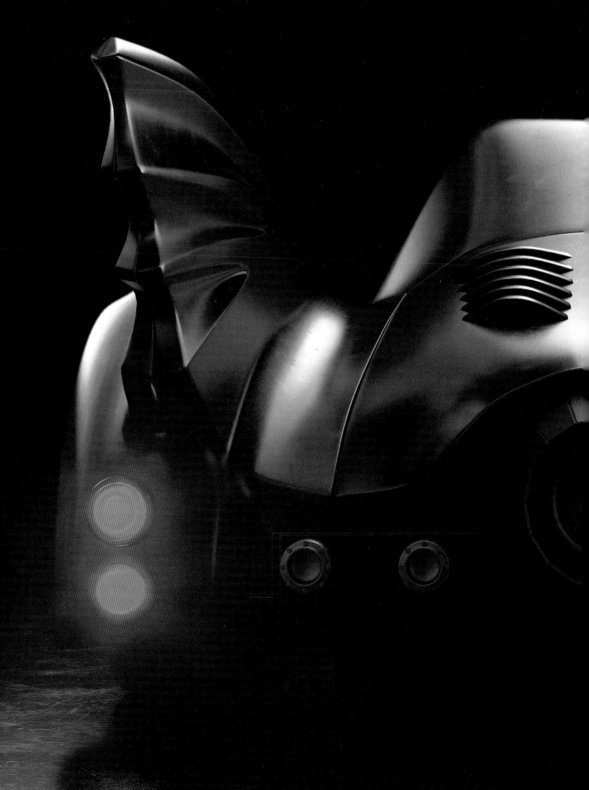

"Batman trusted in his car's armor to deflect bullets while he looked for a way to escape the city's downtown grid."

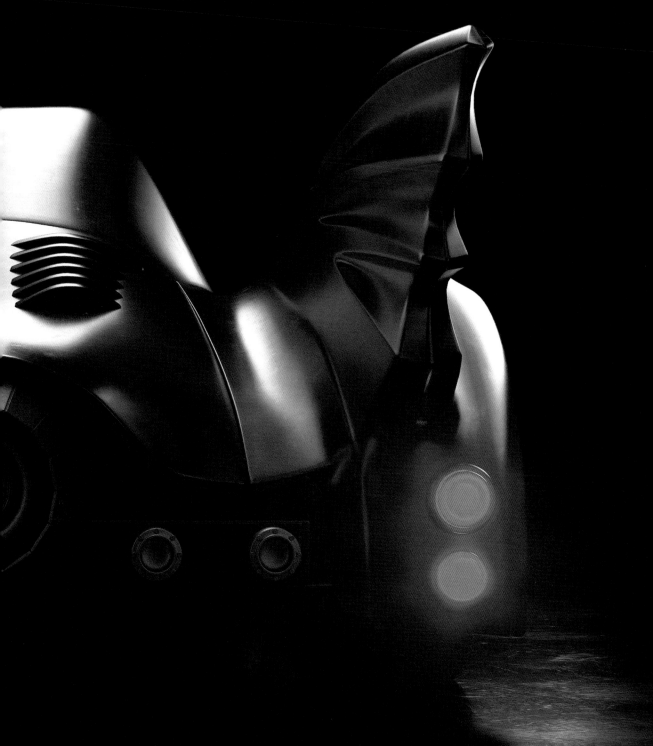

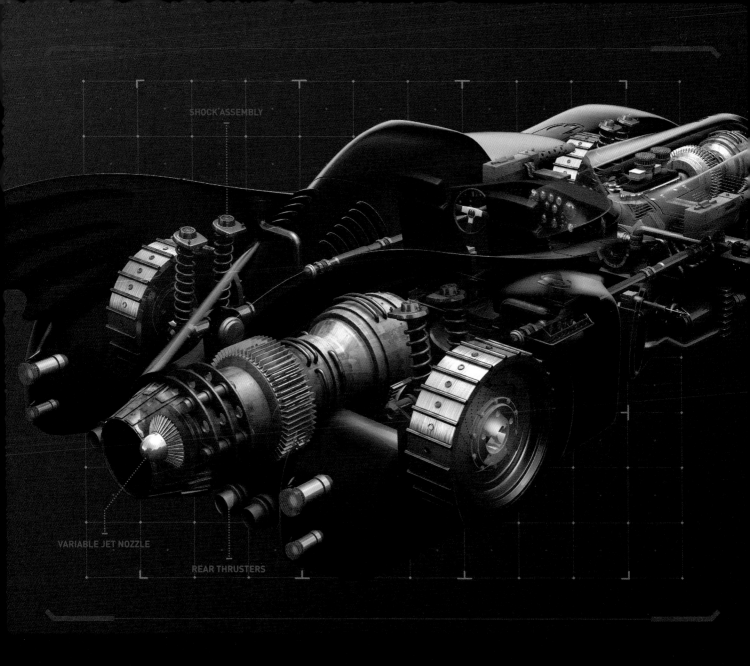

SHOCK ASSEMBLY

VARIABLE JET NOZZLE

REAR THRUSTERS

DRIVETRAIN AND WHEELS

One of the Batmobile's most remarkable elements is its jet turbine engine. Its protruding nose cone acts as a mount for compressor blades beneath the hood that increase incoming air pressure to the engine. Under optimal conditions, the Batmobile's engine can deliver 1,500 pounds of thrust thanks to an integrated afterburner that injects exhaust gases back into a combustor. Using the afterburner depletes fuel even more rapidly than normal, so Batman uses it sparingly during standard patrols. At the rear of the Batmobile, a variable-adaptive nozzle channels the stream of the jet exhaust to help control thrust and direction, aided further by small precision thrusters on both sides of the main thruster.

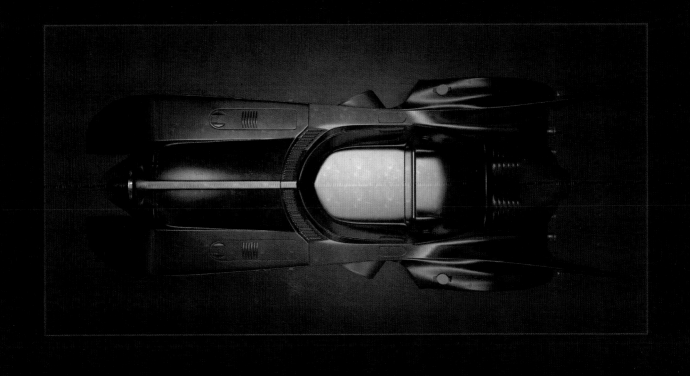
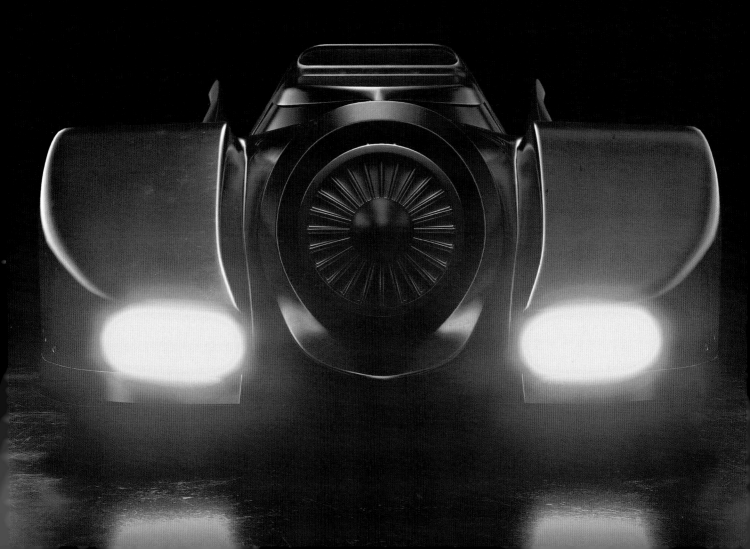

DEFENSE SYSTEMS

Facing the lawlessness plaguing Gotham City, Batman ensured that his ride would be practically immune to attacks by gangsters and thugs. The Batmobile's ceramic fractal armor can deflect bullets while sustaining only negligible damage, and heavy rocket impacts are mitigated by armored contours that redirect destructive forces away from the cockpit and its occupants. The tail end of the Batmobile is equipped with anti-pursuit measures including oil slick dispensers and smoke emitters.

In response to the voice command "shields," the Batmobile can enter cocoon mode when stationary. The command triggers the deployment of an unfolding shell of segmented armor plates. Cast from lightweight ceramic fractal armor, the panels cover the driver's cockpit, the turbine intake, the wheel wells, and other vulnerable areas with interlocking, impact-resistant panels that cannot be easily pried apart.

To facilitate quick getaways, the Batmobile's undercarriage conceals a hydraulic lift. When extended, this "foot" lifts the entire vehicle in the air and pivots it in place, allowing it to make precise, on-the-spot 180-degree U-turns.

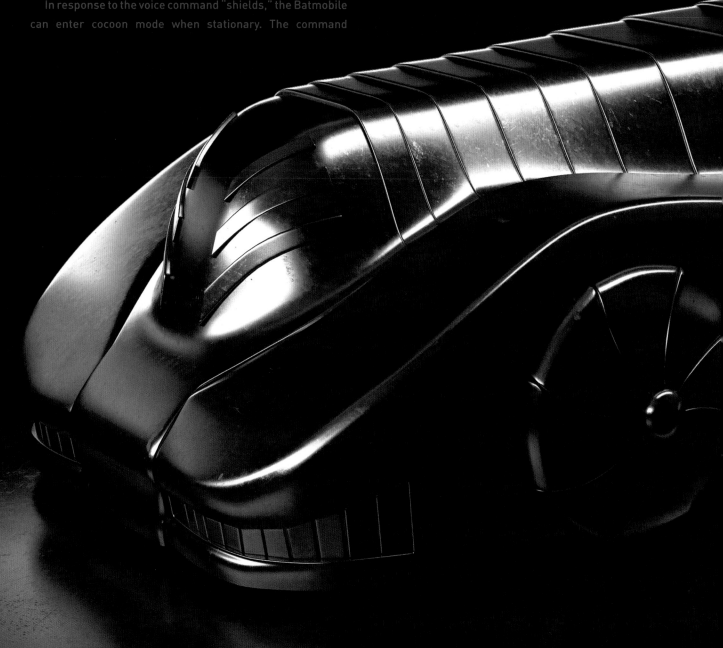

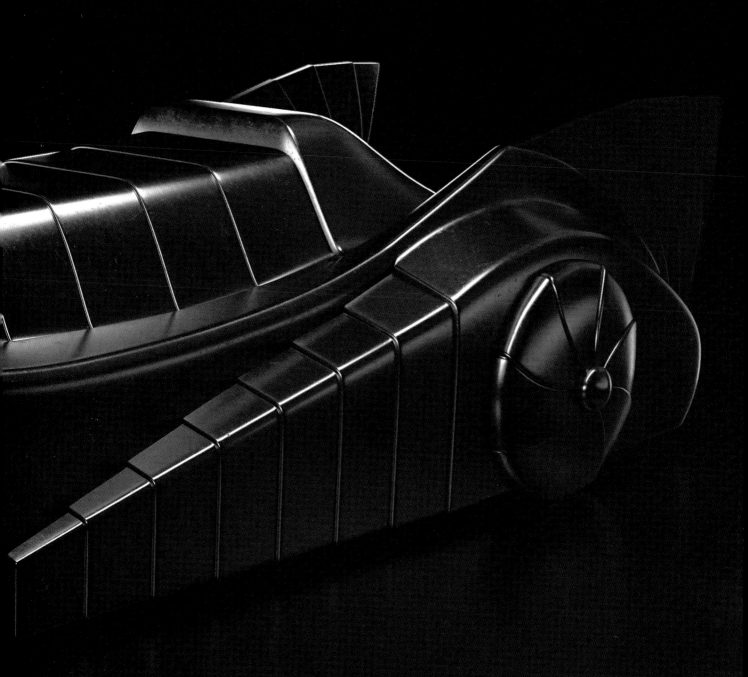

"In response to the voice command 'shields,' the Batmobile can enter cocoon mode when stationary."

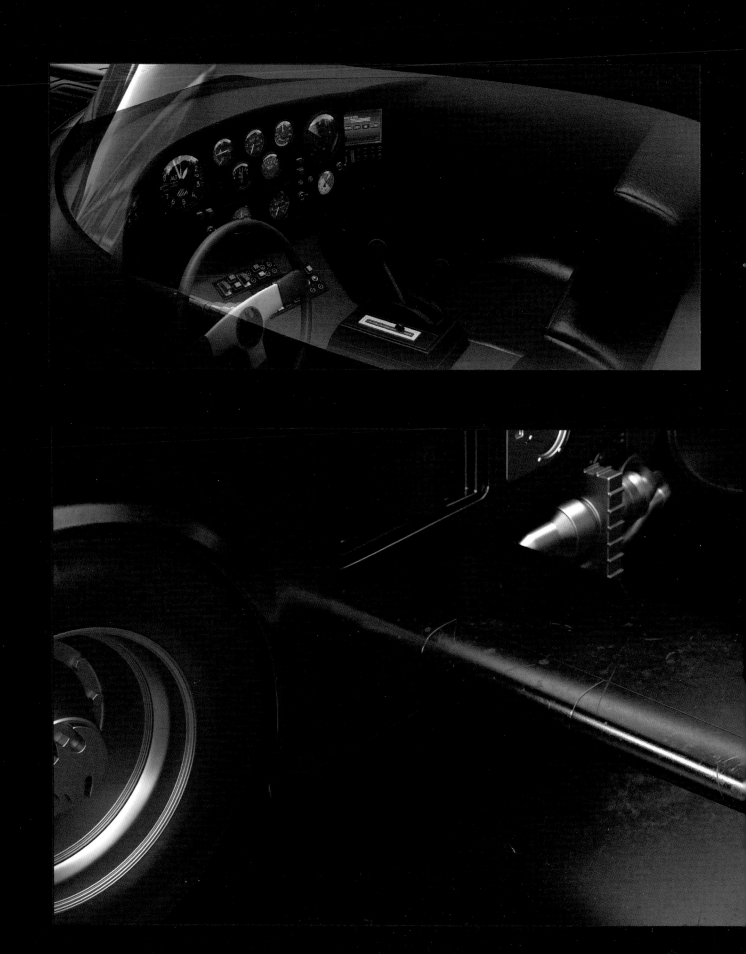

DESIGN EVOLUTION

Though he defeated The Joker, Batman's war against crime was just beginning. Only a few years later, the carnival hoodlums of the Red Triangle Gang terrorized the people of Gotham City until Batman used the Batmobile and its concealed weapons to stop the marauders. When Oswald Cobblepot (aka The Penguin) launched his bid to become mayor, he hijacked the Batmobile using a concealed signal jammer that allowed him to steer the car remotely. With The Penguin in control, the Batmobile became an instrument of mayhem.

Prior to the incident involving The Penguin, Batman's upgrades to the Batmobile remained largely out of sight. The most notable change was the reworking of the vehicle's chassis to allow for a "Batmissile" escape mode, a dynamic function that required explosive shedding of bodywork and a reconfigurable drivetrain. A cockpit TV screen was also installed to permit video communication with the Batcave, while improved self-diagnostics allow the Batmobile to identify the presence of trackers and bugs.

The Batmobile also received a weapons upgrade with the addition of armored "shin breaker" slats that can be extended from both sides to trip up nearby attackers.

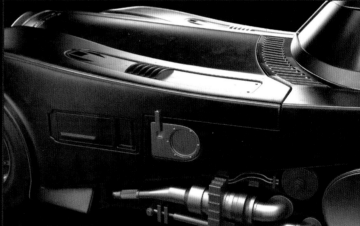

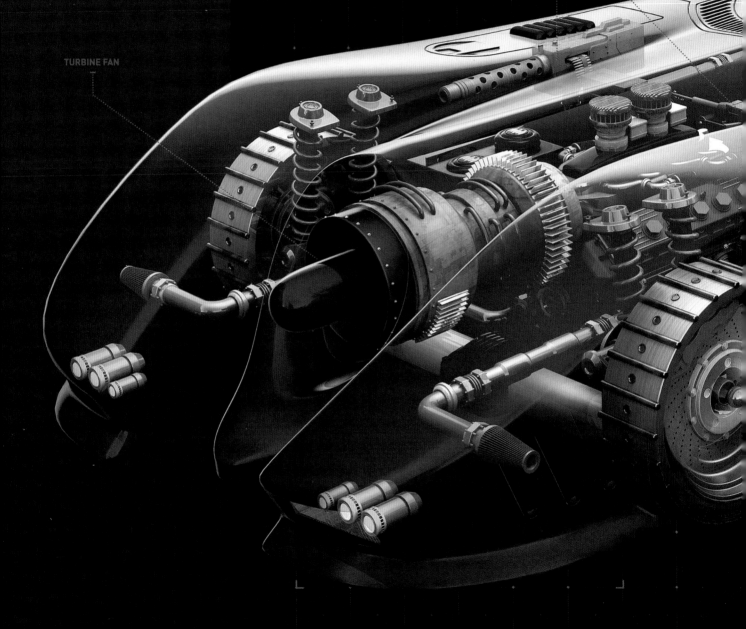

SPECS AND FEATURES

LENGTH: 21.73 feet

WIDTH: 7.87 feet

HEIGHT: 4.27 feet

MAXIMUM SPEED: 330 mph
 with jet booster

ACCELERATION: 0–60 in 3.7 seconds

ENGINE: 10,000-hp jet turbine

VOICE-COMMAND INTERFACE

TWIN FORWARD-MOUNTED BROWNING M1919
.30-CALIBER MACHINE GUNS

TURBINE FAN

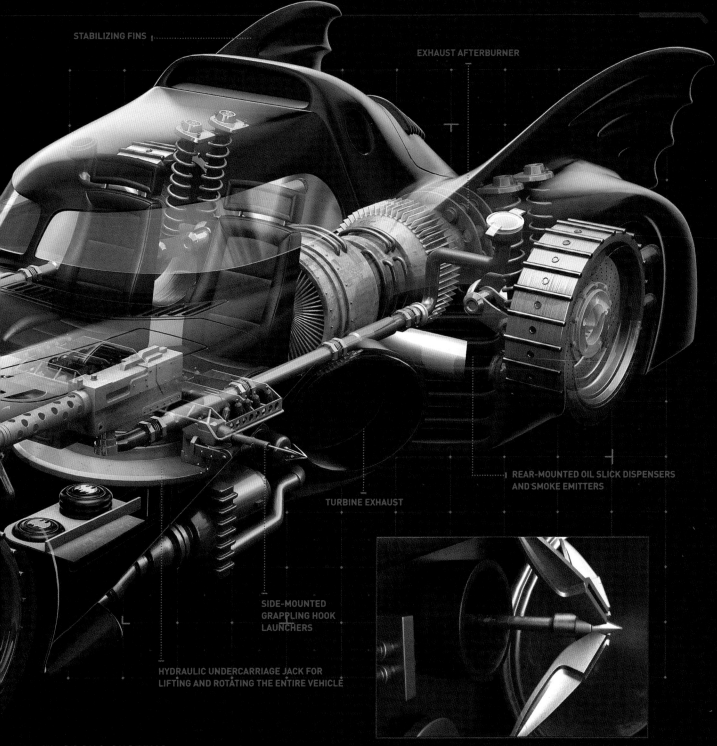

EXHAUST AFTERBURNER

REAR-MOUNTED OIL SLICK DISPENSERS
AND SMOKE EMITTERS

TURBINE EXHAUST

SIDE-MOUNTED
GRAPPLING HOOK
LAUNCHERS

HYDRAULIC UNDERCARRIAGE JACK FOR
LIFTING AND ROTATING THE ENTIRE VEHICLE

WEAPONS SYSTEMS

Bruce Wayne has hated handguns ever since he watched the hoodlum Jack Napier gun down his parents. Nevertheless, he realized that ballistics and explosives could still serve non-lethal strategic functions when incorporated into the Batmobile.

Two heavy machine guns are fitted behind sliding panels in the front fenders, while grapefruit-size spherical bombs (stored in the front and rear wheel axles) can be dropped from any one of the four wheel hubs.

Additional weapons installed aboard the Batmobile include side-mounted disc throwers, used as antipersonnel deterrents for knocking rioters off their feet. The Batmobile's grappling hook can be fired as a weapon, but it is more typically used to hook the vehicle to nearby buildings or lampposts in order to facilitate extremely sharp turns.

BATMISSILE

A triumph of inventive engineering, the Batmissile is a streamlined "escape pod." Because the transformation requires the Batmobile to jettison most of its armor plating and certain side-mounted items like grappling hooks and disc launchers, the Batmissile mode is a last-ditch option that essentially results in the structural destruction of its parent vehicle.

After shedding the entire passenger side of the Batmobile and retracting the wheels into a tight inline configuration, the Batmissile is still able to use the original car's jet turbine engine, as well as several weapons systems, such as its missile launchers and machine guns.

SPECS AND FEATURES

LENGTH: 21.7 feet
WIDTH: 3.96 feet
HEIGHT: 4.27 feet
MAXIMUM SPEED: 330 mph

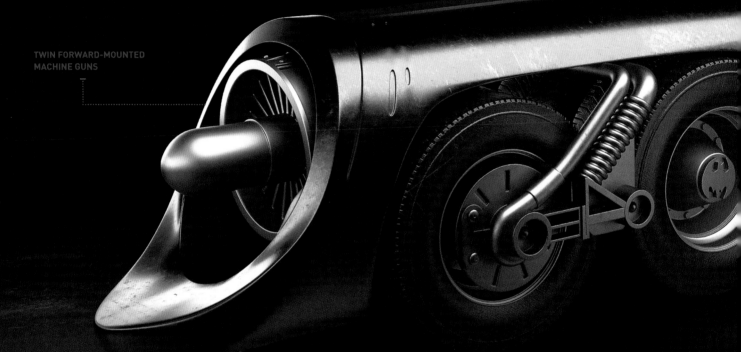

TWIN FORWARD-MOUNTED
MACHINE GUNS

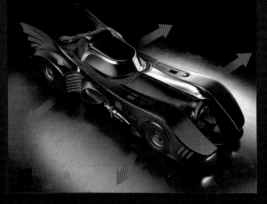
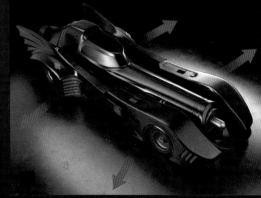

01 BATMISSILE MODE
 IS ENGAGED

02 CAR BODY JETTISONED
 INCLUDING PASSENGER
 SIDE

03 BATMISSILE WITH
 WHEELS IN ORIGINAL
 CONFIGURATION

04 WHEELS RETRACTED

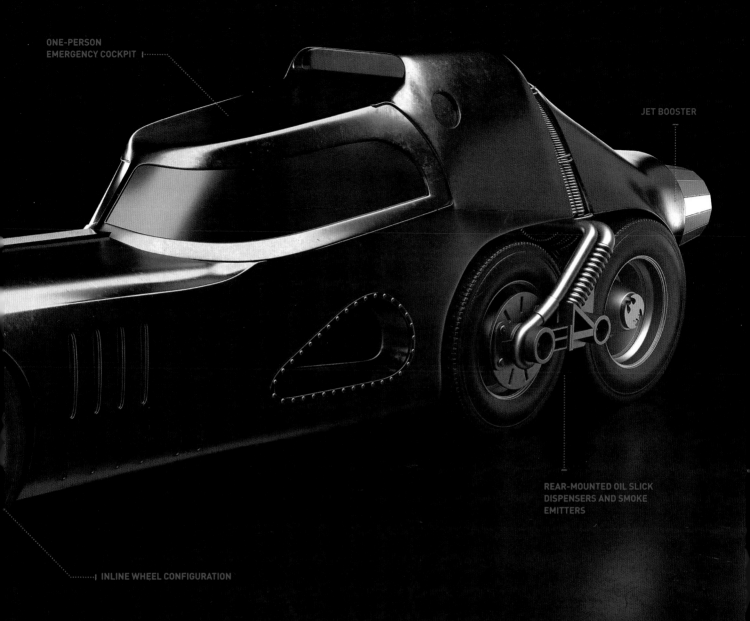

ONE-PERSON
EMERGENCY COCKPIT

JET BOOSTER

REAR-MOUNTED OIL SLICK
DISPENSERS AND SMOKE
EMITTERS

INLINE WHEEL CONFIGURATION

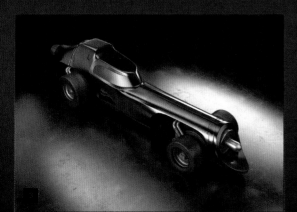

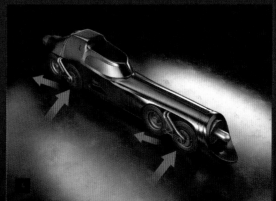

BATWING

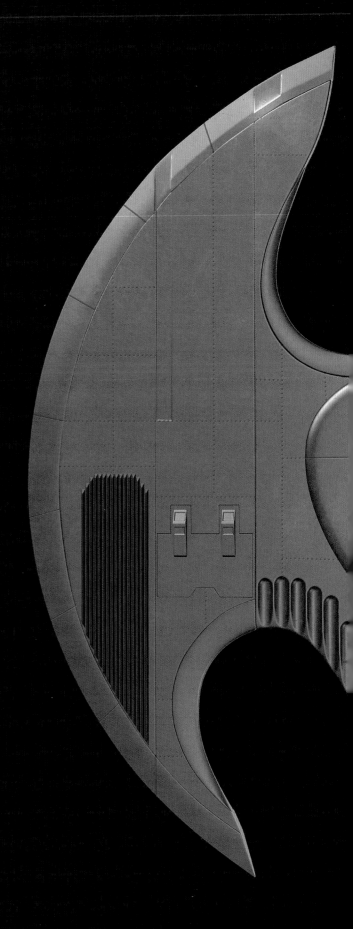

Batman's hunger for purpose-built design wasn't sated with the Batmobile, and thanks to the wealth of the Wayne family, the sky was truly the limit. A supersonic interceptor shaped like the famous bat-symbol, the Batwing is equally proficient at high-altitude surveillance and at strafing street-level targets with its machine guns. In addition, its engines can run silent to conceal its approach, or emit an ear-splitting roar to terrify foes on the ground.

When The Joker tried to poison Gotham City with toxic parade balloons, Batman swooped in to collect them with the Batwing's gripping claw. The Joker, however, remained unscathed by the Batwing's missile and machine gun attacks, and scored a critical hit on the aircraft with a long-barreled pistol. Batman steered the damaged craft into a crash landing in front of Gotham's Old Cathedral.

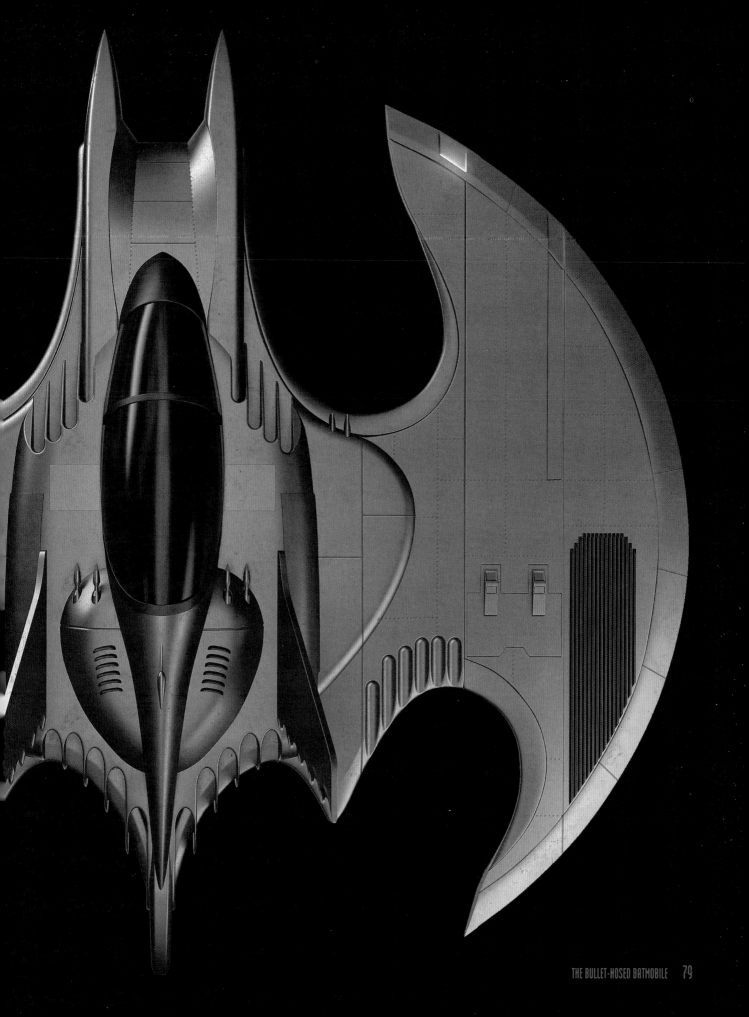

"A supersonic interceptor shaped like the famous bat-symbol, the Batwing is equally proficient at high-altitude surveillance and at strafing street-level targets with its machine guns."

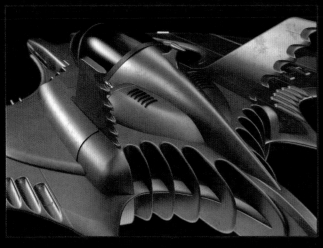

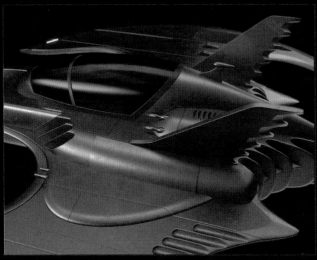

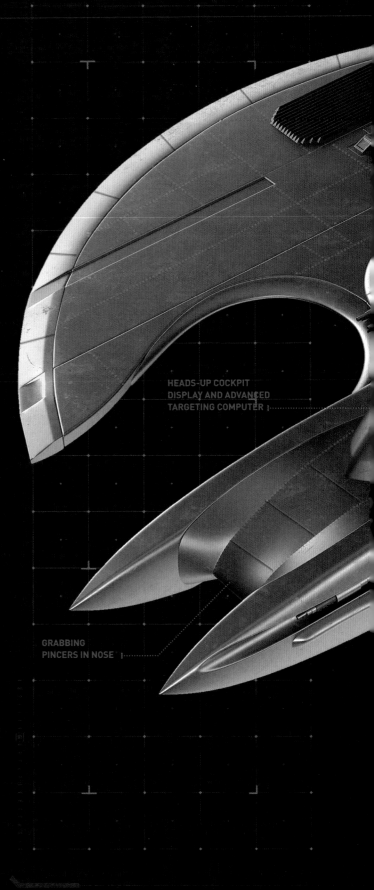

HEADS-UP COCKPIT DISPLAY AND ADVANCED TARGETING COMPUTER

GRABBING PINCERS IN NOSE

FOUR WING-MOUNTED
MISSILE LAUNCHERS

PILOT EJECTION POD

TWIN SIDE-MOUNTED
M134 MINI-GUNS

ILLUMINATORS/RUNNING LIGHTS ON WINGTIPS AND UNDERCARRIAGE

THE ILLUMINATED BATMOBILES

—— Batman Forever and Batman & Robin ——

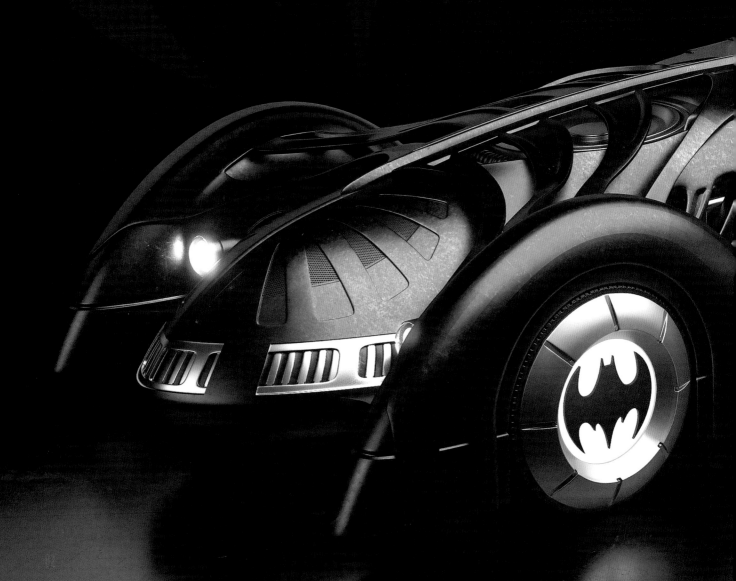

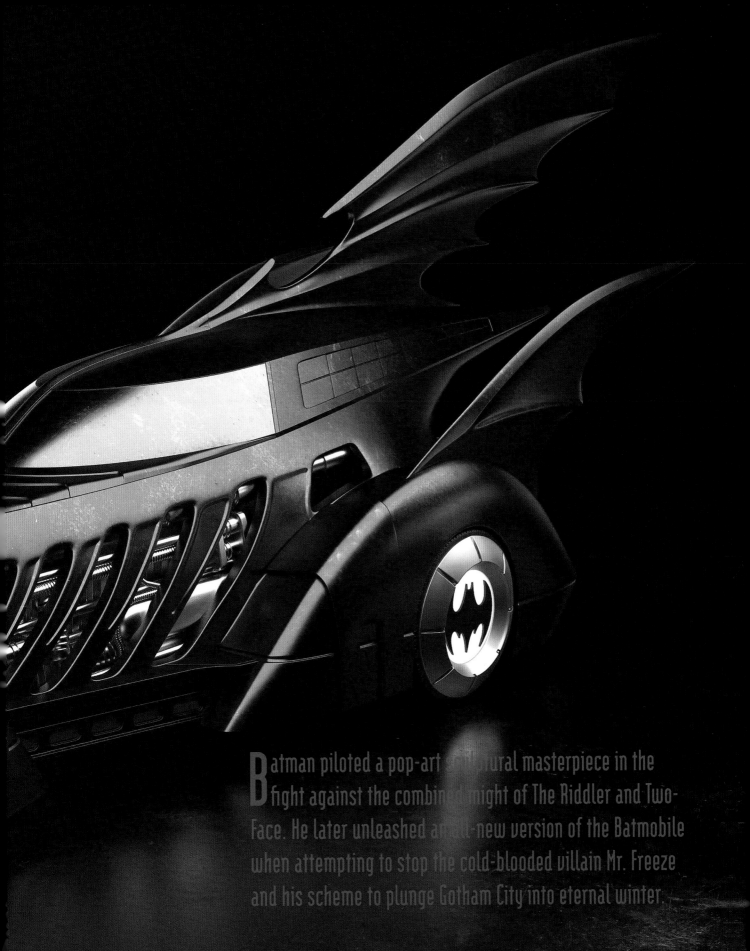

Batman piloted a pop-art architectural masterpiece in the fight against the combined might of The Riddler and Two-Face. He later unleashed an all-new version of the Batmobile when attempting to stop the cold-blooded villain Mr. Freeze and his scheme to plunge Gotham City into eternal winter.

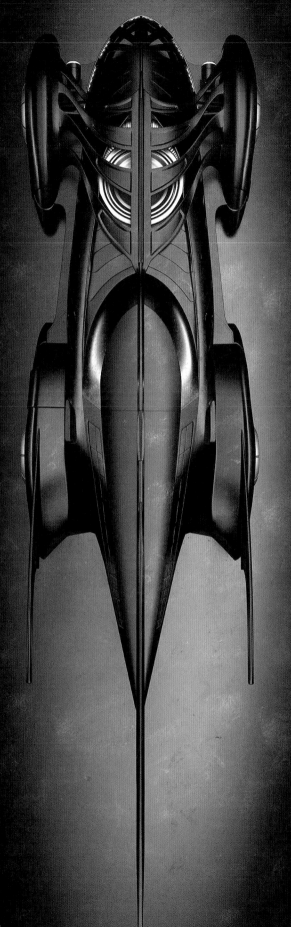

In response to urban crime perpetrated by costumed Super-Villains, Batman designed a multifaceted ride that could meet the accelerating threats facing Gotham City. This Batmobile—and the replacement Batman created after The Riddler destroyed the original—are both among the most outlandish vehicles ever constructed.

Batman incorporated biological cues into the design of the original car, creating a skeletal body decked with bioluminescent highlights. A cutaway rib cage enclosed the driver's cockpit, with triangular sensory grooves drawing stripes along its blunt nose.

This Batmobile's ribbed shell was augmented with concealed neon-blue piping that remained lit both day and night. Lunging front fenders, an illuminated rib cage, and a winged tail fin all gave the vehicle the appearance of a bizarre alien creature. Both rear fenders terminated in sleek bat wings.

The vehicle's rear tail fin could be split into an angled V-shape that facilitated road-gripping downforce. Alternatively, the two halves of the tail fin could be combined to act as a high-speed stabilizer. Each wheel hub bore a bat-symbol that could be illuminated during nighttime patrols.

Similar to a furnace's pilot light, this Batmobile's jet engine spit flames whenever the vehicle was in motion. Its revolutionary functions included a mode that combined the functions of its jet booster and its grappling hook, allowing the vehicle to drive up vertical surfaces.

Shortly after he completed testing, Batman drove this Batmobile into battle against Two-Face to stop a robbery at the Second National Bank of Gotham. The Batmobile's neon-lit splendor caught the eyes of many, including recently orphaned circus acrobat Dick Grayson, who impulsively took the car on a joyride after discovering its hiding place in the Batcave.

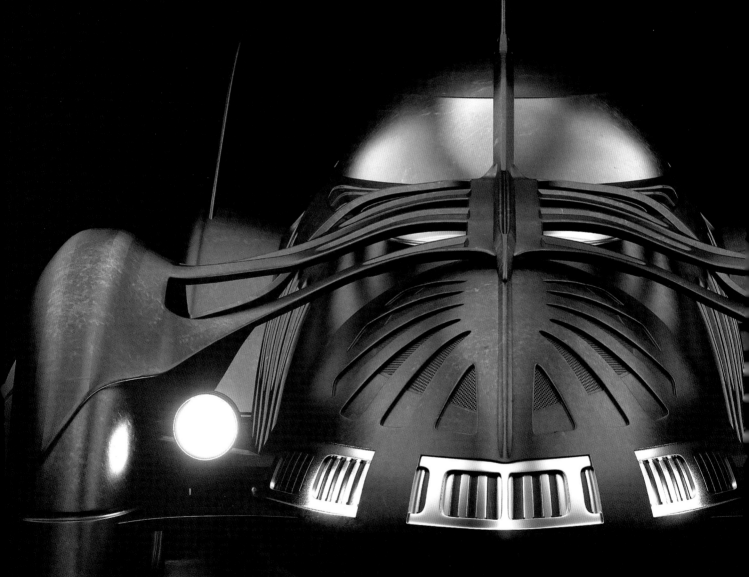

"This Batmobile's ribbed shell was augmented with concealed neon-blue piping that remained lit both day and night."

> "Even at cruising speeds, the rear jet nozzle constantly emitted low-heat flames in the manner of a furnace's pilot light."

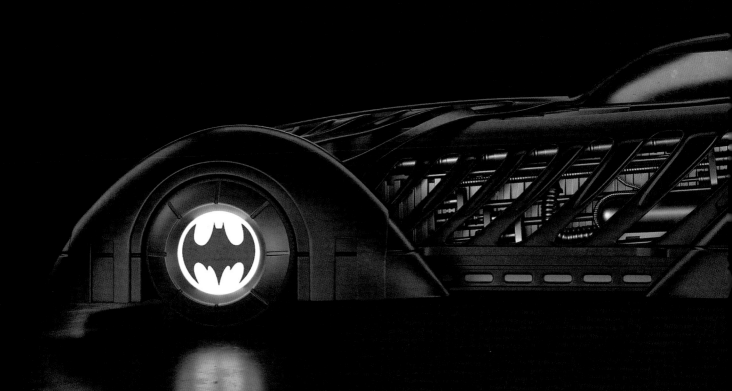

DRIVETRAIN AND WHEELS

This Batmobile switched between a V-8 internal combustion engine at street speeds and a turbine-driven rocket jet when extreme acceleration was needed. Even at cruising speeds, the rear jet nozzle constantly emitted low-heat flames in the manner of a furnace's pilot light.

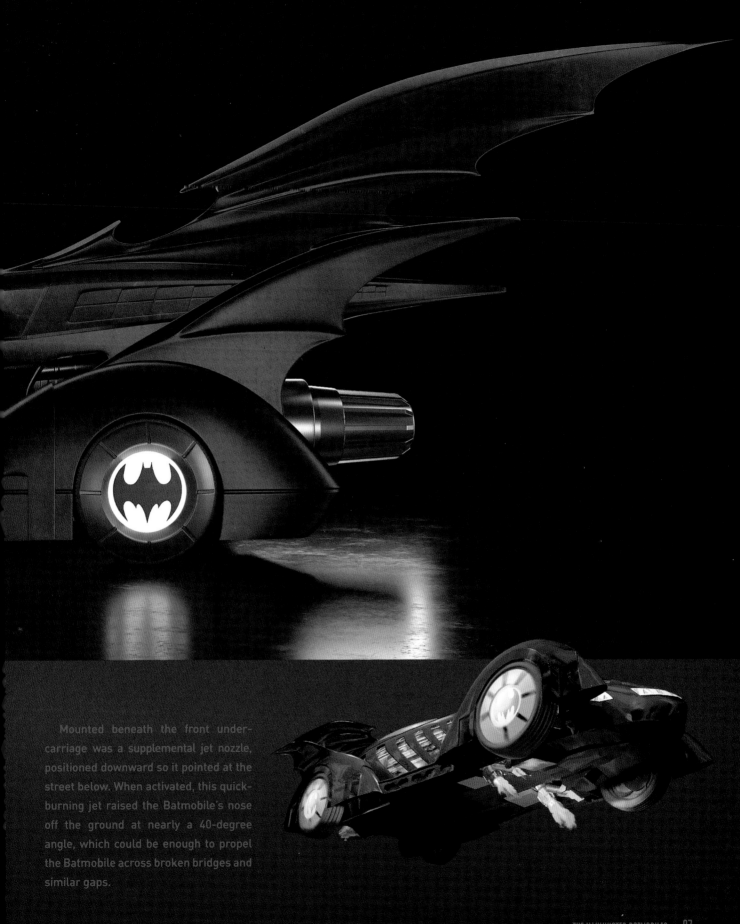

Mounted beneath the front under-carriage was a supplemental jet nozzle, positioned downward so it pointed at the street below. When activated, this quick-burning jet raised the Batmobile's nose off the ground at nearly a 40-degree angle, which could be enough to propel the Batmobile across broken bridges and similar gaps.

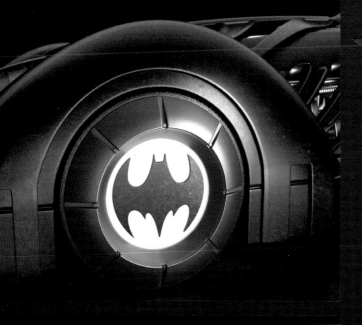

REAR-MOUNTED
VIDEO CAMERA

ROCKET BOOSTER

AUTOMATIC TRANSMISSION

PIVOTABLE WHEELS

DEFENSE AND WEAPONS SYSTEMS

The Batmobile's twin-seat cockpit, shielded by a bullet-proof canopy, allowed the driver to access custom diagnostics including a rear-view display fed from a concealed camera. A circular display screen was concealed behind a sliding panel and was primarily used for communicating with Alfred Pennyworth in the Batcave. It was also capable of showing broadcasts from surveillance cameras and Gotham City television stations.

To perform especially sharp maneuvers, the Batmobile was capable of locking all four wheels at a 90-degree angle—juking the car away from missile attacks or head-on collisions by scooting sideways at high speeds.

SPECS AND FEATURES

LENGTH: 25 feet

WIDTH: 7.87 feet

HEIGHT: 10.5 feet

MAXIMUM SPEED: 330 mph with booster

350-CUBIC-INCH OFF-ROAD V-8
ENGINE CAPABLE OF 350 HP

FRONT-MOUNTED GRAPNEL LAUNCHER
FOR VERTICAL SCALING

CUSTOM FRONT AND
REAR SUSPENSION

THE INCANDESCENT BATMOBILE

T he initial Batmobile met an explosive end when Two-Face and The Riddler breached the Batcave's inner sanctum and reduced the vehicle to smoking cinders. When nothing of value could be salvaged from the wreckage, Batman had no choice but to design a new car from scratch.

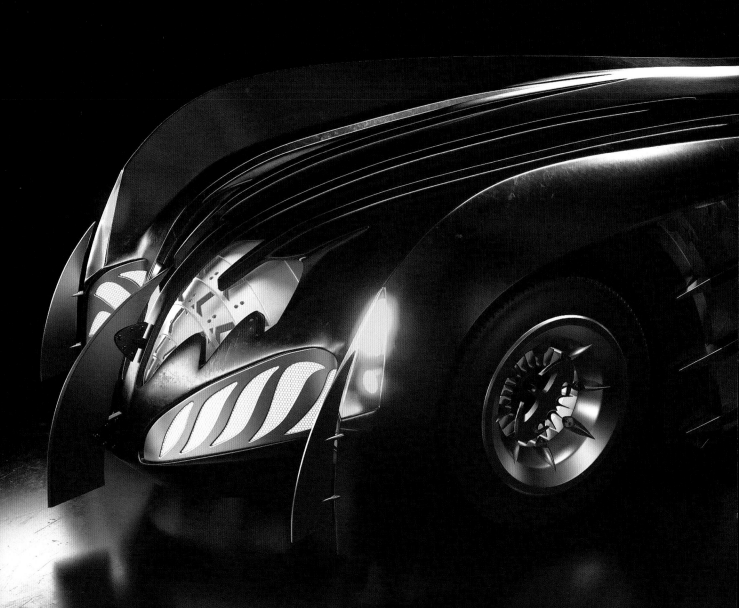

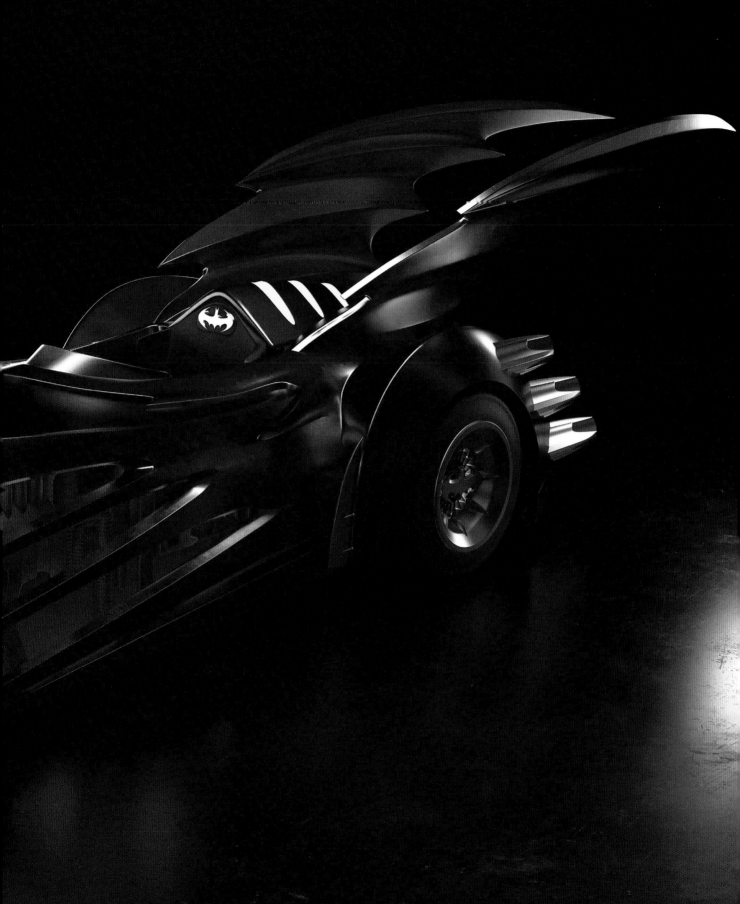

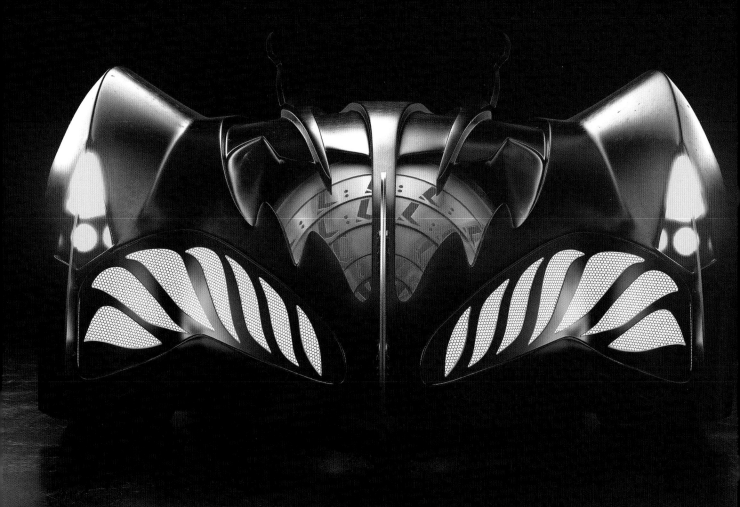

The subsequent Batmobile has a pointed nose and a nearly transparent hood, with pointed metal ribs for structural stability. The outline of the bat-symbol can be seen between the front fenders, and two angled bat-style tail fins sprout from the rear of the car. The vehicle's tapering boattail is flanked by two massive fenders, each equipped with three thrusters for extra power under full acceleration.

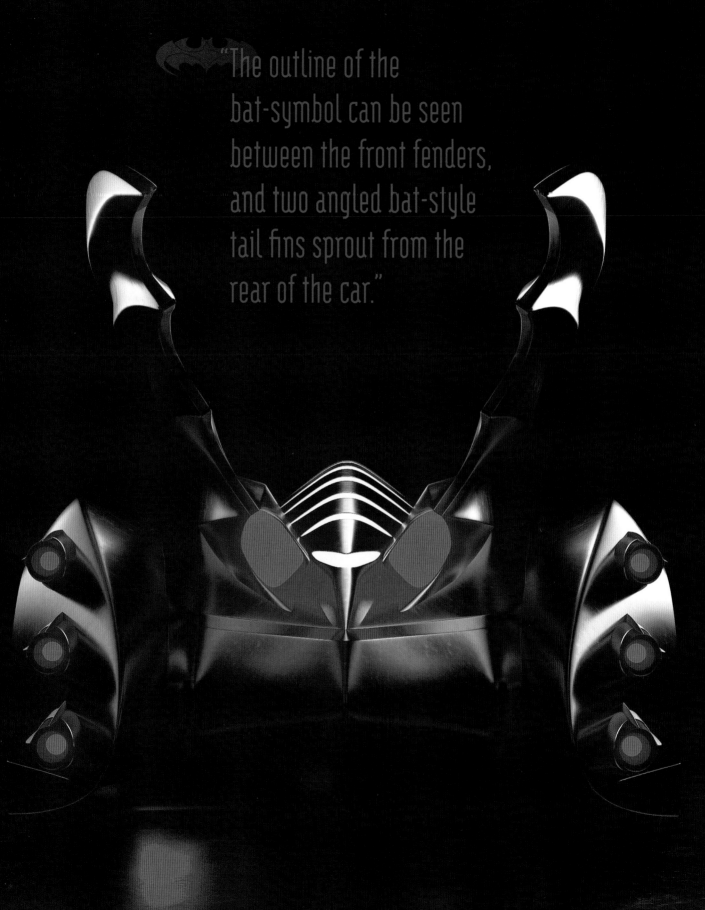

"The outline of the bat-symbol can be seen between the front fenders, and two angled bat-style tail fins sprout from the rear of the car."

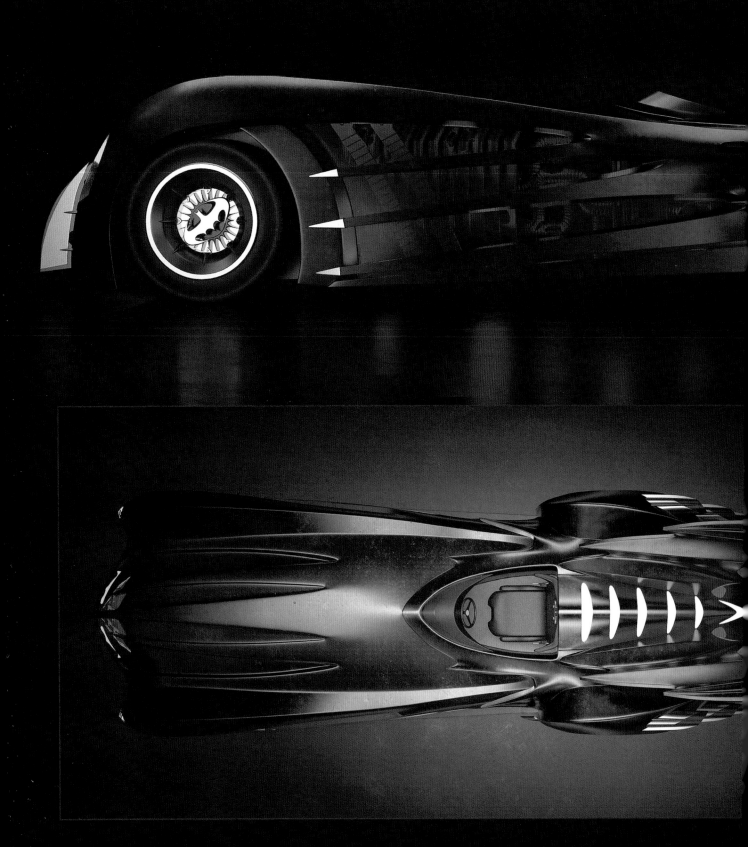

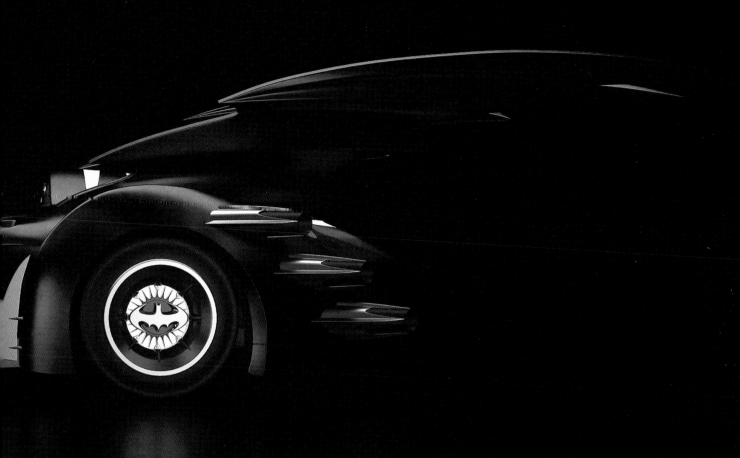

Through this design, the Batmobile is transformed into a work of art. An aesthetic emphasis on negative space leads to exposed components and an increased reliance on open-air cooling. Concealed neon-blue illuminators make the car appear to glow with an inner light. Its hubcaps are fitted with circles of glowing neon, while the engine's turbine constantly rotates within a translucent nose cone, pulsating with color like the rooftop flashers of a police cruiser. Such is the attention to detail afforded to each component of the vehicle that even its tire treads are embossed with tiny bat symbols.

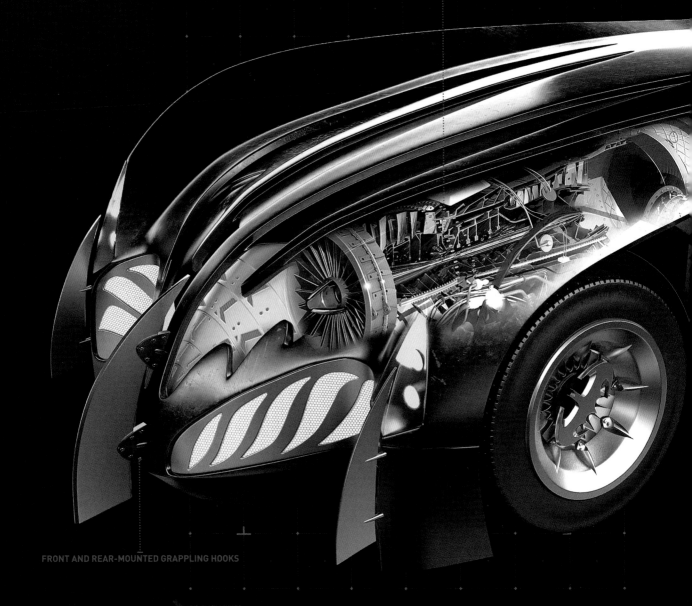

SPECS AND FEATURES

LENGTH: 33 feet

HEIGHT: 4.92 feet

MAXIMUM SPEED: 350 mph
with afterburner thrust

MODIFIED OFF-ROAD ENGINE WITH HIGH-FLOW DUAL
CATALYTIC CONVERTERS CAPABLE OF 380 HP

FRONT AND REAR-MOUNTED GRAPPLING HOOKS

TWO-WAY VIDEO COMMUNICATION
SCREEN IN DASHBOARD

PILOT'S EJECTION SEAT

SINGLE-SEAT COCKPIT

JET TURBINE AFTERBURNER
WITH SIX ANGLED FLAME
COLUMN EXHAUST NOZZLES

BOMB DISPENSERS IN WHEEL AXLES

MULTIPOINT INFRARED, RADAR, AND
LASER TRACKING SYSTEMS

ANGLED ARMOR PANELS
FOR DEFENSE

BATHAMMER

With Gotham City's streets iced over from Mr. Freeze's chilly blasts, Batman and Robin needed a way to steer on zero-traction surfaces without suffering a spinout. The Bathammer was constructed for just such an emergency. It shared the same turbine and cockpit as the mainline Batmobile but added widely set outrigger skis and a balanced rear thruster. Able to react to verbal commands, the Bathammer also featured pivoting body panels that could be angled to protect the driver's cockpit, reflecting lasers and similar energy attacks back toward assailants.

TWIN MISSILE LAUNCHER BATTERIES

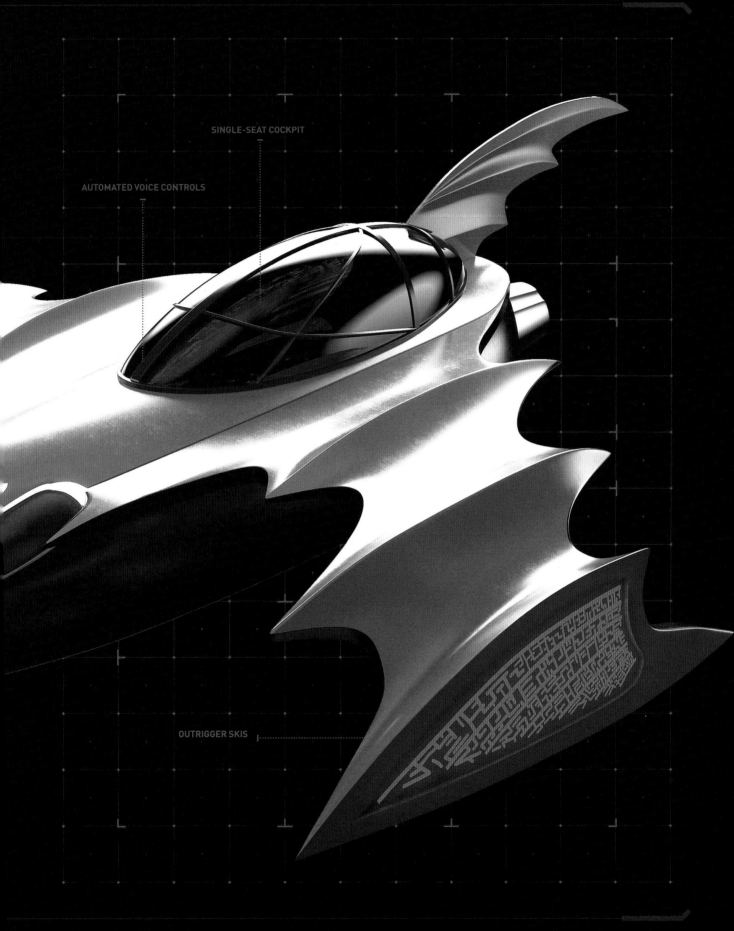

SINGLE-SEAT COCKPIT

AUTOMATED VOICE CONTROLS

OUTRIGGER SKIS

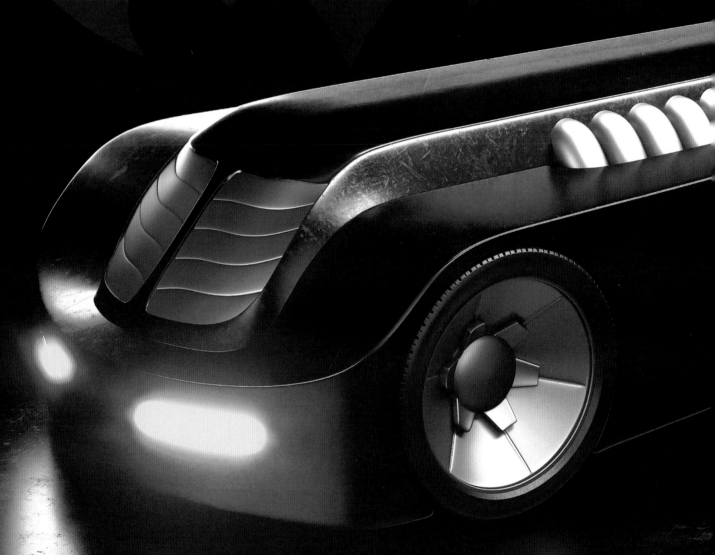

THE NOIR BATMOBILE

── Batman: The Animated Series ──

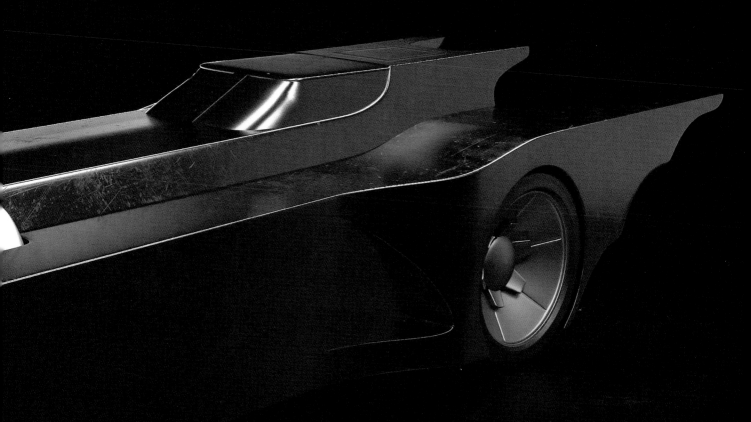

With the Batmobile as his armored chariot, Batman wages a never-ending war on Man-Bat, The Joker, Harley Quinn, The Riddler, and the other criminal elements plaguing Gotham City. In time, he is joined by Robin and Batgirl in the fight for justice, aided by specialized vehicles including the Batwing.

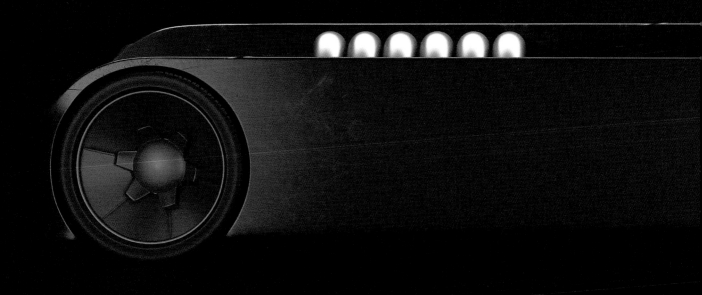

"The Batmobile's symmetric lines evoke the outline
of a swooping nocturnal predator."

Gotham City is under constant assault, as the members of Batman's Rogues Gallery prey upon the helpless citizenry. To fight back against injustice, Bruce Wayne designed an armored, jet-propelled car capable of delivering him to the scene of the crime before crooks can make their escape.

The design of Gotham City favors aesthetics steeped in '30s and '40s noir, and the Batmobile is no exception. A streamlined weapon of pure kinetic force, the Batmobile wears art deco contours that connect its battering-ram nose with its rear-mounted jet booster.

Before he arrived at this final design, Batman's early efforts at modifying a stock automobile proved inadequate for his needs. When a brutal battle left the proto-Batmobile in shambles, Batman took his damaged ride to unemployed automotive engineer Earl Cooper, the only person Batman trusted to build a superior replacement. Batman's pitch was simple: "I need a new car."

Once Cooper and his equally talented daughter, Marva, had signed up to create a new car for Batman, Bruce Wayne purchased several blocks of disused warehouse space and equipped one of the buildings as a hidden garage. With a "no questions asked" supply line enabling Cooper to obtain any automotive components he needed, the engineer set to work designing a car that blends drag racer performance with the sleek bodywork of a "Car of the Future" that Cooper saw exhibited at the Gotham World's Fair.

The resultant Batmobile wears titanium armor plating arranged in a minimalist, rectangular silhouette, with a slatted front grill and sweeping tail fins that suggest hot-rod speed even when the vehicle is parked.

The Batmobile's symmetric lines evoke the outline of a swooping nocturnal predator, and its jet-black paint job seals the deal. Slotted headlights resemble glowing eyes, reminding evildoers that Batman is always on the hunt.

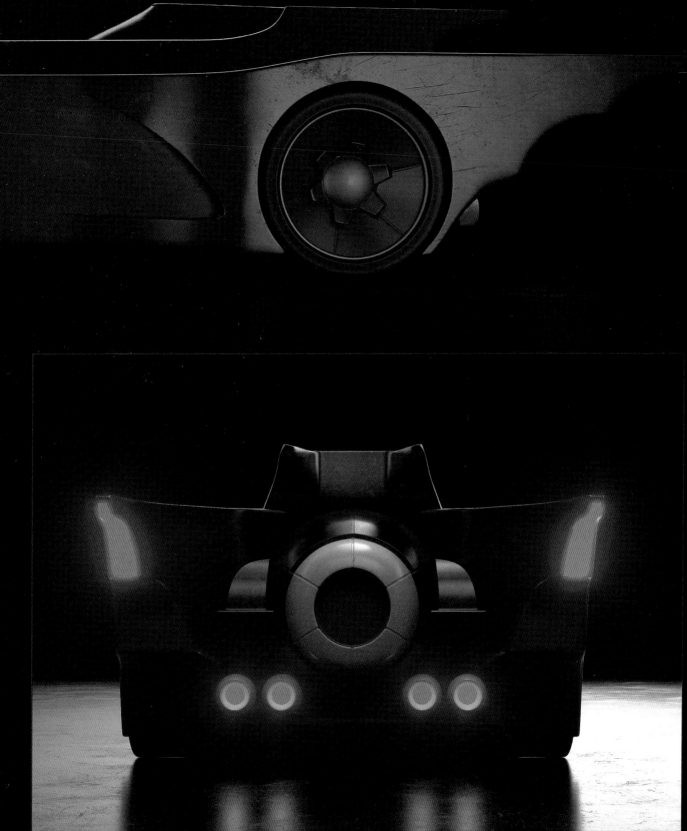

Under the hood, Cooper's Batmobile incorporates both a V-8 internal combustion engine for street driving and a jet turbine for rapid speed boosts. Sliding body panels can reveal any number of hidden gadgets, including grappling hooks, missile launchers, oil sprayers, and smoke emitters.

The Batmobile's onboard computer is critical to its functionality and monitors all the vehicle's systems via a central operational switch. On one occasion, The Penguin's goons took advantage of the centralized technology and used it to seize total operational control of the vehicle. With full remote access to the Batmobile, The Penguin steered the car on a terrifying spree that caused so much damage that it left the vehicle nearly inoperable. To get the Batmobile back on the road, the Cooper father-and-daughter team put hundreds of hours into a major rebuild.

"The Batmobile's onboard computer is critical to its functionality and monitors all the vehicle's systems via a central operational switch."

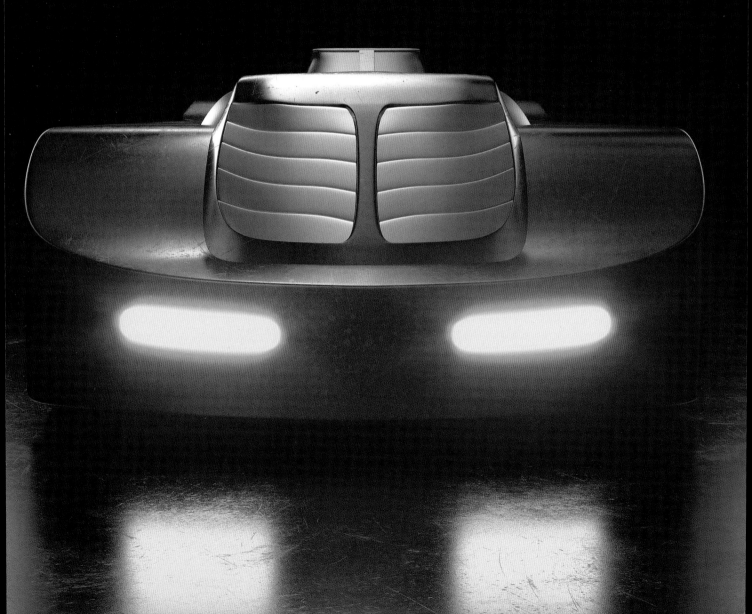

"Sliding body panels can reveal any number of hidden gadgets, including grappling hooks, missile launchers, oil sprayers, and smoke emitters."

DEFENSE AND WEAPONS SYSTEMS

To discourage tampering, the Batmobile is equipped with an anti-theft system that delivers a painful shock to anyone who touches the components installed under the hood. The driver and passenger seats are both equipped with compressed-air ejection mechanisms should the occupants need to exit the vehicle in a hurry. Once the seats have been launched skyward, glider wings pop out from the back rests, allowing Batman and Robin to follow their targets from the air.

The vehicle's offensive weaponry includes a front-mounted grappling hook for securing getaway cars, plus a missile rack and tear gas dispensers. Oil spillers, smoke sprayers, and wheel-mounted tire-slashers can all be used when the Batmobile is in motion to shake off vehicular pursuit.

In addition to the car's onboard gear, Batman often stores spare utility belt items and other gadgets in the trunk or glove compartment. These gizmos can include spare Batarangs, explosive gel, flash-freeze grenades, timed bombs, cable guns, electromagnetic pulse generators, and stun guns (rated for shocks up to 100,000 volts).

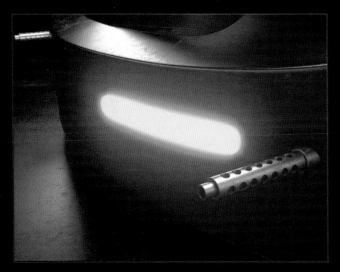

TROUBLESHOOTING _____ [02]

BY EARL COOPER, BATMOBILE MECHANIC

Listen, it breaks my heart talking bad about Global Motors. When I was a kid, I idolized those sports cars and ragtop coupes, enough to go to school and study automotive engineering. After graduation, I landed my dream job: I became a Global Motors designer. But then there came a day when I discovered a deadly safety flaw in our upcoming fall model. Not only did management not back me up, but they fired me to prevent me from leaking the news to the press. I quickly found out that I'd been blacklisted by the other car companies, too. Just like that, my career was kaput.

Thank heavens for Batman, who gave me the opportunity of a lifetime right out of the blue. Turns out that Batman had his own custom Batmobile already, but I knew me and Marva had the skills to build him something better. We're doing just fine, but things sometimes get pretty rough for the Batmobile! Whenever she's not performing up to spec, I run her through Marva's checklist:

- **TIRE PRESSURE.** I like to keep tires slightly underinflated for better road contact. This can lead to greater wear and sometimes even trigger the Batmobile's emergency auto-inflation tire gel. On the other hand, if you inflate them too

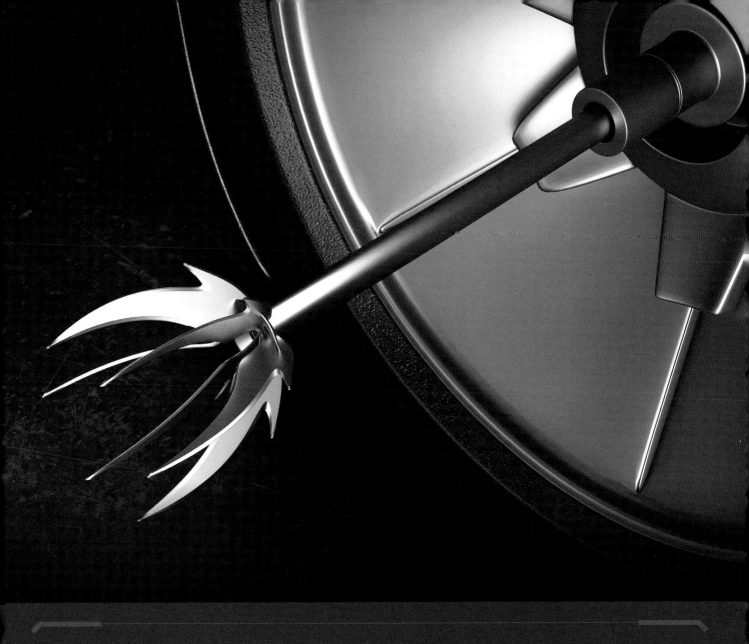

much, you might accidentally end up popping out the gripping studs, and those are gonna get shredded at highway speeds.

- **BRAKES.** Every time the Batmobile goes from a jet boost to a full stop, it does a number on the brake pads. They get worn out pretty fast, but I don't want to add even an inch to the max stopping distance—I'd rather not be the guy responsible for sending the Batmobile tipping over a bridge to get dunked in Gotham Harbor. Better to switch the brake pads out every time you have the car in the garage.

- **ALIGNMENT.** The Batmobile's suspension was built to high tolerances. But wear and tear changes things, not to mention collisions with cars and police barricades. That

kind of abuse results in a misaligned suspension pretty quick, something that can only be fixed by laser-measuring the toe (the degree to which the tires are angled inward or outward) and the camber (the tilt of the tires toward or away from the car body). Little tweaks here and there can dramatically improve traction and cornering, so it's important to get it right.

- **FILTERS.** The jet intake filters catch a lot of debris when the Batmobile is out there on the streets. Maybe it's Poison Ivy's plant spores; maybe it's icicle shards courtesy of Mr. Freeze. No matter what, the air filters must be inspected and replaced during every pit stop, even if the worst they've seen is standard Gotham City smog.

DRIVETRAIN AND WHEELS

During low-speed patrols, the Batmobile is propelled by a compression-ignition V-8 turbo-charged engine running on diesel fuel. If sudden acceleration is needed—when pursuing a fleeing vehicle, for example, or making a quick escape—the Batmobile can switch over to its auxiliary turbine jet. Both systems were designed by Earl and Marva Cooper, the only mechanics qualified to replace components or tinker with the car's power output.

The Batmobile's body and wheel wells are cast from a titanium alloy that is nearly impervious to small-arms fire, as demonstrated during prototype testing. The vehicle is incredibly tough, but extreme mechanical stress (like the time the Batmobile's nose was trapped beneath a lowering drawbridge) is theoretically capable of popping the seams of the armor panels and exposing the inner systems to subsequent damage.

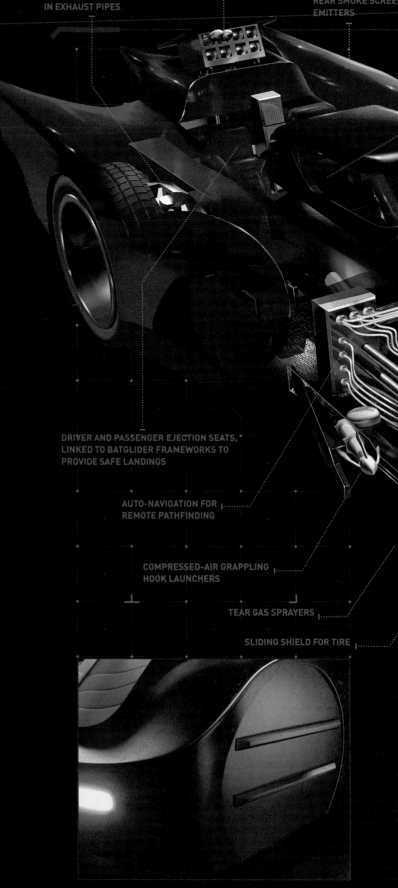

OIL-SLICK EJECTORS IN EXHAUST PIPES

HYDRAULIC MISSILE RACK

REAR SMOKE SCREEN EMITTERS

DRIVER AND PASSENGER EJECTION SEATS, LINKED TO BATGLIDER FRAMEWORKS TO PROVIDE SAFE LANDINGS

AUTO-NAVIGATION FOR REMOTE PATHFINDING

COMPRESSED-AIR GRAPPLING HOOK LAUNCHERS

TEAR GAS SPRAYERS

SLIDING SHIELD FOR TIRE

CLOSED-CIRCUIT VIDEO
COMMUNICATION
SYSTEM

TITANIUM BODY WITH
ABLATIVE SKIN COWLING

RETRACTABLE FRONT
MISSILE LAUNCHERS

EXTENDABLE TIRE-SLASHER
HUBS IN HUBCAPS

FLAME THROWER

SPOTLIGHT AND INFRARED
SENSOR PACKAGE

AUTOBALANCING GYROSCOPIC WHEELS

ENGINE MUFFLERS AND
VIBRATION DAMPENERS

SENSOR-SCATTERING
MATTE BLACK FINISH

BATCYCLE

While the Batmobile is Batman's vehicle of choice, some urban pursuits require a smaller, more maneuverable ride. The Batcycle is a custom motorcycle powered by a 761cc V-Twin engine, capable of 202 hp and speeds up to 200 mph. Its unibody frame can shake off the impact of most collisions, while exhaust mufflers and vibration bafflers allow for near-silent stealth approaches. A wireless link to the Batcave allows Batman to access records while in transit using hands-free voice commands.

BATWING

The Batmobile is sufficient for handling the vast majority of Gotham City threats, but there are times when a vigilante must take to the skies. The supersonic Batwing gives Batman the freedom to deal with the aerial villains in his Rogues Gallery (such as Man-Bat) and allows him to travel overseas without needing to buy a ticket on a passenger airliner.

The Batwing exhibits bat-shaped contours with jutting wingtips, nose-mounted prongs that resemble ears, and a pointed tail fin. VTOL engines allow the craft to hover in place, while vertical takeoffs and landings can usually be performed by the Batwing's onboard computer without any pilot input. The craft's offensive weaponry includes a front-mounted grappling claw and a bank of air-to-air missiles.

The Batwing's advanced airframe benefits from classified research conducted during the development of the Wayne Enterprises Raven X1-11 helicopter. The resulting upgrades include a silent-running mode to muffle engine sounds, and active sensor cloaking that makes the Batwing nearly invisible to enemy radar.

SENSOR-JAMMING SUITE

FORWARD-GRIPPING CLAW

SPECS AND FEATURES

HEIGHT: 14.5 feet

LENGTH: 57.7 feet

WINGSPAN: 47.6 feet

ALTITUDE CEILING: 60,000 feet

MAXIMUM SPEED: 1,875 mph

RANGE: 3,400 miles

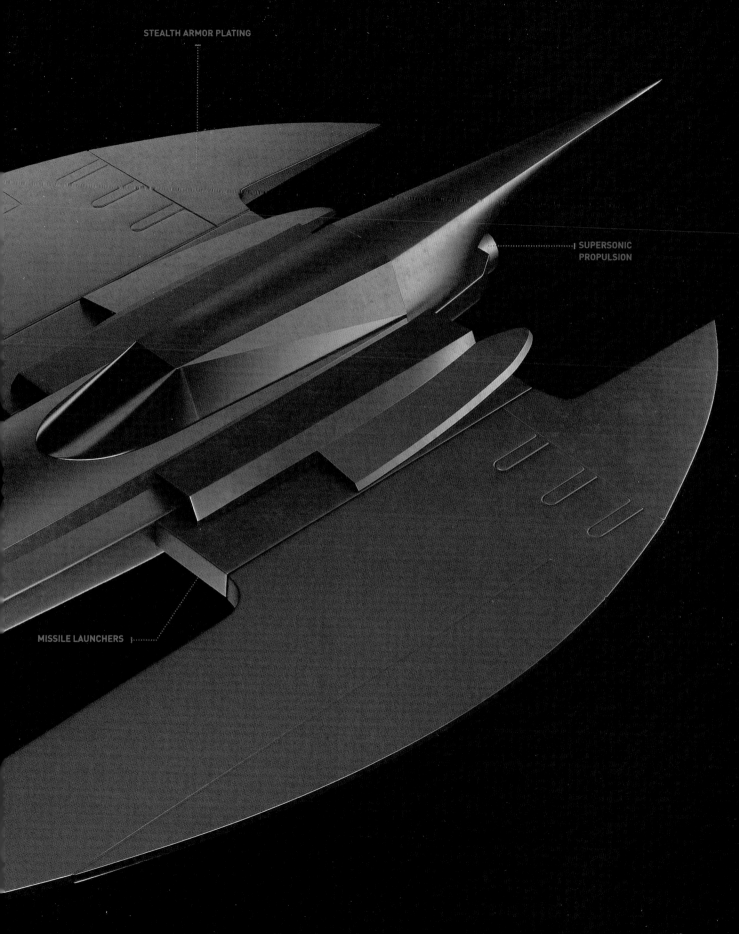

STEALTH ARMOR PLATING

SUPERSONIC
PROPULSION

MISSILE LAUNCHERS

THE CAPED CRUSADER BATMOBILE

Batman Classic TV Series, 1966

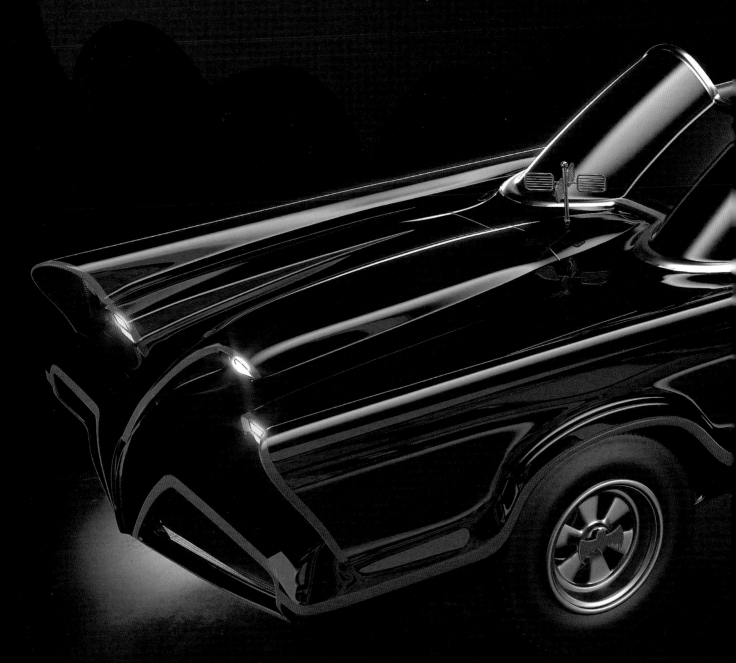

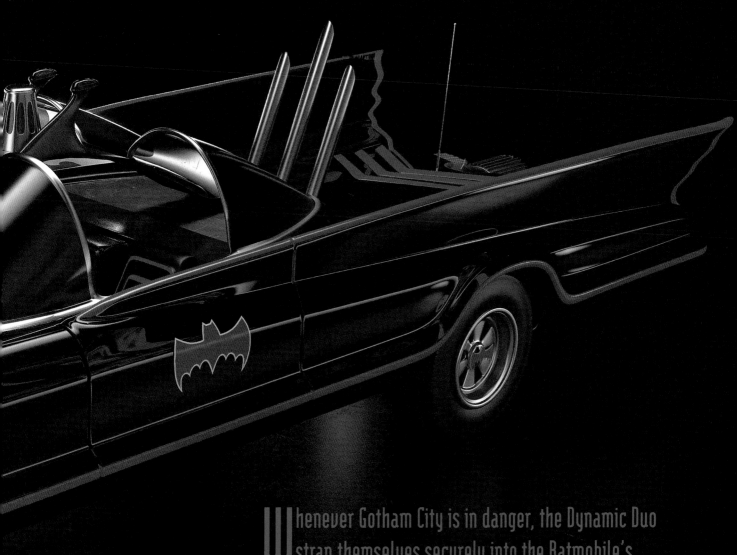

Whenever Gotham City is in danger, the Dynamic Duo strap themselves securely into the Batmobile's bucket seats. Roaring from the Batcave, Batman and Robin steel themselves against the direst perils! What nefarious new crime wave will bedevil the Dynamic Duo? Stay tuned to find out!

In the Batcave beneath stately Wayne Manor, Batman and Robin maintain a veritable arsenal of revolutionary Bat-gadgets, but the Batmobile is undoubtedly their most important creation.

The noblest efforts are often the most difficult, and the Batmobile has been painstakingly modified over many months to become a high-speed interceptor and a rolling arsenal.

When designing his signature vehicle, Batman took inspiration from the police cruisers operated by the Gotham City Police Department but quickly recognized that stock vehicles had little chance of stopping unpredictable offenders like Egghead, Mr. Freeze, Bookworm, or King Tut. Instead, he acquired a one-of-a-kind vehicle design—specifically, the Lincoln Futura 1955 concept car—and began modifying the two-door, open-air coupe for four-wheeled crime-fighting.

With a body made of bulletproof steel and a shatterproof twin-bubble windscreen, the Batmobile protects its driver and passenger from projectile attacks while rocketing forward at jet-propelled speeds. Because Batman's utility belt has gotten him out of so many jams, he has carried the same degree of versatility over to the Batmobile by wiring a host of gadgets to the car's atomic battery. The Batmobile became a test bed for experimental technology including the Bat-Beam, the Bat-Ray, and the Detect-A-Scope.

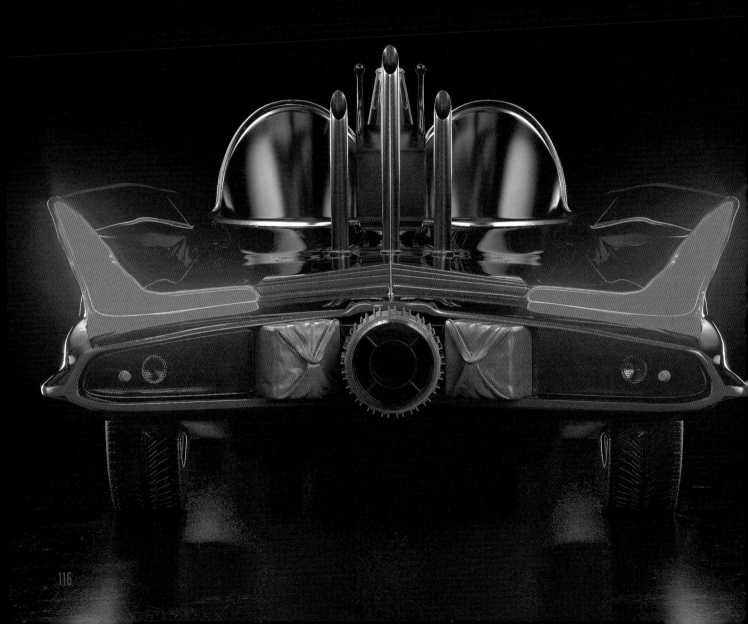

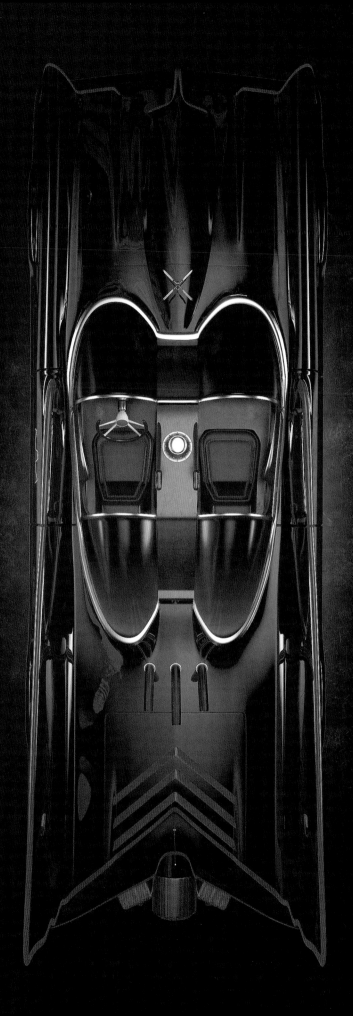

"With a body made of bulletproof steel and a shatterproof twin-bubble windscreen, the Batmobile protects its driver and passenger from projectile attacks while rocketing forward at jet-propelled speeds."

For an ingenious crusader like Batman, there is nothing that can't be reconfigured as a bat-themed item in the service of justice. Simple objects like the Bat-Ladder and the Bat-Tweezers require little more than a change in name, a rule that eventually encompassed such esoteric trends as the Batusi dance craze and the Batburger that appears on the menus of many Gotham City diners.

The Batmobile, however, is much more than just a name. Batman leans into the car's bat-like visual inspirations, knowing that a mere glimpse of the Caped Crusader's custom vehicle will frighten evildoers, letting them know that the long arm of the law can follow them anywhere.

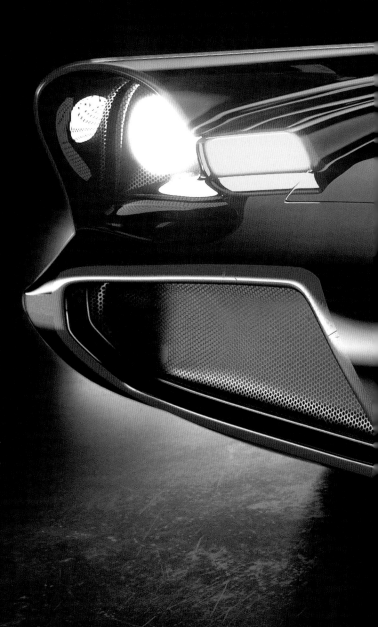

The tail fins on the Futura chassis already suggest the pointed tips of a bat's wings, which is one of the reasons Batman selected this particular design. He added a number of themed augmentations of his own, including front-end bodywork in the shape of a bat's face, defined by a hood scoop resembling twin nostrils and a pair of headlight "eyes." Super-gloss paint renders the Batmobile as black as midnight, with fluorescent red trim to accentuate the vehicle's contours and form sleek racing stripes along both sides.

The bat-symbol appears in multiple places, including as emblems on both doors and four smaller logos on each wheel. Luminescent paint ensures that the emblems appear to glow under headlight beams and other forms of nighttime illumination.

"The bat-symbol appears in multiple places, including as emblems on both doors and four smaller logos on each wheel."

DRIVETRAIN AND WHEELS

A twin turbocharged V-8 engine powers the Batmobile under normal conditions, providing more than enough horsepower to overtake most getaway cars on the open road. Batman, of course, is loath to exceed posted highway speed limits, but if duty requires him to proceed with utmost urgency, he can activate the Batmobile's atomic turbine engine. The flaming exhaust produced by the turbine is channeled through a variable nozzle in the rear, propelling the car in the manner of an Air Force jet fighter. Thanks to the Batmobile, no man can outrun justice!

The atomic batteries installed in the Batmobile can be recharged only with a unique formula that includes generous amounts of heavy water—a substance that is toxic to all living things. In one instance, The Penguin tried to restore his thugs from hydro-depleted stasis by infusing their powdered remains with heavy water taken from the

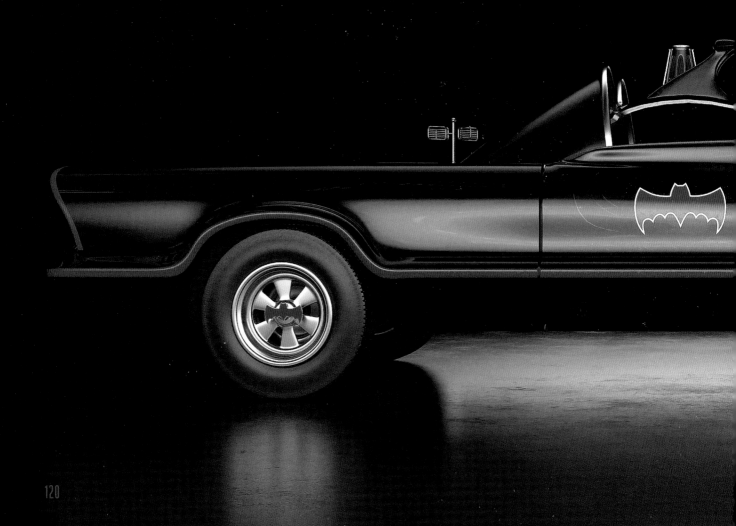

Batcave's supply tanks. The tactic worked in the short term, but The Penguin's unstable minions soon found themselves vanishing out of existence when subjected to physical shocks, most notably during fisticuffs with the Caped Crusaders.

By contrast, the Batmobile's V-8 engine uses regular gasoline, ensuring that Batman and Robin are never far from a convenient fill-up. Just in case, Batman carries extra tanks of gasoline in the trunk, and often gives the fuel away as a good deed when assisting stranded motorists.

The Batmobile has a dual-coil suspension with steel-belted wheels and double-disk antilock brakes. If a tire suffers a blowout, it can easily be reinflated with the press of a dashboard button, triggering a gel infusion that simultaneously seals the puncture and restores the tire pressure to recommended levels.

"The Batmobile has a dual-coil suspension with steel-belted wheels and double-disk antilock brakes."

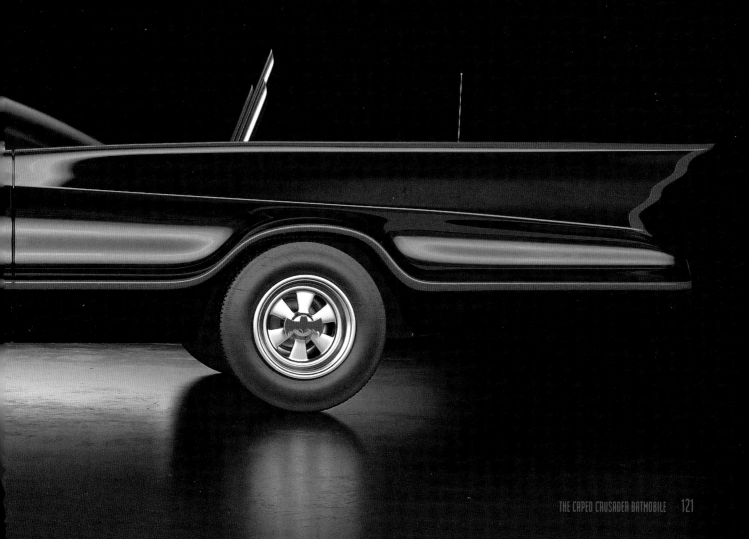

DEFENSE AND WEAPONS SYSTEMS

Keeping the Batmobile safe is just as important as retaliating against attackers.

If criminals get too close during high-speed driving, the Batmobile can shake them off with a visibility-obscuring smoke screen, a wheel-skidding oil slick, or a tire-puncturing deployment of sharp nails.

The Batmobile can also perform a dynamic evasive maneuver known as the Bat-Turn. Hitting a "Parachute Jettison" button releases the drogue chutes and stops the vehicle dead in its tracks, while Batman spins the vehicle to perform a complete about-face. (Batman employs a pickup service to collect the parachutes, keeping the streets of Gotham City free of his litter.)

By activating the Batmobile's anti-theft system, Batman can ensure that his ride will remain safe and secure while he is away from the vehicle. Whenever a devious delinquent tries to steal the Batmobile, it responds with flashing lights and whistling alarms, and launches incandescent flares into the sky. Using remote activators, Batman can also deluge the hijacker in a flood of fire-extinguishing foam, or even launch the would-be thief 300 feet in the air via pressurized ejection seats.

Onboard hardware enables Batman and Robin to call the Batmobile to their current location with the palm-size Batmobile Bat-Tracker. Similarly, the Dynamic Duo can track the Batmobile from their utility belts by reverse-mapping the same electromagnetic signal.

From *BIFF!* to *ZLOPP!*, Batman and Robin aren't afraid to let their fists do the talking. But sometimes it's wiser to deal with enemies from a distance. The Batmobile's offensive weaponry includes a Bat-Ray that can disable engines, and a Bat-Beam for blasting holes in solid steel. In addition, the Batmobile's diamond-edged chain-slicing saw makes short work of barriers, while an extendable battering ram can crumble concrete. Three missile launcher tubes behind the cockpit, normally stocked with anti-theft flares, can also accommodate surface-to-air missiles. In addition, the Batmobile's wheels can project spinning tire-slashers for shredding the treads of nearby vehicles and sending them into uncontrollable spinouts.

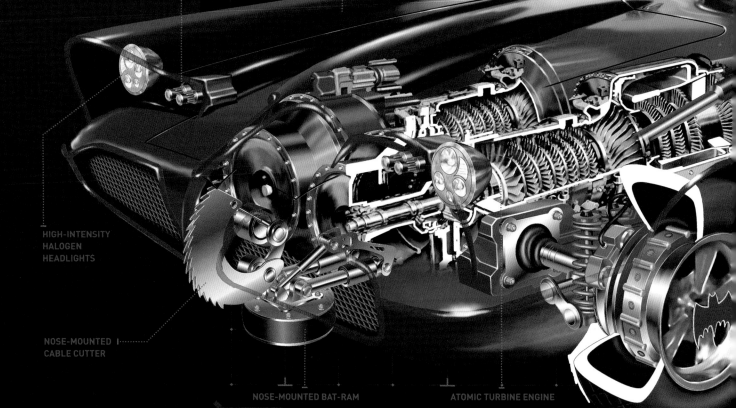

SPECS AND FEATURES

- LENGTH: 18.83 feet
- WIDTH: 7.5 feet
- HEIGHT: 4 feet
- WEIGHT: 5,500 pounds

BAT-RAY PROJECTORS

SHATTERPROOF BUBBLE CANOPIES

BAT-BEAM ANTENNA

BULLETPROOF BODY ARMOR

HIGH-INTENSITY HALOGEN HEADLIGHTS

NOSE-MOUNTED CABLE CUTTER

NOSE-MOUNTED BAT-RAM

ATOMIC TURBINE ENGINE

WHAT'S INSIDE THE BAT-TRUNK?

No one can dispute that the Batmobile is a formidable crime-fighting chariot. And yet even the Batmobile can't accommodate enough wiring and activation switches to power everything that Batman might require on a mission. For this reason, the Batmobile's trunk and glove compartment are packed with specialized equipment that can be slotted into the Dynamic Duo's utility belts, leaving them well equipped for missions.

- **BAT-DRONE PLANE:** This miniature aircraft can scan for energy wavelengths while being remote-steered from the Batmobile or Batcave.

- **BAT-KEY:** A universal skeleton key, capable of opening almost any lock in Gotham City.

- **BAT-NESIA GAS:** A handy chemical concoction used to knock out enemies or erase their short-term memories.

- **BAT OXYGEN TANK:** An emergency breathing supply for use during underwater missions.

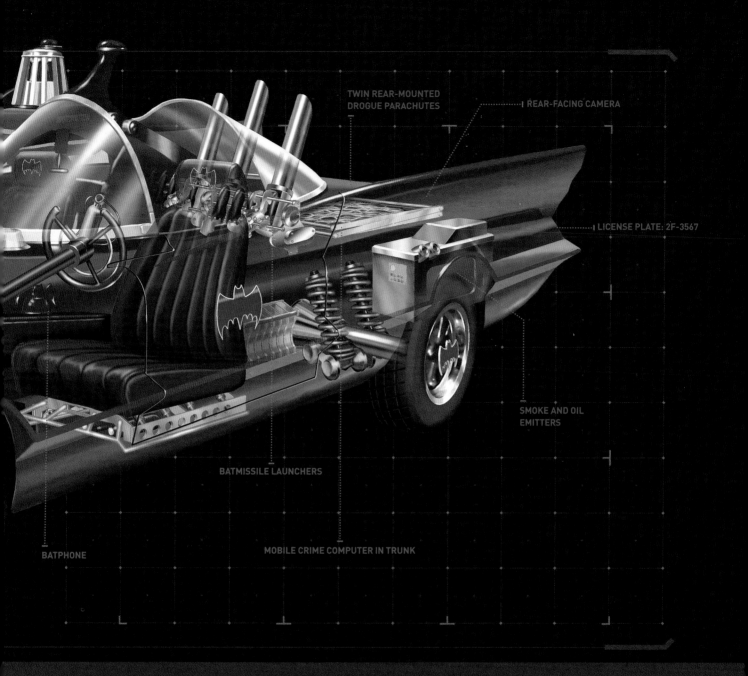

TWIN REAR-MOUNTED
DROGUE PARACHUTES

REAR-FACING CAMERA

LICENSE PLATE: 2F-3567

SMOKE AND OIL
EMITTERS

BATMISSILE LAUNCHERS

BATPHONE

MOBILE CRIME COMPUTER IN TRUNK

- **TRANSISTORIZED SHORT WAVE BAT-TRANSMITTER:** This compact bundle of electronics permits the transmission of Morse code signals between Batman's location and a specialized receiver in the Batcave.

- **BAT-BOMBS:** Time-delayed adhesive bombs that explode with a bang, a flash, and a puff of smoke. Often used as distractions.

- **PARTICLE BAT-ACCELERATOR:** A device that generates an anti-charge field with enough intensity to deflect bolts of static electricity.

- **EQUIPMENT BAYS:** Some compartments in the Batmobile are reserved for mission-specific gadgets, and Batman seemingly possesses an uncanny talent for knowing exactly which item will save him during a particular scenario. In the past, the Dynamic Duo have survived certain death thanks to unique formulations including African Death Bee antidote pills and Oceanic Repellent Bat-Spray (available in Shark, Whale, Barracuda, and Manta Ray varieties). When confronting villainy, one can never be too prepared!

BATBOAT

ven the intrepid Batmobile has its limits. Its range ends at the water's edge, a fact that would seemingly give Gotham City's criminals free reign over Gotham Harbor. The Dynamic Duo, however, planned for such lawlessness. Enter the Batboat!

The nuclear-powered Batboat can be summoned to appear at any dock in Gotham Harbor, but is typically stored inside a humble shack along the shoreline. Protected from rubberneckers behind a NO TRESPASSING sign, a high-tech boat launch allows the craft to be deployed at a moment's notice. Activated with a hidden lever, the launch's mechanized track gently lowers the Batboat into the water.

The Batboat was retrofitted from a commercially available speedboat, its gas engine swapped out for a nuclear reactor that supplies thrust through a vectored rocket nozzle in the rear. Easily identified at a distance by its blue-and-white paint job and the glowing Bat logo on its tail fin, the Batboat also features a sporty flame decal running down both sides near the waterline.

The Dynamic Duo can activate an overhead Bat Beacon that flashes like a police siren when they are closing in on troublemakers, and a watertight compartment contains a rocket-firing Bat-zooka for use against seagoing enemies.

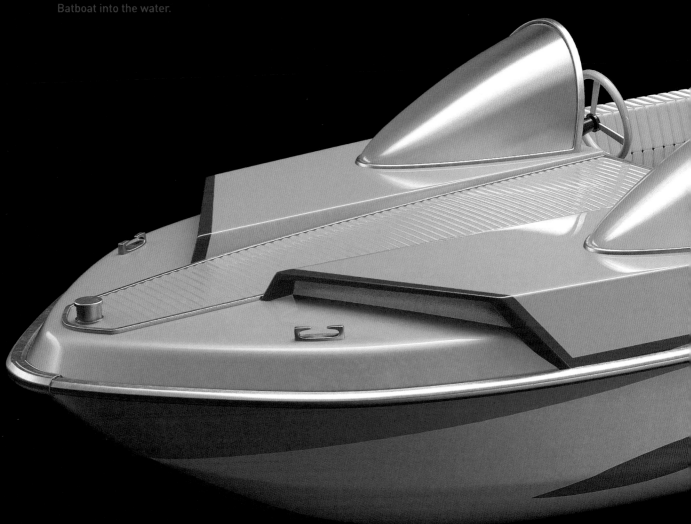

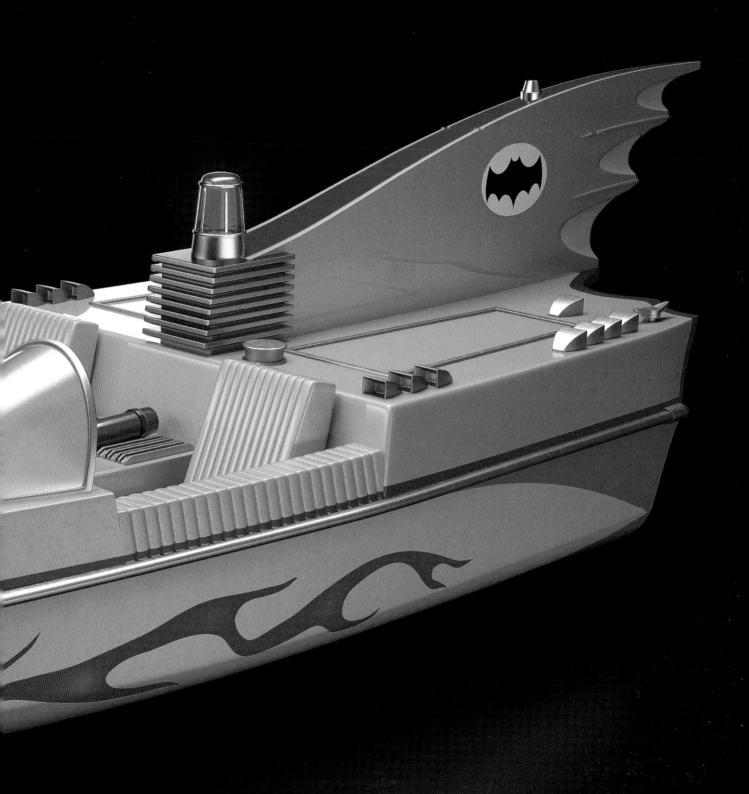

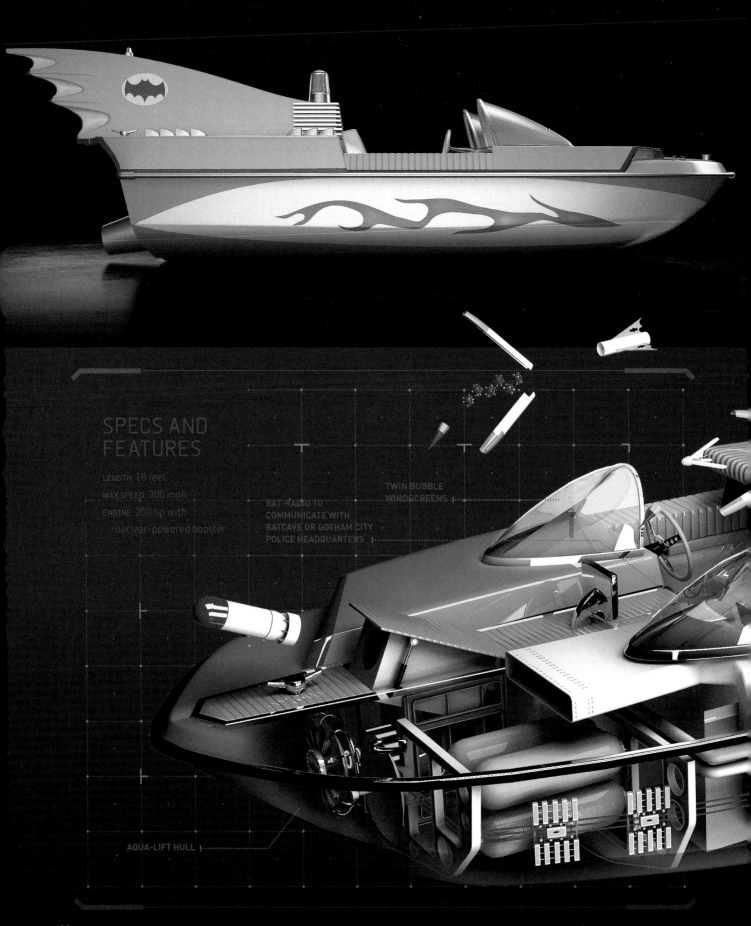

SPECS AND FEATURES

LENGTH: 18 feet

MAX SPEED: 300 mph

ENGINE: 250 hp with
nuclear-powered booster

BAT-RADIO TO
COMMUNICATE WITH
BATCAVE OR GOTHAM CITY
POLICE HEADQUARTERS

TWIN BUBBLE
WINDSCREENS

AQUA-LIFT HULL

"The Batboat was retrofitted from a commercially available speedboat, its gas engine swapped out for a nuclear reactor that supplies thrust through a vectored rocket nozzle in the rear."

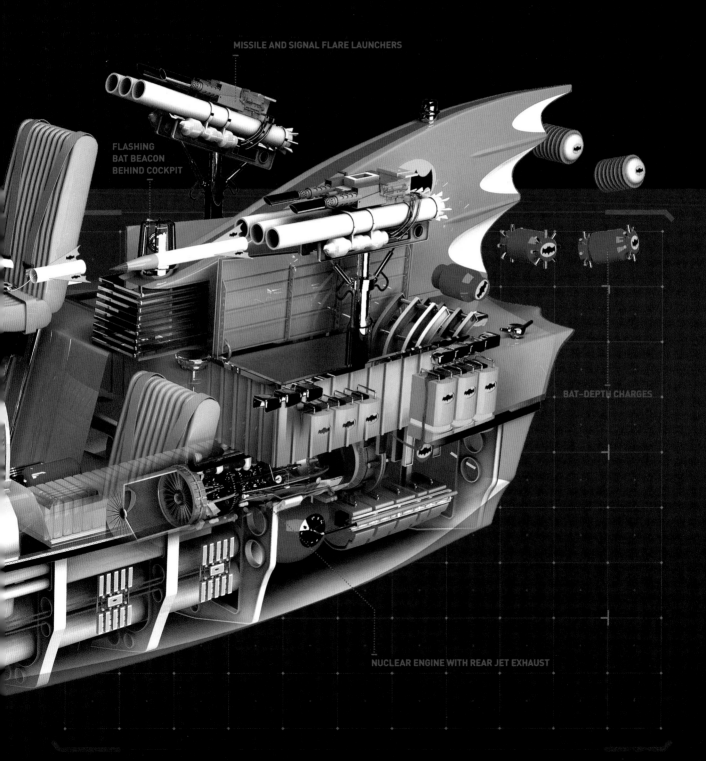

MISSILE AND SIGNAL FLARE LAUNCHERS

FLASHING
BAT BEACON
BEHIND COCKPIT

BAT–DEPTH CHARGES

NUCLEAR ENGINE WITH REAR JET EXHAUST

THE TRANSFORMING BATMOBILE

Batman: The Brave and the Bold

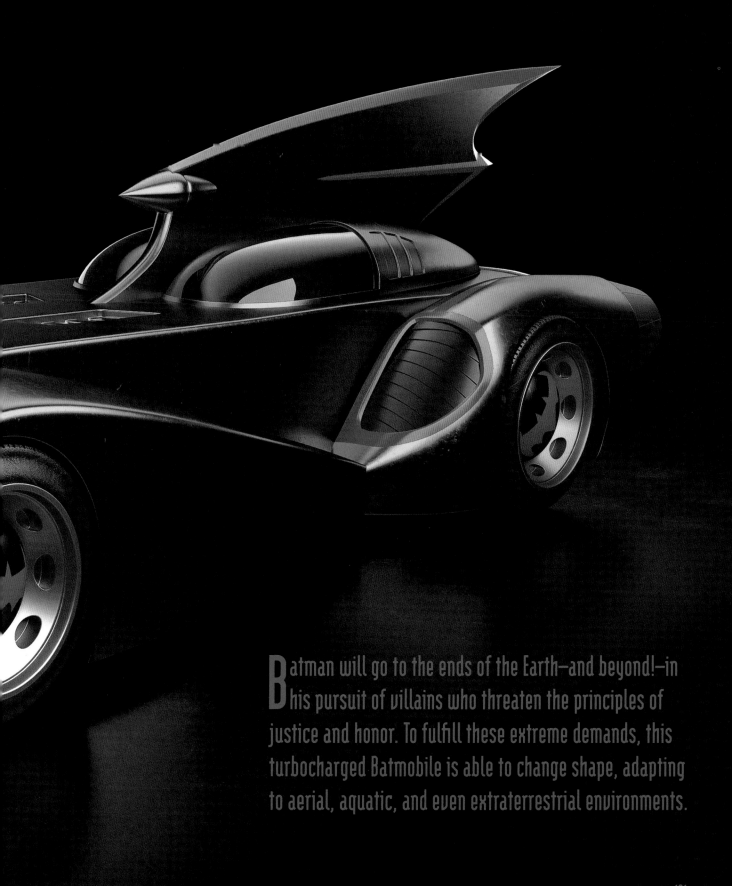

Batman will go to the ends of the Earth—and beyond!—in his pursuit of villains who threaten the principles of justice and honor. To fulfill these extreme demands, this turbocharged Batmobile is able to change shape, adapting to aerial, aquatic, and even extraterrestrial environments.

Batman often teams up with his fellow crime fighters, be they time travelers, magic users, Greek gods, or aliens from distant worlds. Because such varied adventures inevitably lead him into bizarre and hostile alien environments, Batman designed this Batmobile as a shape-shifter that can reconfigure its structure into a submarine, a spaceship, an aerial interceptor, or a giant mech on command.

Its true capabilities become apparent only when its preprogrammed transformation modes are triggered. Thanks to a reconfigurable drivetrain and morphable exterior cladding, the Batmobile can become the perfect vehicle for navigating a wide variety of environments, including deep sea, space, and offworld terrain.

The car's ebony paint job is an experimental concoction that traps visible light, making it appear "blacker than black" and increasing its nighttime stealth capabilities. As a visual offset, Batman painted the front fenders, rear air scoops, and the spine of the tail fin with luminous red stripes, creating an effect that makes the vehicle appear to have a glowing circulatory system.

"Thanks to a reconfigurable drivetrain and morphable exterior cladding, the Batmobile can become the perfect vehicle for navigating environments that are aerial, aquatic, and even extraterrestrial in nature."

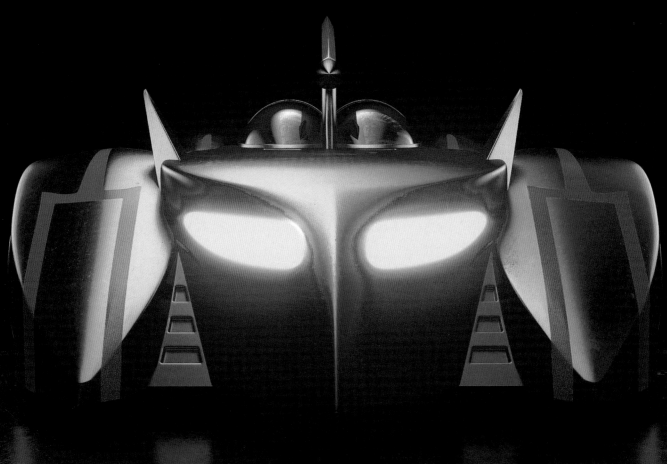

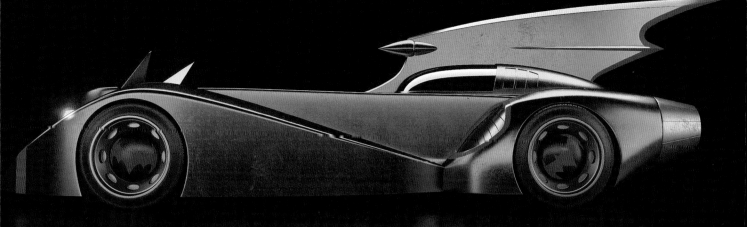

DRIVETRAIN AND WHEELS

The Batmobile's engine is a custom creation, built using proprietary components sourced from Ferris Aircraft, a leader in aerospace innovation. This engine incorporates a turbocharger that forces air into its combustion chamber, accelerating the vehicle at a rate faster than that of any known sports car. Additionally, the Batmobile features an experimental subatomic drive that can power its transfigured jet, space, sub, or armor modes for optimal performance despite radical structural changes. However, use of this subatomic drive results in extreme fuel depletion.

All four wheels of the Batmobile are coated with a mesh of tough synthetic fibers to protect against punctures and filled with aerated gel to avoid explosive blowouts. The standard tires are rated for all-weather terrain but can be swapped out for smooth, road-gripping racing tires when speed is a priority.

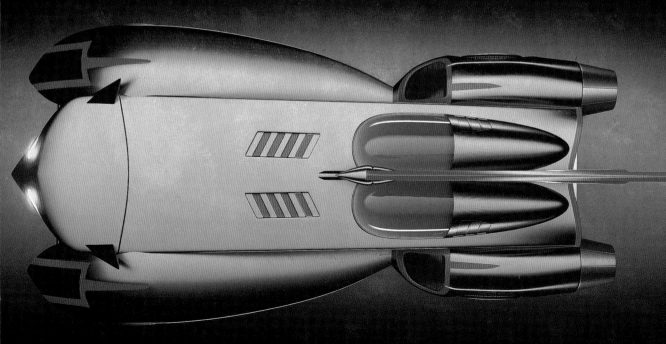

SPECS AND FEATURES

LENGTH: 19.89 feet

WIDTH: 8.37 feet

HEIGHT: 5.45 feet

MAXIMUM SPEED: 300 mph
with jet booster

ACCELERATION: 0–60 in 3.9 seconds

AIRTIGHT COCKPIT WITH
ENVIRONMENTAL SENSORS

ADHESIVE GLUE SPRAYERS

EXPERIMENTAL
SUBATOMIC
POWER PLANT

KNOCKOUT GAS SPRAYERS

100 PERCENT RECONFIGURABLE DRIVETRAIN AND
BODYWORK, ALLOWING THE BATMOBILE TO ARRANGE
ITSELF INTO SPECIALIZED ENVIRONMENTAL FORMS

SELF-DESTRUCT MECHANISM KEYED
TO ENGINE'S SUBATOMIC DRIVE

6-SPEED MANUAL TRANSMISSION

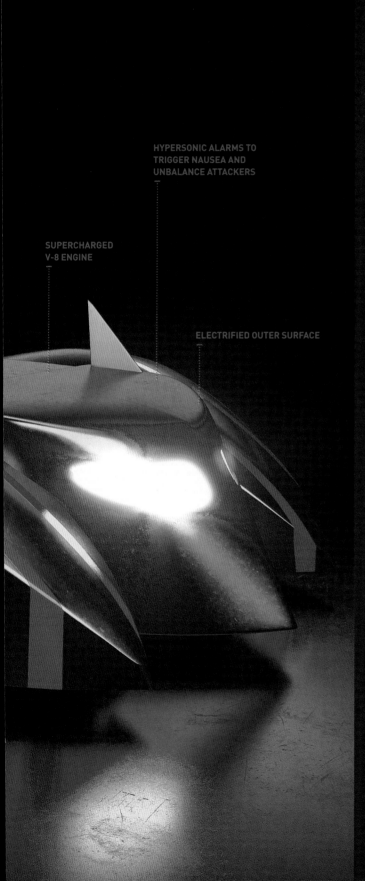

HYPERSONIC ALARMS TO TRIGGER NAUSEA AND UNBALANCE ATTACKERS

SUPERCHARGED V-8 ENGINE

ELECTRIFIED OUTER SURFACE

DEFENSE AND WEAPONS SYSTEMS

A voice-authorization passcode is required to access the Batmobile's basic functions. When parked, the Batmobile enters a standby state with multiple options for defense. If an aggressor gets too close, the Batmobile can electrify its outer surface and spray knockout gas from concealed nozzles. Disorienting hypersonic alarms and immobilizing super-adhesive sprayers can also be deployed. If all else fails, the Batmobile can self-destruct by overloading its subatomic drive.

The tail end of the Batmobile is equipped with nozzles for releasing lubricant slicks and liquid smoke. Additionally, the car can drop sharp-edged caltrops in its wake to puncture the tires of pursuing vehicles. The front end features sliding panels that conceal grapnels, chain cutters, and antipersonnel Batarangs.

STRUCTURAL TRANSFORMATION

The Batmobile can reconfigure its form at the touch of a button. This restructuring pushes the Batmobile's chassis to its limit. These environmental modes are detailed here and on the following pages.

STREAMLINED VERTICAL STABILIZER

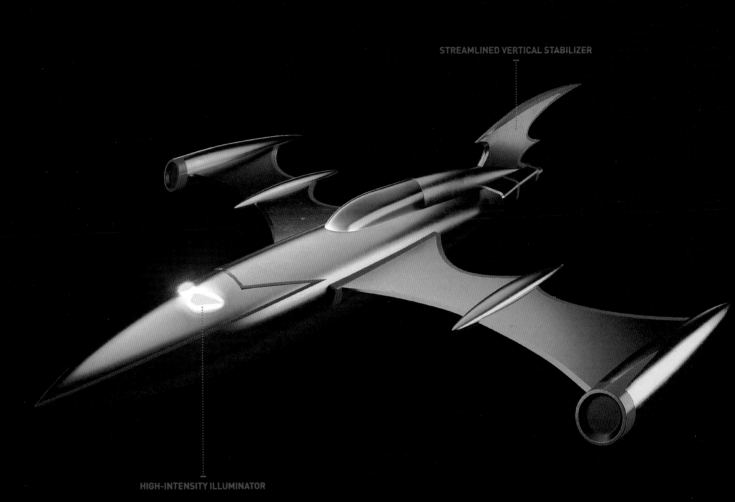

HIGH-INTENSITY ILLUMINATOR

JET MODE

In jet mode, the Batmobile's nose elongates into a missile-like nose cone with glowing "eye" spotlights on either side. Wings extend from either side of the chassis, scalloped with bat edging and terminating in streamlined pods. A single jet thruster in the rear is used for propulsion, with the Batmobile's tail fin now acting as a rear stabilizer and rudder.

SUBMARINE MODE

Transforming the Batmobile into a submersible seals the cockpit and critical internal systems, creating airtight tolerances capable of withstanding the punishing pressures of the ocean depths. In this mode, the vehicle retains its distinctive three-dimensional Batman cowl and tail fin, but retracts its wheels while extending twin pontoons as outrigger floats. Spotlights on both fins illuminate murky waters, and propulsion is achieved with a pair of rear-mounted aquatic thrusters. When Batman visited Aquaman in the undersea kingdom of Atlantis, he used the sub to intercept an explosive missile fired by Black Manta.

BAT-COWL REINFORCED NOSE

OUTRIGGER FLOTATION PODS

"In armor mode, the Batmobile reshapes into a bipedal battle machine, the driver's cockpit becoming the vehicle's head and the wheel wells transforming into independently operated hands and feet."

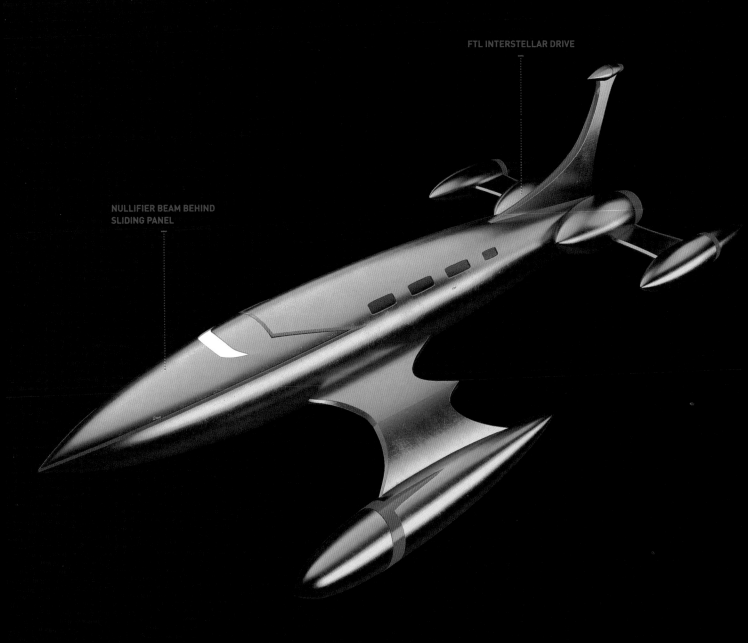

FTL INTERSTELLAR DRIVE

NULLIFIER BEAM BEHIND
SLIDING PANEL

SPACE MODE

When it comes to crime, Batman's reach doesn't end at the borders of Gotham City.
By activating the Batmobile's space mode, the Caped Crusader can thwart evildoers
on distant planets across the cosmos. This transmogrification turns the Batmobile
into a pressurized rocket capable of nimble zero-G flight. As in sub mode, angled,
pontoon-like outriggers are extended for use in maneuvering through the vacuum
of space. The craft is equipped with missiles as well as an "alien nullifier beam"
capable of disabling the engines and weapons systems of extraterrestrial warships.
Accompanied by sibling crime fighters Hawk and Dove, Batman used the nullifier to
disarm two factions of hostile aliens and force them to the negotiating table.

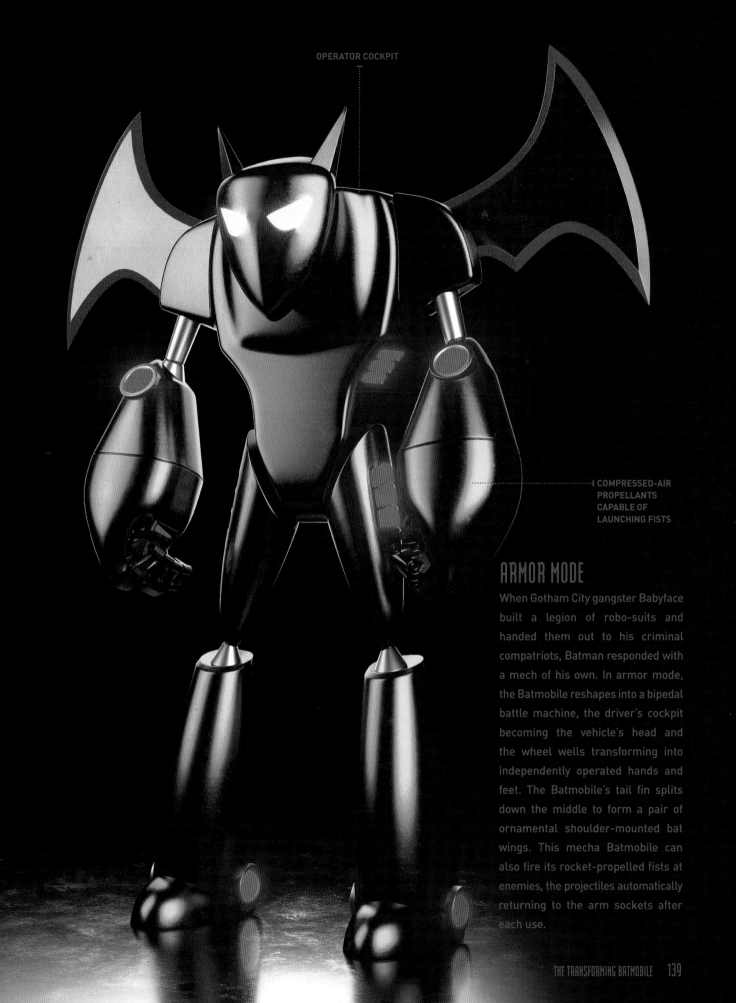

OPERATOR COCKPIT

I COMPRESSED-AIR
PROPELLANTS
CAPABLE OF
LAUNCHING FISTS

ARMOR MODE

When Gotham City gangster Babyface built a legion of robo-suits and handed them out to his criminal compatriots, Batman responded with a mech of his own. In armor mode, the Batmobile reshapes into a bipedal battle machine, the driver's cockpit becoming the vehicle's head and the wheel wells transforming into independently operated hands and feet. The Batmobile's tail fin splits down the middle to form a pair of ornamental shoulder-mounted bat wings. This mecha Batmobile can also fire its rocket-propelled fists at enemies, the projectiles automatically returning to the arm sockets after each use.

BAT-MANGA BATMOBILE

Batman is just one crime fighter existing alongside thousands of parallel-world duplicates, and Bat-Mite—a reality-warping imp from the Fifth Dimension—can view any one of these alternate existences on a whim. One universe, dubbed "Bat-Manga" by Bat-Mite, features a Batmobile similar in style to the Lincoln Futura existing in the "Batman 1966" reality. But in this world, Batman and Robin exist as Westernized anime characters whose adventures reflect the tropes of decades-old serialized Japanese animation. The Bat-Manga Batmobile features a bevy of gadgets including a smoke screen, forward-mounted lasers, rocket launchers, a radar jammer, and a flashing police beacon on the roof.

PRECISION CUTTING LASERS

HIGH-VISIBILITY POLICE BEACON

SMOKE SCREEN GENERATORS

RETRACTABLE ROCKET LAUNCHERS

THE ARKHAM BATMOBILE

—— Batman: Arkham Knight ——

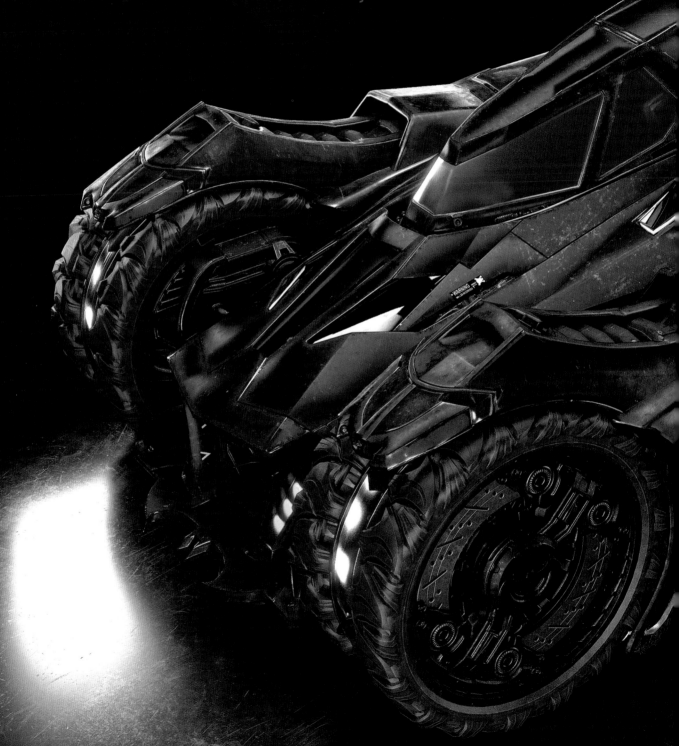

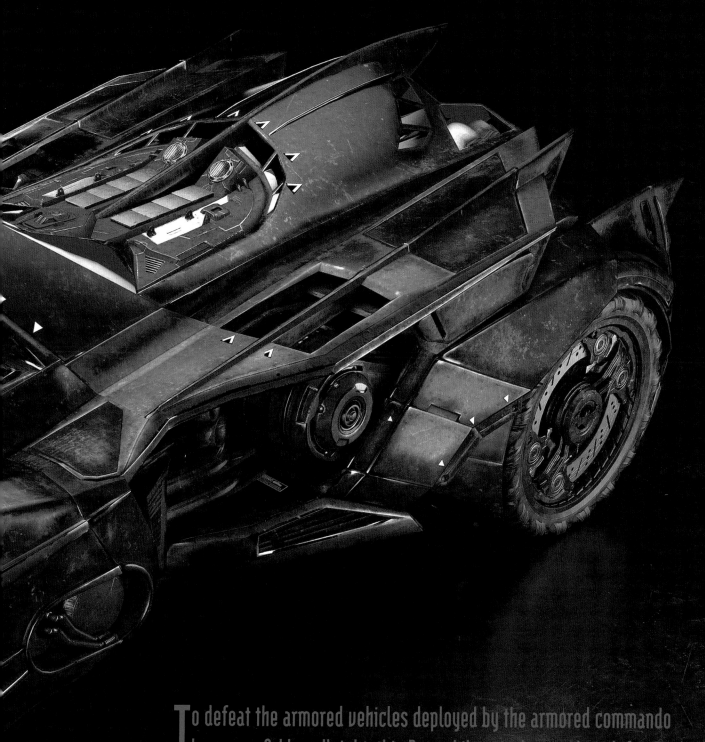

To defeat the armored vehicles deployed by the armored commando known as Arkham Knight, this Batmobile was designed to shift between a high-speed pursuit mode and a heavy-hitting battle mode. The Batmobile's arsenal is deployed to prevent Arkham Knight from dispersing a fear toxin that threatens to overwhelm Gotham City.

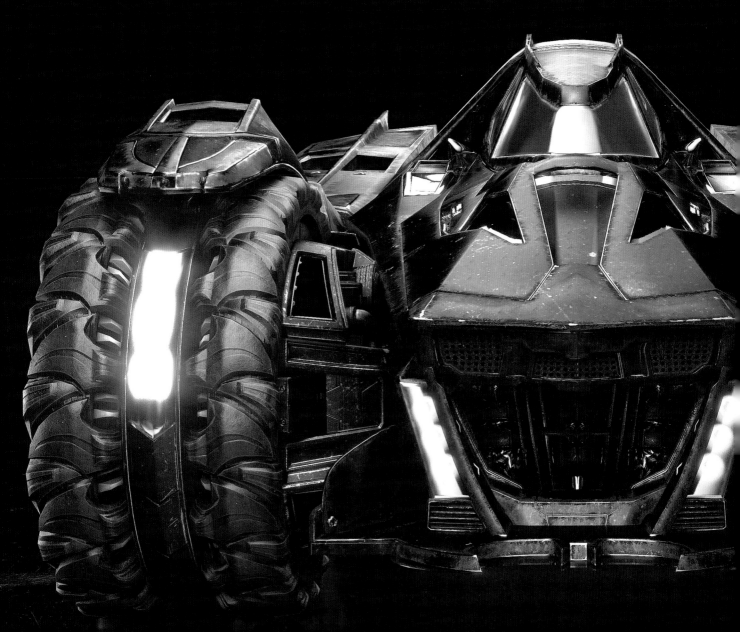

Gotham City suffered devastating set-backs after The Joker's takeover of Arkham Asylum and Hugo Strange's creation of the lawless no-man's-land "Arkham City." Batman needed a major upgrade to stem the tide, and so he unleashed an all-new Batmobile on the streets just in time to combat the rise of the enigmatic Arkham Knight.

"The vehicle's squared-off nose helped define its blunt silhouette, which eschewed pointed tail fins and other traditional bat motifs."

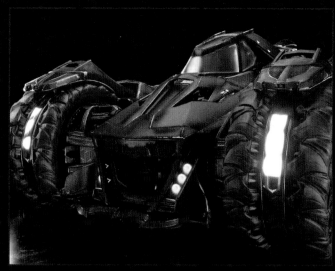

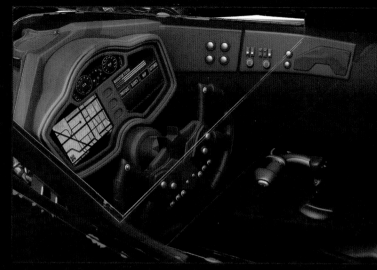

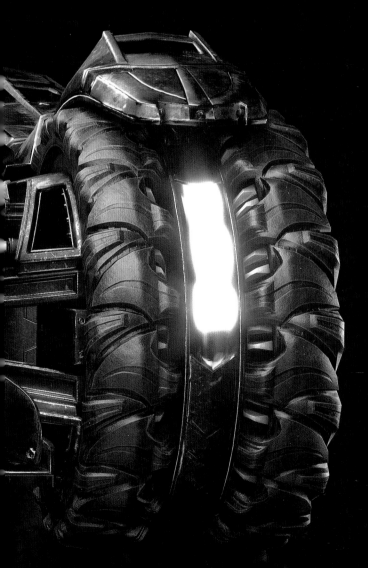

A bomb threat masterminded by the Arkham Knight and the Scarecrow led to the evacuation of the Gotham City boroughs of Bleake, Founders, and Miagani Island, including such nighttime hotspots as Chinatown. Batman—assisted by tech genius Oracle from her position in the Gotham City clock tower—steered the Batmobile into battle against the villains and the Arkham Knight's mechanized militia.

Constructed overseas at a facility operated by German manufacturer Zimmer Automobil-Maschinenbau, this all-new Batmobile was subsequently shipped to Wayne Enterprises and smuggled into the Batcave under the direction of chief engineer Lucius Fox.

This model emphasized rugged practicality over streamlined chrome. With a lifted suspension and two tires packed inside each wheel well, the Batmobile could cross any terrain, including parked cars and concrete police barricades. The vehicle's squared-off nose helped define its blunt silhouette, which eschewed pointed tail fins and other traditional bat motifs.

The Batmobile's integrated weapons platform and variable suspension allowed the vehicle to assume a formidable configuration dubbed "battle mode." Essentially an urban assault vehicle, it retained the Batmobile's bulletproof armor while deploying the firepower of a light tank.

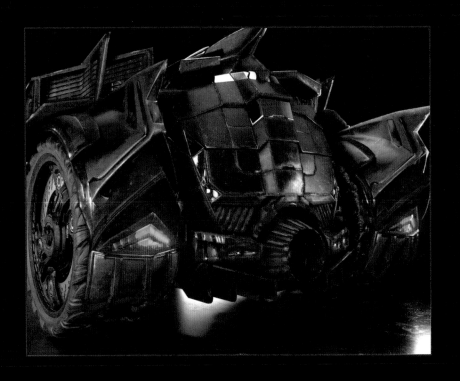

DRIVETRAIN AND WHEELS

The Batmobile's primary power cell was a revolutionary WayneTech hybrid engine capable of speeds exceeding 200 mph. A secondary jet turbine used an after-burner and a nitromethane fuel supply to achieve short bursts of acceleration for closing the gap on fleeing vehicles or vaulting across short gaps.

A kinetic energy recovery system allowed the Batmobile to recapture a portion of its expended energy by chan-neling the heat and friction of its braking systems into an auxiliary storage battery. This battery could be tapped on demand to power the Batmobile's onboard sys-tems and boost its operational range.

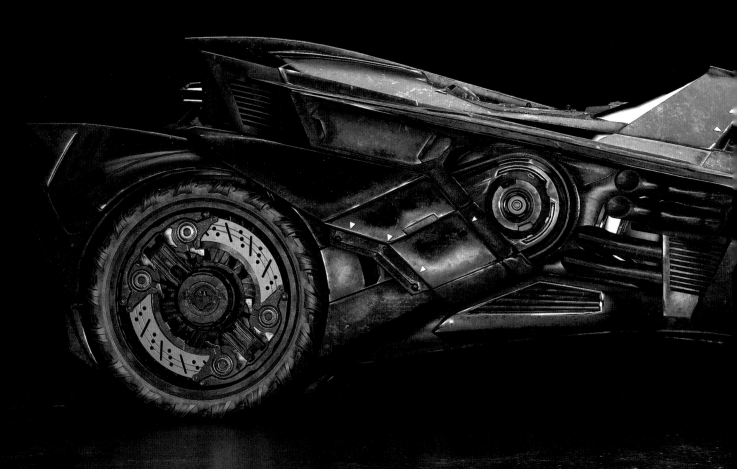

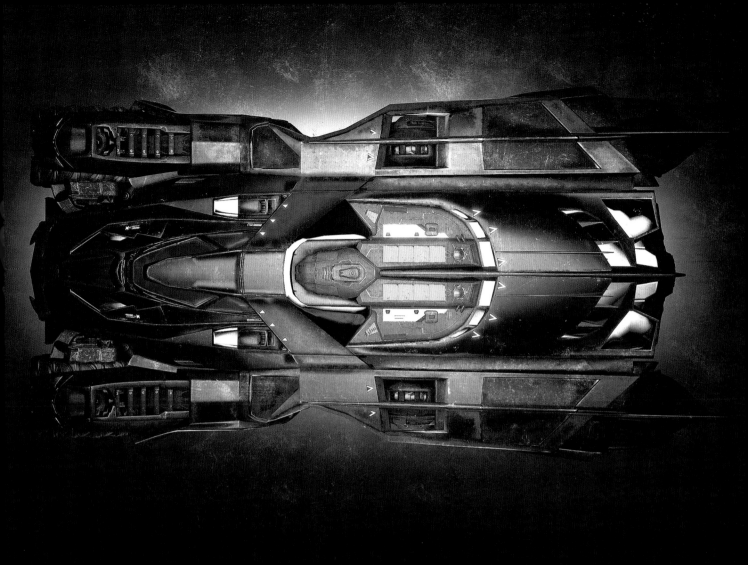

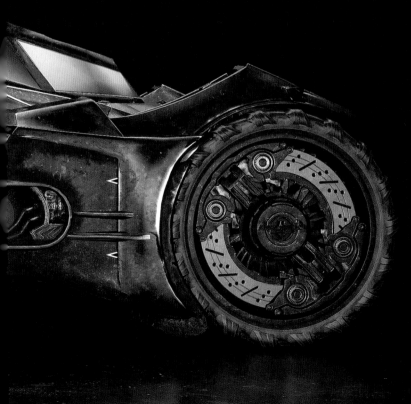

The Batmobile's continuously variable transmission allowed it to smoothly shift between gear ratios, maintaining optimal performance at varied speeds and under heavy load. Should Batman prefer manual control, he could switch the transmission into a seven-speed dual-clutch configuration. Because the Batmobile's transmission required phase-changing elastohydrodynamic fluid for lubrication, the connections had to be inspected frequently for leakage.

All eight tires were made of synthetic composite materials and embedded with all-terrain treads. A compressed-air braking system, similar to those used on semitrailers, was used to slow and stop the Batmobile given its weighted momentum. Gyroscopic pivots on each axle allowed each set of wheels to operate independently when the car switched over to battle mode, allowing for forward, backward, and side-to-side movements.

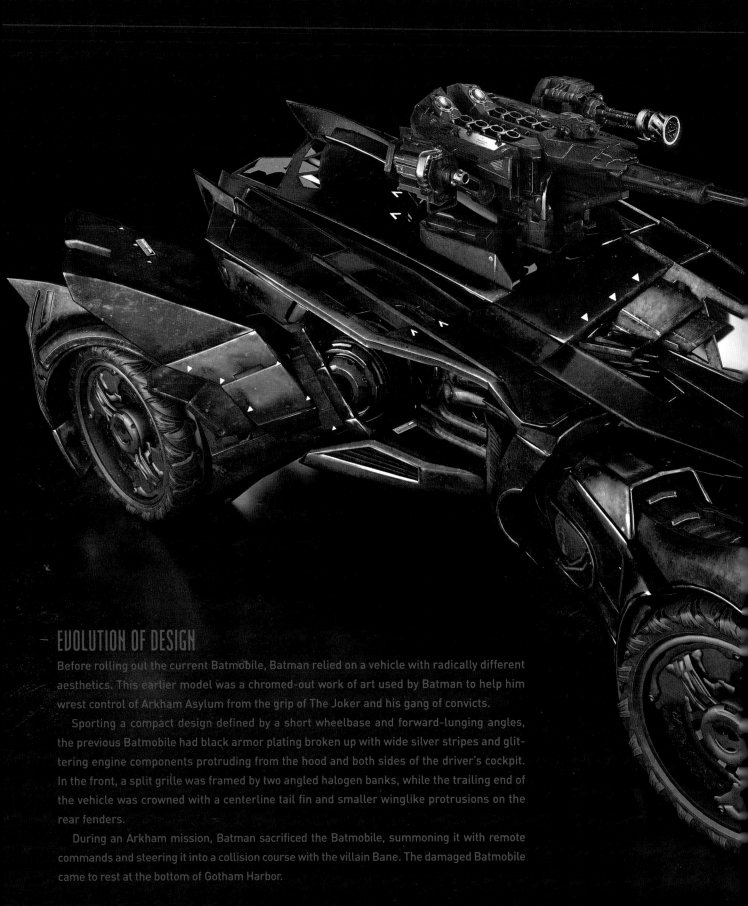

EVOLUTION OF DESIGN

Before rolling out the current Batmobile, Batman relied on a vehicle with radically different aesthetics. This earlier model was a chromed-out work of art used by Batman to help him wrest control of Arkham Asylum from the grip of The Joker and his gang of convicts.

Sporting a compact design defined by a short wheelbase and forward-lunging angles, the previous Batmobile had black armor plating broken up with wide silver stripes and glittering engine components protruding from the hood and both sides of the driver's cockpit. In the front, a split grille was framed by two angled halogen banks, while the trailing end of the vehicle was crowned with a centerline tail fin and smaller winglike protrusions on the rear fenders.

During an Arkham mission, Batman sacrificed the Batmobile, summoning it with remote commands and steering it into a collision course with the villain Bane. The damaged Batmobile came to rest at the bottom of Gotham Harbor.

TACTICAL TRANSFORMATION

When the Batmobile switched to battle mode, it activated a number of related frame reconfigurations including a wider wheelbase that creates a more stable footprint. To complete the transformation, an automated weapons turret rose from behind the cockpit and the rear suspension pushed skyward to create an elevated firing platform with boosted ground clearance. In battle mode, the Batmobile's external LED illuminators changed from blue to red.

For increased maneuverability, in battle mode the Batmobile's wheels shifted to individual articulation, which allowed for precision maneuvering along forward, backward, and sideways ranges of motion. This enabled Batman to sidestep vehicular attacks or to circle a target while firing at it with the overhead cannon.

The Batmobile's weapons turret was equipped with a trifecta of options for dealing with heavy tanks, aerial drones, or gangs: The machine gun, explosive cannon, and nonlethal riot suppressor all saw action against the Arkham Knight's paramilitary armies.

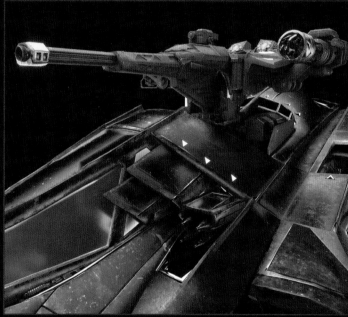

SPECS AND FEATURES
"BATTLE MODE" TURRET

- 25mm hypervelocity rotary cannon with anti-air tracking software

- 60mm direct-fire cannon equipped with anti-tank explosive shells

- Riot suppressor loaded with nonlethal slam rounds (rubber pellets packed into flexible plastic casings)

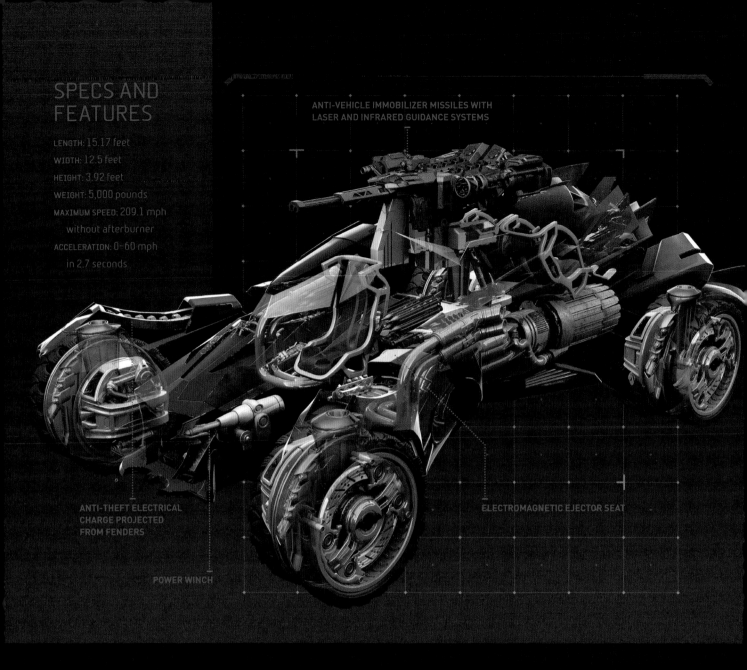

ANTI-VEHICLE IMMOBILIZER MISSILES WITH
LASER AND INFRARED GUIDANCE SYSTEMS

SPECS AND FEATURES

LENGTH: 15.17 feet

WIDTH: 12.5 feet

HEIGHT: 3.92 feet

WEIGHT: 5,000 pounds

MAXIMUM SPEED: 209.1 mph
 without afterburner

ACCELERATION: 0–60 mph
 in 2.7 seconds

ANTI-THEFT ELECTRICAL
CHARGE PROJECTED
FROM FENDERS

ELECTROMAGNETIC EJECTOR SEAT

POWER WINCH

DEFENSE AND WEAPONS SYSTEMS

The Batmobile benefited from two-way technological support, with Oracle allowed unrestricted access to the vehicle's data feeds, onboard systems, and navigational controls. On Oracle's suggestion, Batman equipped the Batmobile with enhanced sensors for performing reconnaissance sweeps, as well as an artificial intelligence (AI) node capable of city-grid pathfinding and identifying and neutralizing threats.

The Batmobile's carbon nanotube armor resisted direct impact without warping or shattering. Reactive armor surrounded the driver's cockpit and could explode outward if struck by a sufficiently high-velocity projectile in order to minimize the kinetic damage, requiring the installation of

replacement panels during downtime. The boxy contours of the Batmobile helped scatter electromagnetic signals, reducing its footprint under thermal and radar scans.

The driver's ejection seat wasn't just for emergencies: It used a resetting electromagnetic charge to propel Batman hundreds of feet in the air, enabling him to reshape his cape's memory cloth into a glider and steer himself to a soft touchdown on a nearby roof or balcony. Batman relied on this ability to reach out-of-the-way targets or to surprise groups of enemies.

When the Batmobile was in its default "pursuit" mode, Batman could still activate several weapons, including a

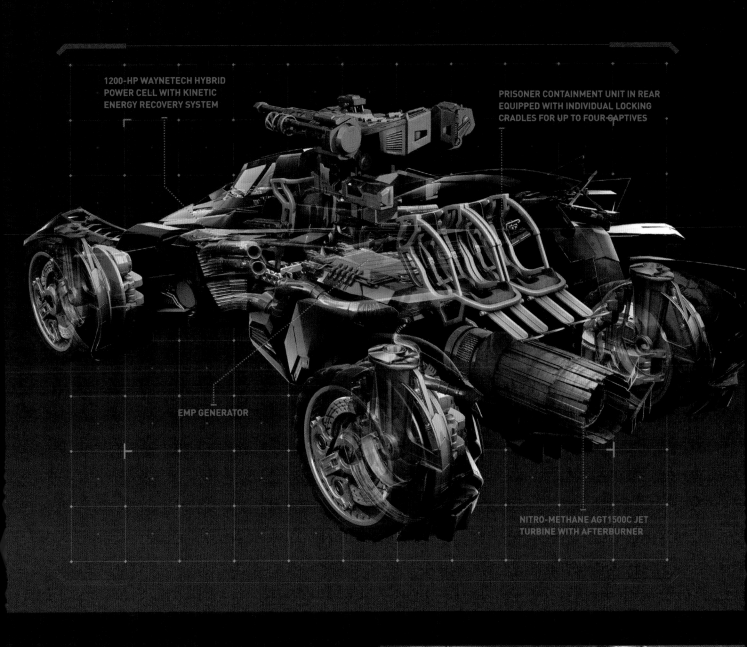

1200-HP WAYNETECH HYBRID POWER CELL WITH KINETIC ENERGY RECOVERY SYSTEM

PRISONER CONTAINMENT UNIT IN REAR EQUIPPED WITH INDIVIDUAL LOCKING CRADLES FOR UP TO FOUR CAPTIVES

EMP GENERATOR

NITRO-METHANE AGT1500C JET TURBINE WITH AFTERBURNER

bank of immobilizer missiles (calibrated for disabling street vehicles) and an EMP generator that scrambled the signals of hovering drones. Conductor rods concealed in the front and rear fenders could stun nearby attackers with an electrical charge of 300,000 volts.

Additional features installed on the vehicle included a nose-mounted power winch that could latch onto other cars or help tow the Batmobile out of a gulch. At the rear of the car, the Batmobile was fitted with a dedicated lock-up chamber, perfect for transporting captured criminals to GCPD headquarters.

FULL VERTICAL TAKEOFF AND LANDING
CAPABILITY, NO RUNWAY REQUIRED

PILOT EJECTION MECHANISM

MULTI-SPECTRAL
SENSOR ARRAYS

BOTTOM HATCH FOR DEPLOYMENT
OF EQUIPMENT PODS

COCKPIT CONTROL SYSTEMS ENABLING REMOTE
PILOTING AND FULLY AUTONOMOUS FLIGHT

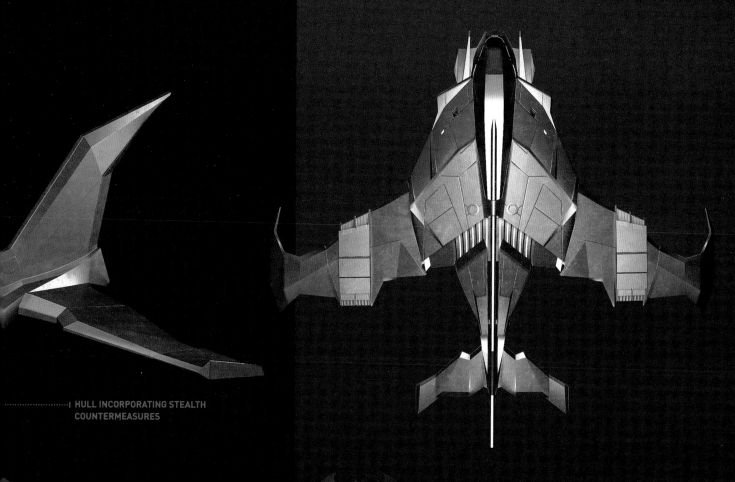

|---I HULL INCORPORATING STEALTH
COUNTERMEASURES

JET ENGINE CAPABLE OF SUPERSONIC
SPEEDS IN EXCESS OF MACH 2

DRONE BATWING

This Batwing entered service as a Wayne Aerospace stealth craft before undergoing refitting as a fast-moving hauler with remote-piloting capabilities. Batman is able to pilot the Batwing from the cockpit, but the aircraft is more commonly used as a remote drone for making precision supply drops.

In silhouette, the Batwing resembles an elongated tube flanked by winged prongs. A pair of vectored thrusters can be angled to provide horizontal thrust or vertical hovering, while a cluster of spotlights projects bright white beams into the night sky as it flies.

Batman uses a miniaturized gadget on his utility belt to remote-steer the Batwing or directs others (such as Oracle or Alfred Pennyworth) to fly it on his behalf. The Batwing can also operate using independent AI guidance. When making a drop, the craft lowers a hatch on its underbelly and fires an airtight pod containing supplies to the ground below—everything from grapnel guns to an upgraded Batsuit.

THE LEGENDARY BATMOBILES

Batman and *Detective Comics*, 1940s and Beyond

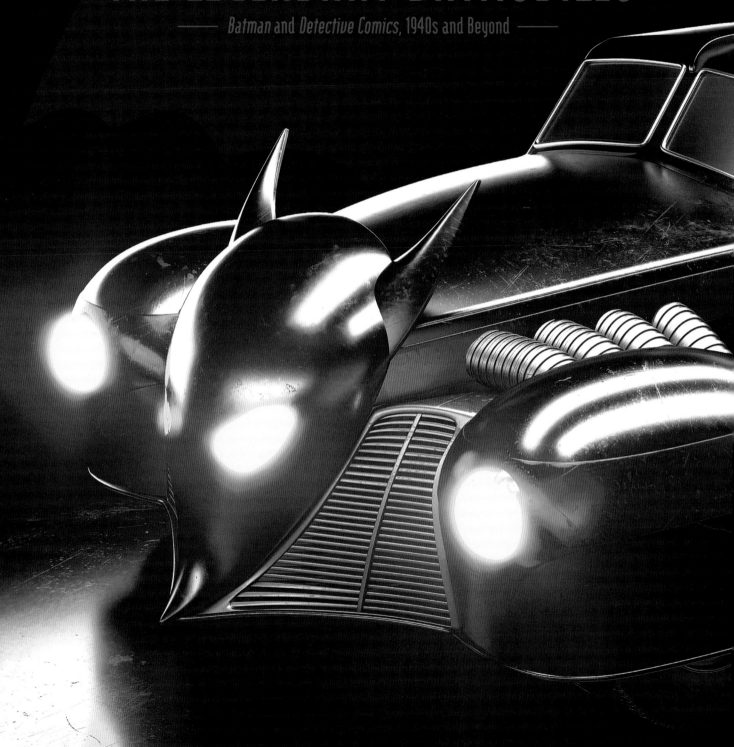

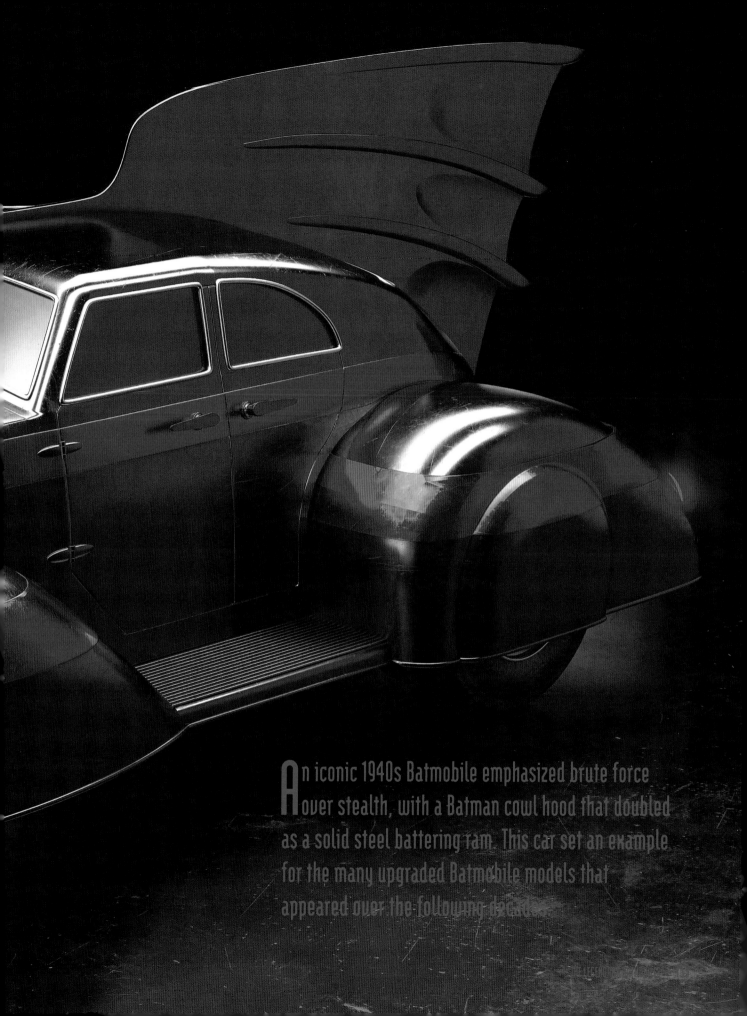

An iconic 1940s Batmobile emphasized brute force over stealth, with a Batman cowl hood that doubled as a solid steel battering ram. This car set an example for the many upgraded Batmobile models that appeared over the following decades.

etting his start before the onset of the Second World War, the Batman who created this seminal Batmobile set an example for generations of costumed heroes. The car played a critical role in his approach to crime-fighting throughout many subsequent evolutions in vehicle design.

But it was not the very first of its kind. The first car to be called the Batmobile was a crimson-painted open-air coupe, with a heavy steel body hammered into streamlined, forward-angled shapes that telegraphed its capacity for

speed. Headlight-capped front fenders flanked a silver grille and a jutting, ship-like nose that was topped with a small hood ornament shaped like a bat.

This early design didn't last long. Batman soon recast the Batmobile into something more suitable for a nocturnal vigilante, with a black paint job and an enormous, bat-wing tail fin. In the front, a glowing-eyed Batman mask loomed over the grille and did double duty as a battering ram.

The Cord 812, an American luxury coupe manufactured in

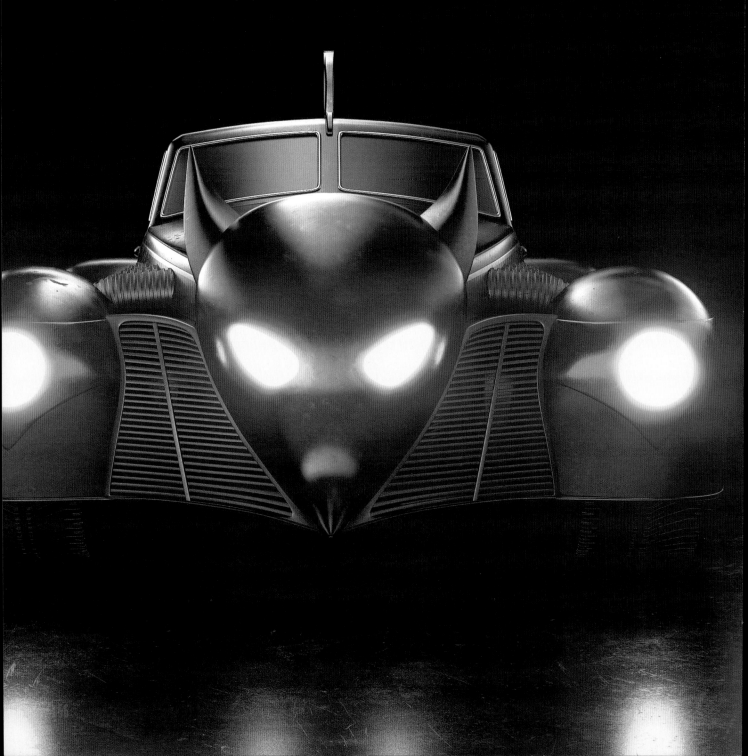

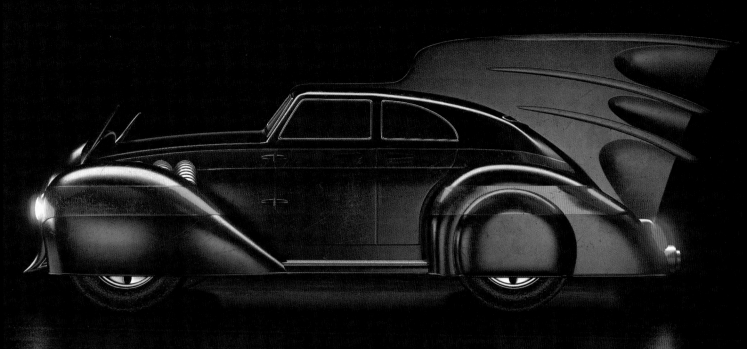

"Painted with multiple coats of a rich blue-black hue, the Batmobile's exterior was defined by art deco curves and small ovoid windows."

1936 and 1937, served as the inspiration for the framework of the battering-ram Batmobile. Batman valued the Cord for its technological innovations, which included front-wheel drive, a semi-automatic transmission with overdrive, and retractable headlights.

Batman hid the louvered grille and protruding "coffin nose" behind the three-dimensional bodywork that mimicked the shape of the crime fighter's distinctive eared cowl. The pontoon fenders remained, as well as the hand-cranked headlights, which were supplemented with glowing inserts in the sides of the grille and in the narrow eye slits on the front end of the vehicle.

Painted with multiple coats of a rich blue-black hue, the Batmobile's exterior was defined by art deco curves and small ovoid windows, contributing to the uncanny feeling that the vehicle was a living thing.

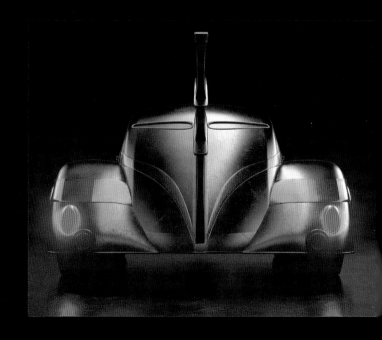

SPECS AND FEATURES

LENGTH: 16.33 feet

WIDTH: 5.92 feet

HEIGHT: 4.83 feet

MAXIMUM SPEED: 190 mph

ACCELERATION: 0–60 mph in
10.5 seconds

ENGINE: Supercharged V-8
200 hp

I REAR TAIL FIN ACTS AS
STABILIZER AT HIGH SPEEDS

SECRET COMPARTMENTS
FOR STASHING EMERGENCY
EQUIPMENT AND
SPARE CLOTHING

STEEL-ARMORED EXTERIOR I

RETRACTABLE HIGH-BEAM HEADLIGHTS

DEFENSE AND WEAPONS SYSTEMS

The battering ram employed by this early Batmobile relied on the solid steel pointed-ear cowl welded directly to the nose. Under full acceleration, the Batmobile could smash through doors to take the fight to the hoodlums inside their hideouts. The vehicle's steel frame and armored fender skirts were able to shrug off concentrated fire from tommy guns during shootouts.

I SEMI-AUTOMATIC FOUR-SPEED TRANSMISSION

GRILLE-MOUNTED BATTERING RAM SHAPED LIKE BATMAN'S COWL

DRIVETRAIN AND WHEELS

This particular Batmobile packed a 1937 V8 engine under its hood. Its Schwitzer-Cummins supercharger used a mechanical air compressor to increase oxygen flow and boost the engine's power output. Chrome-skinned exhaust pipes snaked out from the Batmobile's hood, which was vulnerable to gunfire. The pipes required careful inspection during downtime to ensure that they had not been perforated by bullets.

The Batmobile's low-slung body hugged the road and its setback engine was shifted rearward, closer to other heavy components like the axle and fuel tank. This configuration provided more grip to the rear wheels while allowing space for the battering ram's shock-absorbing pistons, which were installed directly behind the vehicle's nose.

THE BATMOBILE IMPERATIVE

At the time of Batman's debut in the late 1930s, American cars were completing their decades-long transformation from undependable jalopies to multi-ton road masters forged from Detroit steel. The evolution proved to be ideal for a crime fighter who lacked superpowers and needed a speedy armored ride to race to the scene of the crime.

The Batmobile was a necessity, and the fast pace of automotive development meant that each Batmobile had an operational life of only a few years before it was retired in favor of an upgraded model. The open-air coupe seen here was Batman's very first Batmobile.

BAT-SYMBOL ORNAMENT

SHIP-LIKE NOSE

160

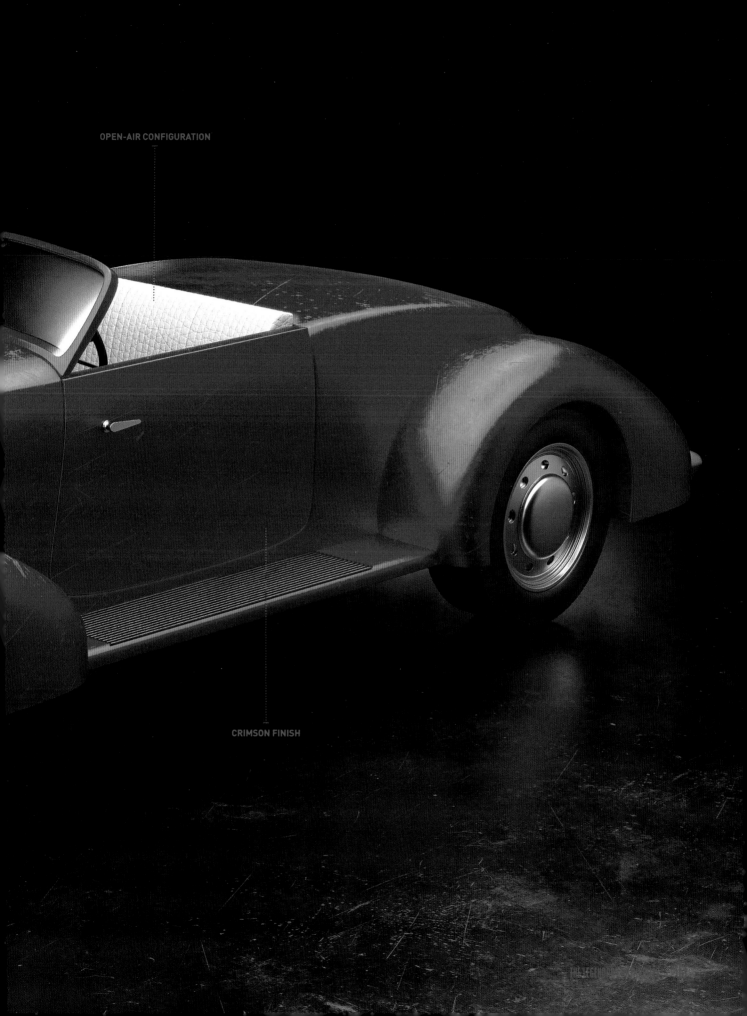

OPEN-AIR CONFIGURATION

CRIMSON FINISH

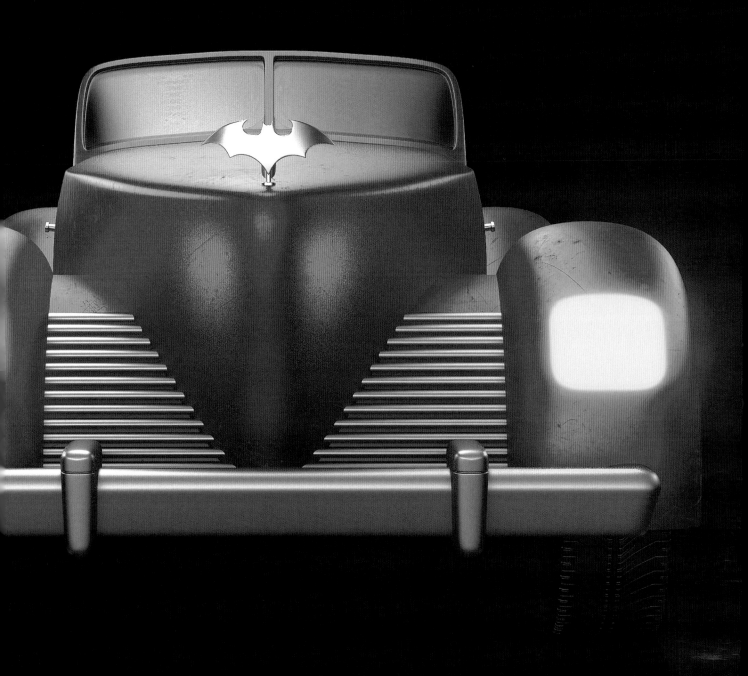

"With the constant infusion of new technologies, the archetypal 1940 Batmobile was eventually supplanted by more advanced models."

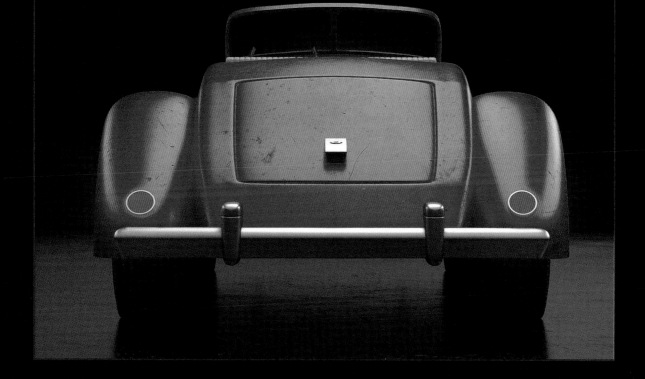

During the Second World War, the Allied military forces made tremendous strides in rocketry, bullet-resistant plastics, and automated manufacturing. Batman was among the first beneficiaries of these breakthroughs, incorporating experimental tech into his Batmobiles that elevated his vehicle's capabilities far beyond those of civilian autos.

Despite the changes, all Batmobiles shared bat-like embellishments, leaving onlookers with no doubt that Gotham City's hero was on the case.

With the constant infusion of new technologies, the archetypal 1940 Batmobile was eventually supplanted by more advanced models.

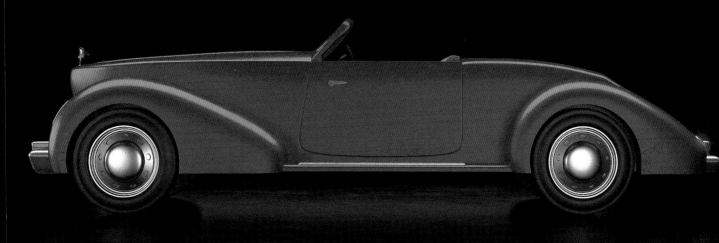

THE BURNISHED BATMOBILE

By 1954, the Batmobile had achieved streamlined perfection. This model was a compact, two-person prowler, with every inch of space outside the cockpit dedicated to housing the engine plus the coolant, electrical, steering, braking, and exhaust systems. This car's distinctive bubble-dome windshield—topped with a spotlight—gave Batman and Robin increased visibility. Later upgrades included parachutes for emergency braking and hydrofoil struts for skimming above the water at high speeds.

SPOTLIGHT

BUBBLE-DOME WINDSHILED

COWL BATTERING RAM

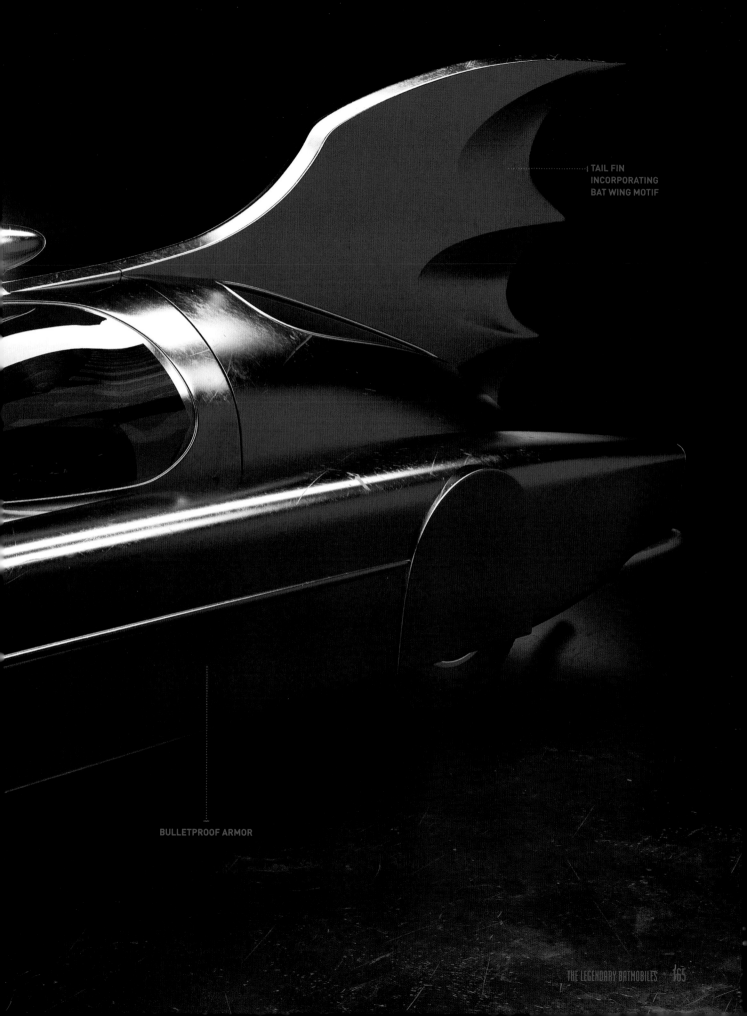

| TAIL FIN
INCORPORATING
BAT WING MOTIF

BULLETPROOF ARMOR

"This car's distinctive bubble-dome windshield—topped with a spotlight—gave Batman and Robin 360-degree visibility."

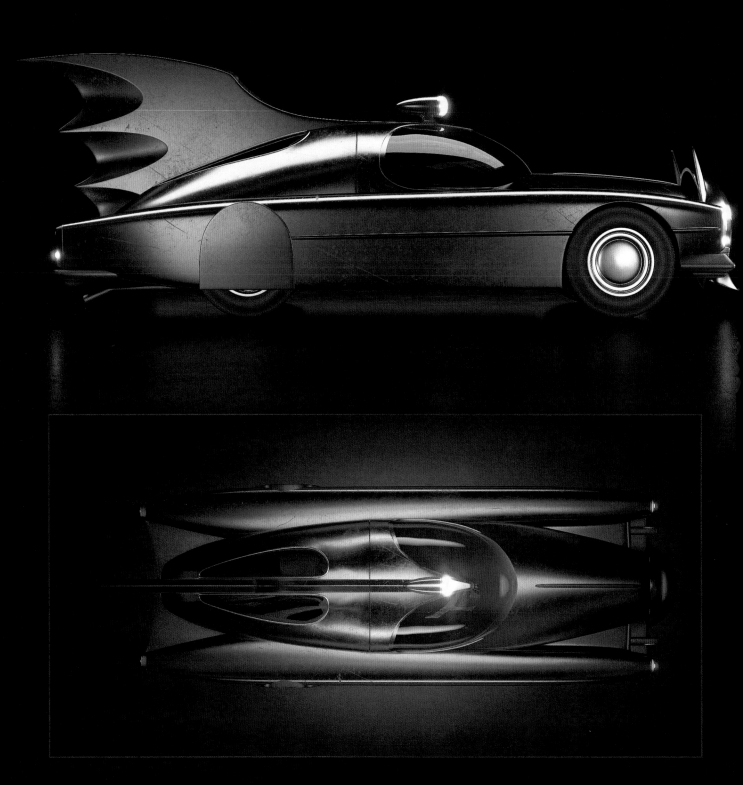

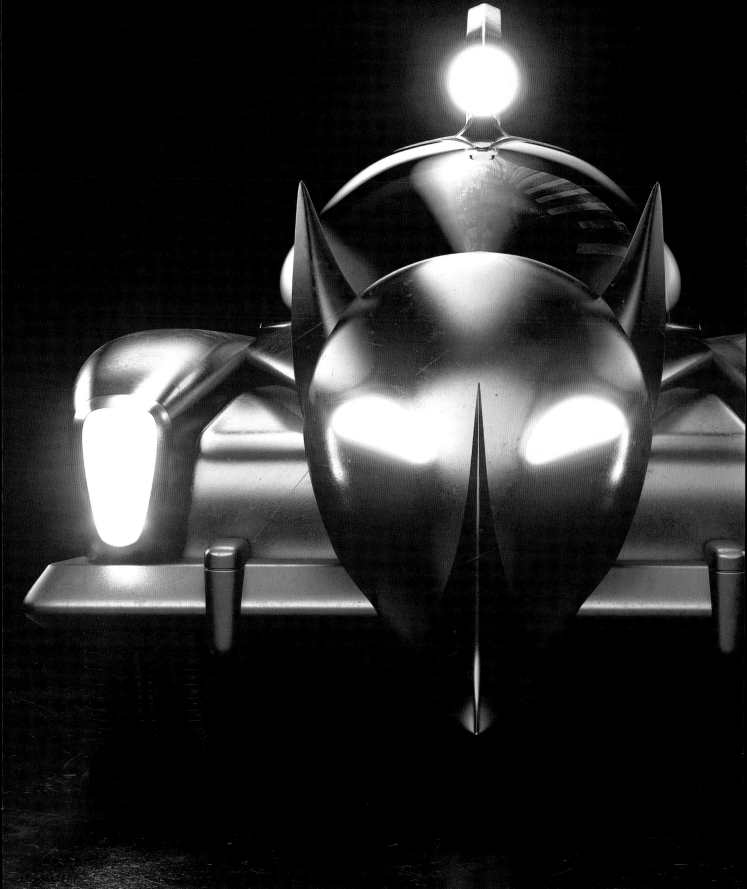

THE NIMBLE BATMOBILE

This Batmobile from the 1970s was a two-seater painted light blue, with the black outline of Batman's cowl silhouetted on its hood. On the dashboard, an anti-theft deterrent disguised as a radio required the driver to input the passcode BATMAN before the ignition could be activated.

PASSCODE-PROTECTED
ANTI-THEFT SYSTEM

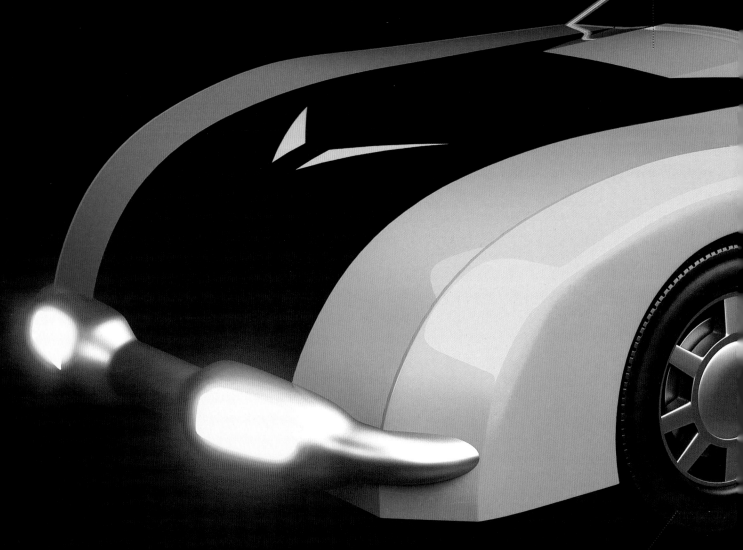

PUNCTURE-PROOF TIRES

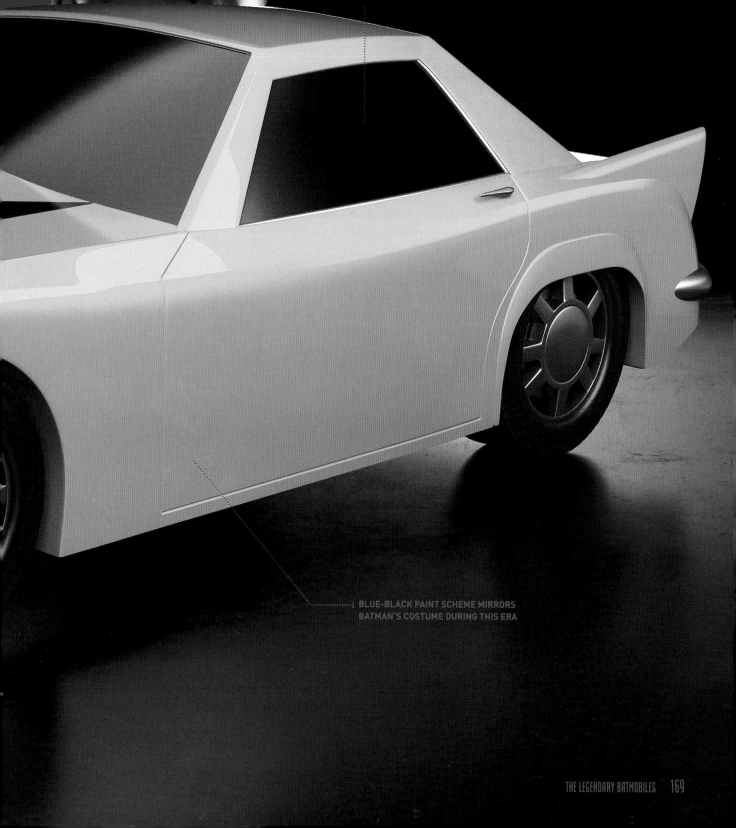

BLUE-BLACK PAINT SCHEME MIRRORS
BATMAN'S COSTUME DURING THIS ERA

THE SPORTY BATMOBILE

During the 1980s, Batman drove a sporty convertible version of the Batmobile with a canopy of bulletproof glass that could be deployed to cover the driver's cockpit if needed. The compact dimensions of this vehicle allowed it to be concealed inside the breakaway shell of a high-end luxury vehicle. In this way, billionaire socialite Bruce Wayne could hit the scene in his luxury car and quickly deploy the Batmobile without needing to return to the Batcave.

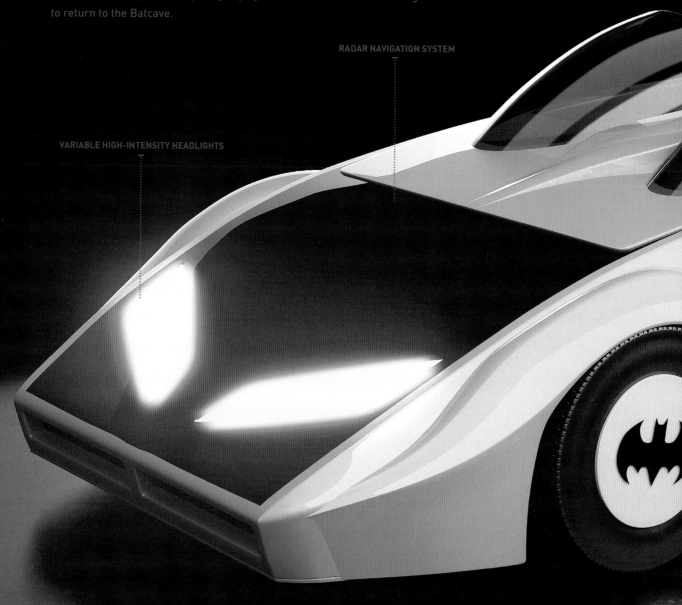

RADAR NAVIGATION SYSTEM

VARIABLE HIGH-INTENSITY HEADLIGHTS

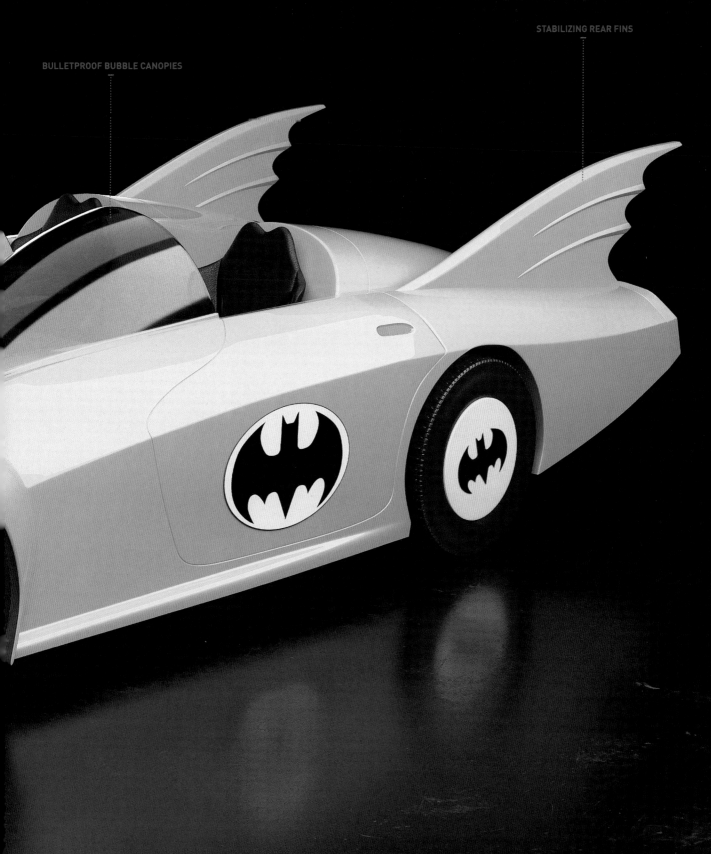

BULLETPROOF BUBBLE CANOPIES

STABILIZING REAR FINS

THE VISIONARY BATMOBILE

By the 1990s, Batman had switched to a wide-set, road-hugging Batmobile with protruding fenders, a glass-topped cockpit, and a split fantail in the rear. An angled nose and headlight "eye slits" gave the vehicle its distinctive face. Fully bulletproof and fire resistant, the Batmobile relied on flaming jet propulsion and was painted with yellow highlights, including bat-symbols on both sides.

AGGRESSIVE SILHOUETTE

ELECTROMAGNETIC SCANNERS

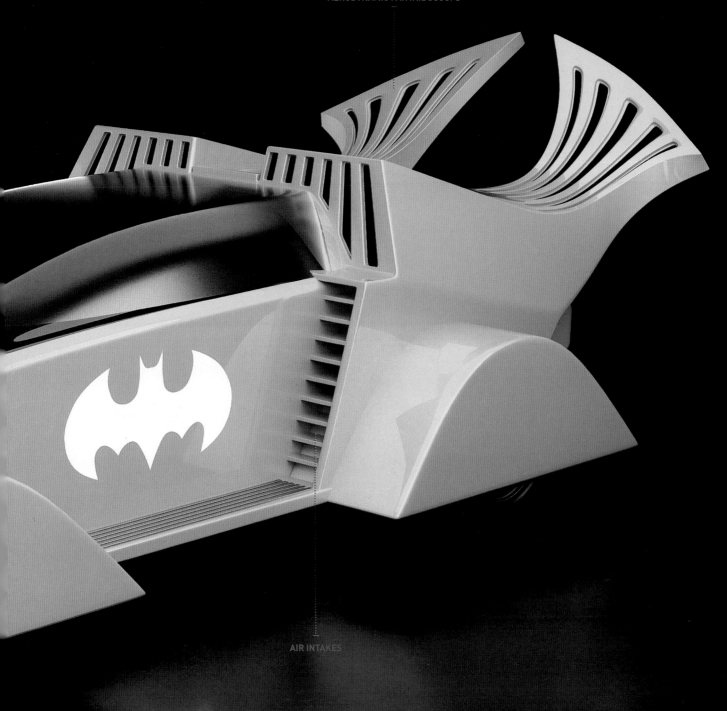

AERODYNAMIC FANTAIL SCOOPS

AIR INTAKES

THE BARBED BATMOBILE

After the turn of the millennium, the Batmobile returned to classic form with a jet-black model that had spiked tailfins and sported a jagged pattern on its hood. Other distinctive features included a slatted grille and bat-symbols on the armored hubcaps. From her Watchtower in downtown Gotham City, Batman's ally Oracle could interface with this Batmobile's computer and remote-steer the vehicle to perform pickups and investigations.

**AUTOPILOT LINKED TO
ORACLE'S WATCHTOWER**

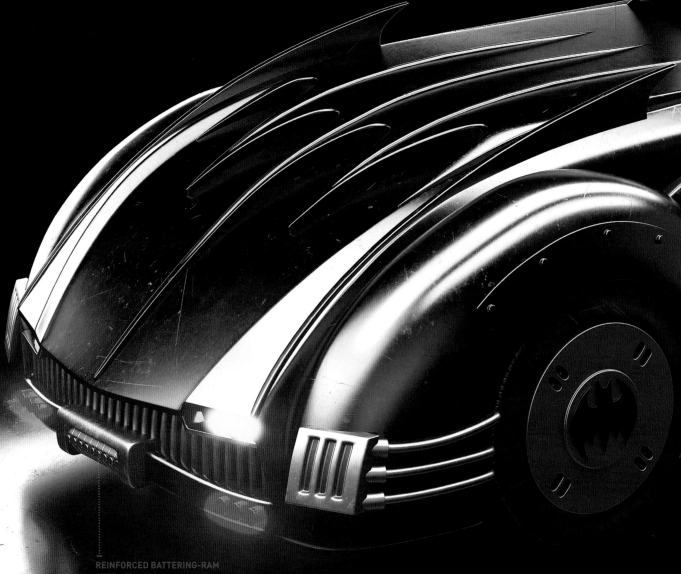

**REINFORCED BATTERING-RAM
STEEL FRAMES**

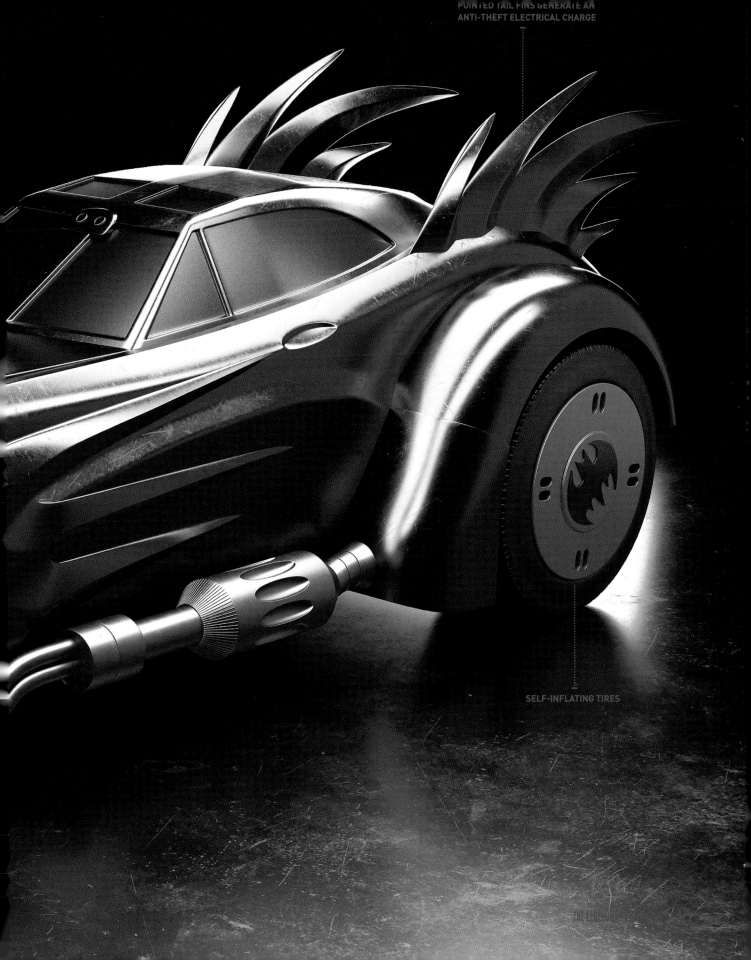

POINTED TAIL FINS GENERATE AN
ANTI-THEFT ELECTRICAL CHARGE

SELF-INFLATING TIRES

"After the turn of the millennium, the Batmobile returned to classic form with a jet-black model that had spiked tailfins and sported a jagged pattern on its hood."

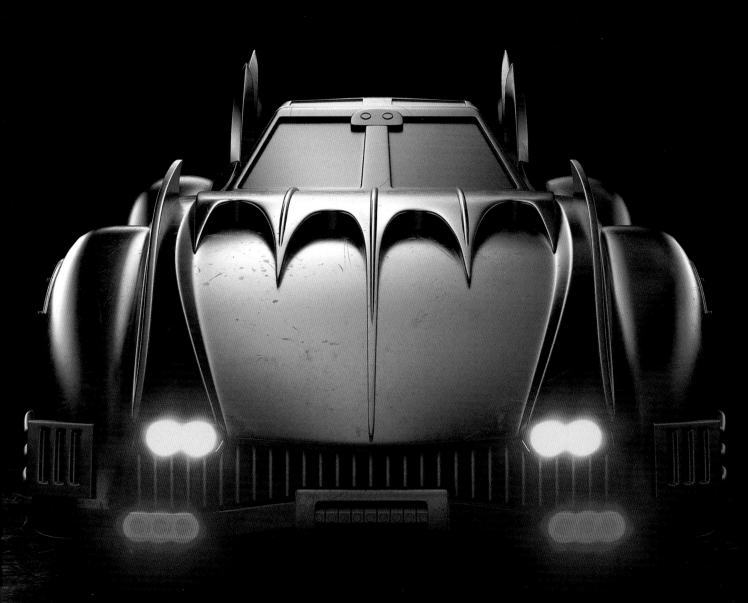

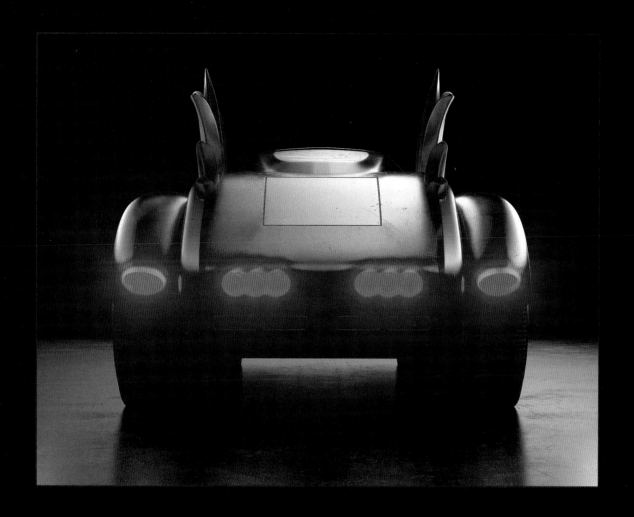

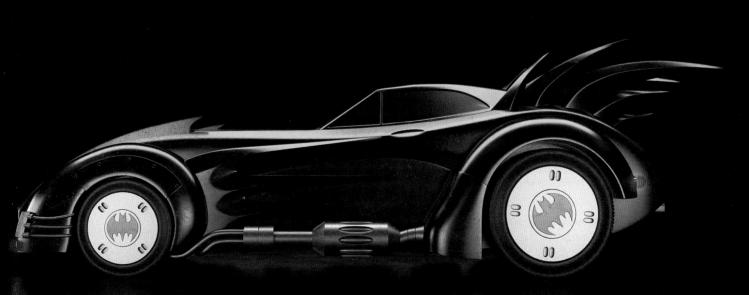

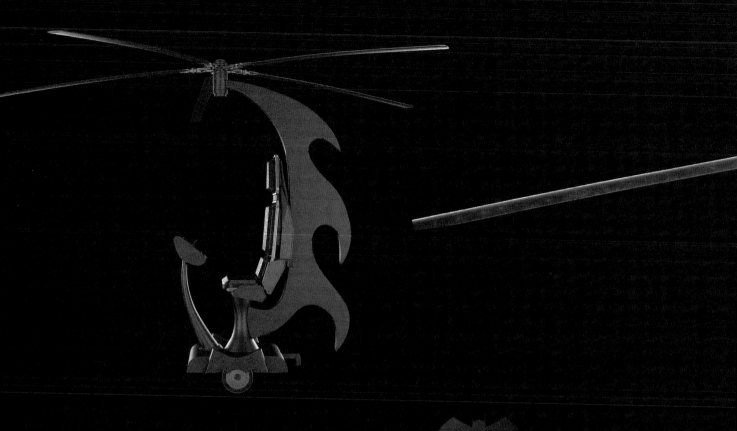

WHIRLY-BAT

The Whirly-Bat was Batman's early attempt at creating an airborne vehicle and served as the prototype for the Batcopter and Batwing to come. Lightweight and lacking armor, the Whirly-Bat used an angled rotor to provide lift and lateral propulsion. The midnight-black framework connecting the rotor to the pilot's chair was sculpted with pointed wing tips.

The first incarnation of the Whirly-Bat emphasized nimble aerial performance and did not carry weapons or equipment. Later versions incorporated grappling hooks, smoke bombs, and guided missiles. With its foldable rotor and collapsible framework, the Whirly-Bat could even be loaded into the Batmobile, ready to be sent into action at a moment's notice.

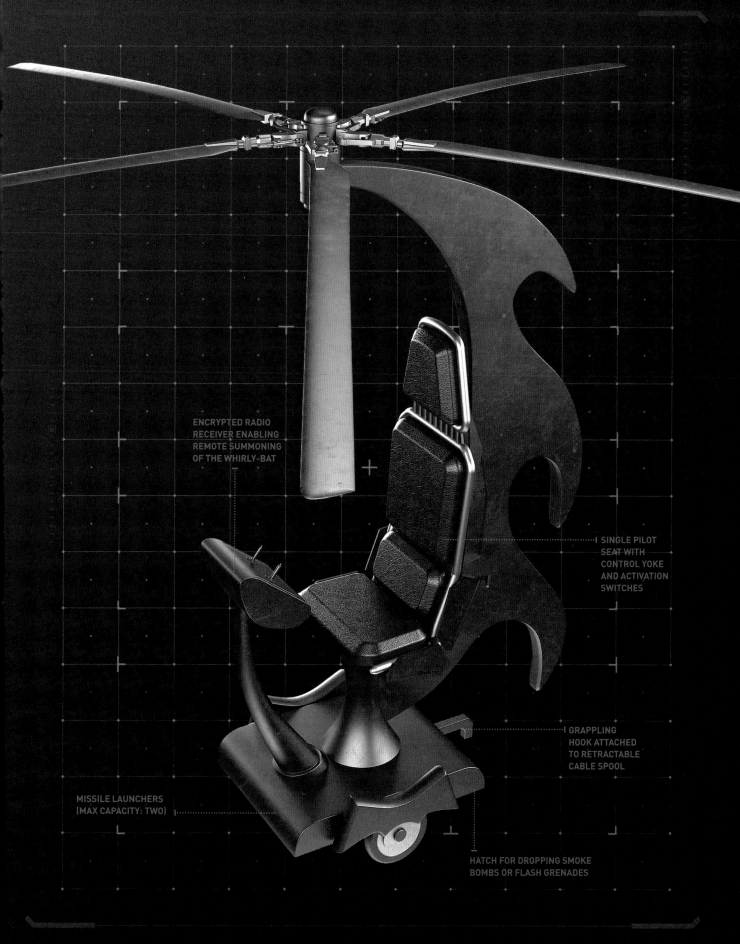

ENCRYPTED RADIO
RECEIVER ENABLING
REMOTE SUMMONING
OF THE WHIRLY-BAT

SINGLE PILOT
SEAT WITH
CONTROL YOKE
AND ACTIVATION
SWITCHES

GRAPPLING
HOOK ATTACHED
TO RETRACTABLE
CABLE SPOOL

MISSILE LAUNCHERS
(MAX CAPACITY: TWO)

HATCH FOR DROPPING SMOKE
BOMBS OR FLASH GRENADES

THE ARMAGEDDON BATMOBILE

Batman: The Dark Knight Returns

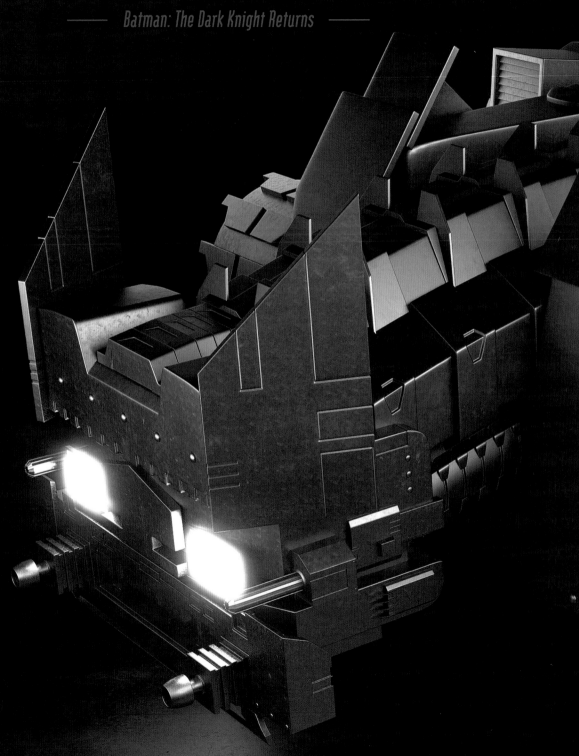

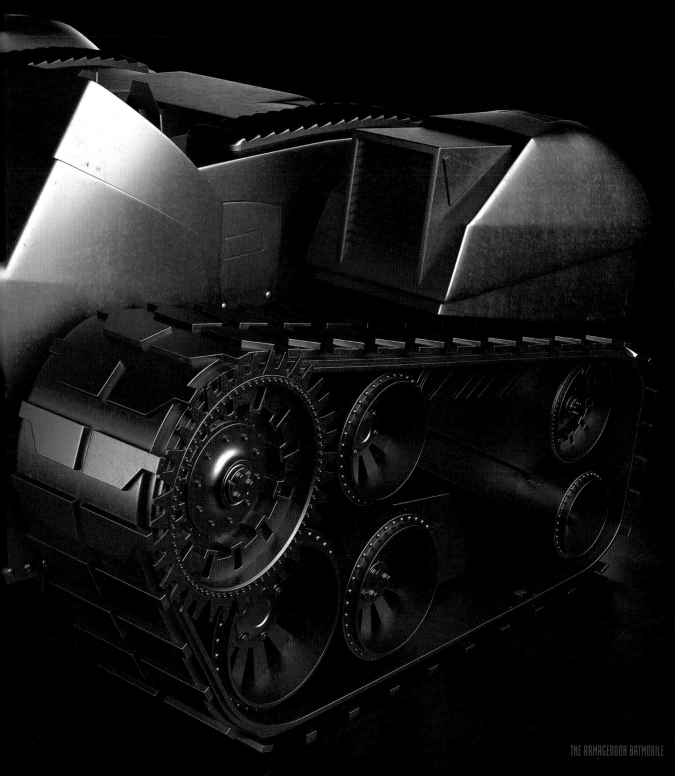

A Batmobile that rules the streets through intimidation. Only a weapon of this power could quell the destruction unleashed by the Mutant Gang in a dystopian Gotham City of the future.

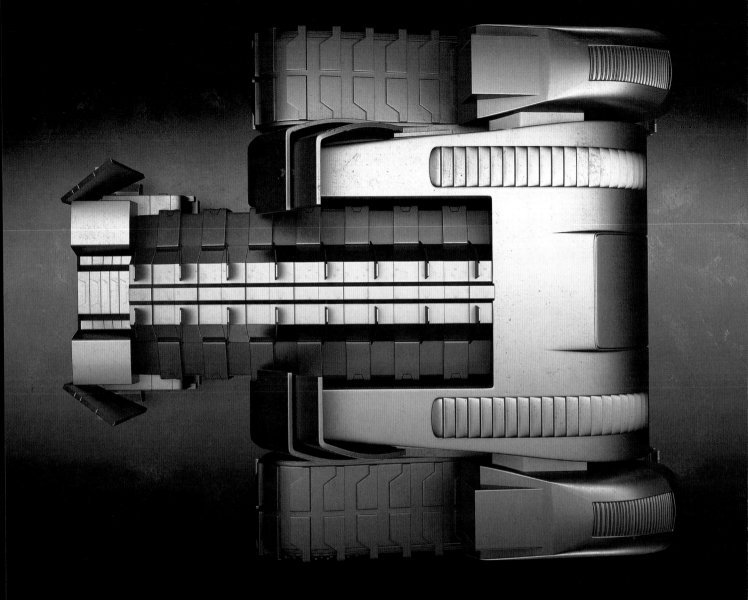

After the government outlawed costumed vigilantes, an aging Batman faced a world that no longer seemed to need him. But when the violence plaguing Gotham City became more severe than ever, Batman re-emerged to establish order with a militarized arsenal and a Batmobile resembling an armored tank. With an anarchic street gang known as the Mutants on the rampage, the new Batmobile packed enough firepower to restore the peace.

All prior Batmobiles were designed and constructed around standard vehicle chassis, but this mold-breaking model is patterned after a treaded military combat vehicle.

This land-crawling behemoth exemplifies the most extreme qualities of gritty utilitarianism and armed militarism, with an onboard arsenal of antipersonnel weaponry. But even a focus on firepower over flair didn't prevent Batman from imbuing this Batmobile with a few thematic flourishes, including sharp metal prongs welded to the sides of the cockpit that resemble the pricked-up ears of an echolocating bat.

In all other ways, however, this Batmobile is intentionally inelegant. Its muted color scheme is calibrated to blend in with Gotham City's omnipresent mud and grime, while its armored shell is devoid of glowing lights and elegant curves.

"This land-crawling behemoth exemplifies the most extreme qualities of gritty utilitarianism and armed militarism, with an onboard arsenal of antipersonnel weaponry."

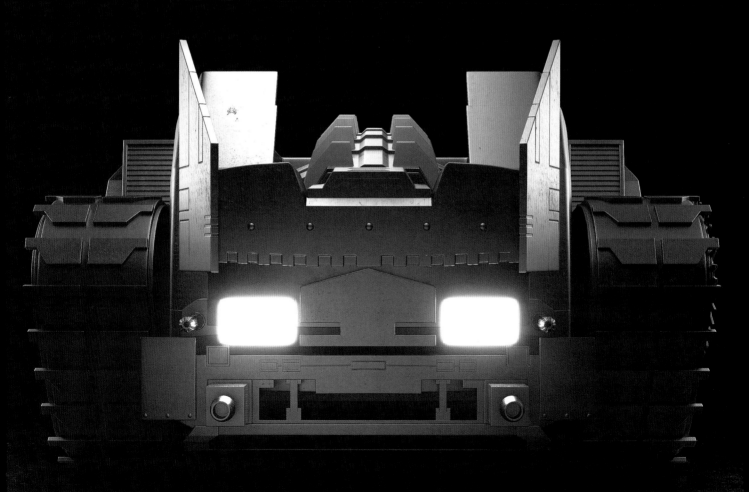

DRIVETRAIN AND WHEELS

The Batmobile packs a powerful military -grade engine with enough force to traverse the treacherous wastes of Gotham City. An engine of this size would normally be serviced by a throng of tank technicians, but to uphold operational security Batman can rely only on himself and Alfred Pennyworth to maintain the vehicle—with help from the remote-controlled robotic arms installed in the Batcave's garage.

"An engine of this size would normally be serviced by a throng of tank technicians, but to uphold operational security, Batman can rely only on himself and Alfred Pennyworth to maintain the vehicle."

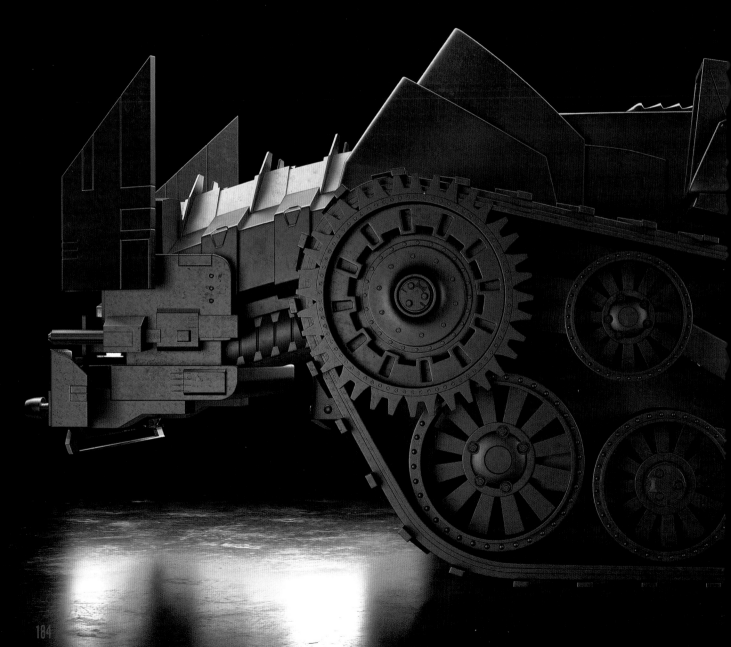

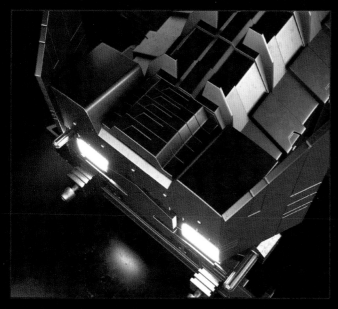

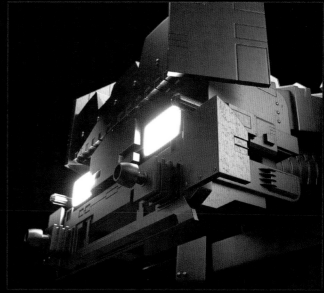

DEFENSE AND WEAPONS SYSTEMS

The Batmobile's armor plating features rounded contours and overlapping edges produced through custom manufacturing. This eliminates structural weaknesses like seam welding, which can be breached by precision attacks.

The interior of the Batmobile is accessed via a sealed top hatch, though Batman can also exit through a secret panel in the underbelly located between the two tank treads. High-beam spotlights on the front and rear of the vehicle can be used to inspect the environment or for temporarily blinding throngs of enemies.

A pair of missile launchers jut out from beneath the Batmobile's chin, while nonlethal antipersonnel repeating guns are mounted just in front of the tank treads. Flame jets installed on the undercarriage can project fire out to a range of up to 65 feet, perfect for keeping crowds of enemies at bay.

The Batmobile is designed to travel out of sight by navigating Gotham City's water mains. Its computational processor allows it to respond to voice commands or return to the Batcave if its operator is incapacitated.

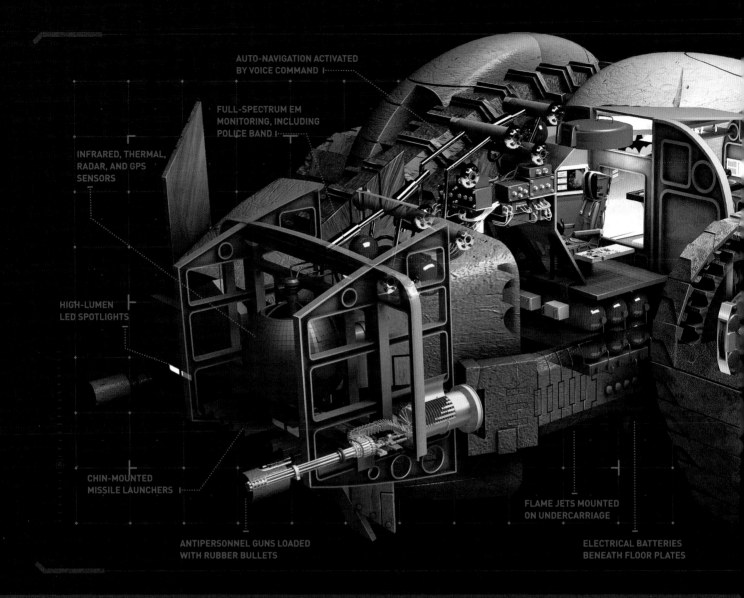

AUTO-NAVIGATION ACTIVATED
BY VOICE COMMAND

FULL-SPECTRUM EM
MONITORING, INCLUDING
POLICE BAND

INFRARED, THERMAL,
RADAR, AND GPS
SENSORS

HIGH-LUMEN
LED SPOTLIGHTS

CHIN-MOUNTED
MISSILE LAUNCHERS

ANTIPERSONNEL GUNS LOADED
WITH RUBBER BULLETS

FLAME JETS MOUNTED
ON UNDERCARRIAGE

ELECTRICAL BATTERIES
BENEATH FLOOR PLATES

BATMOBILE INTERIOR

The Batmobile is a mobile command post equipped with a medical bay, an armory, and sealed equipment lockers. The medical chamber is arranged around a gyroscopically mounted stretcher, which keeps the patient perfectly stable no matter what shocks the Batmobile might experience. Supply bins are equipped with quick-pull latches for one-handed opening and lined with elastic webbing to secure items in place. Included in the Batmobile's medical supplies are tourniquets, rolled gauze, vented seals for treating sucking chest wounds, pressure dressing, alcohol-based surgical scrubs, and defibrillators. The lab also houses a DNA scanner and electron microscope, both connected to the Batcave's Batcomputer for use in analyzing unique pathogens and other forms of chemical analysis.

The Batmobile's armory contains everything needed for onboard weapons resupply. Racks of missiles and rubber bullet magazines are stored here, alongside explosive charges that could sink a battleship. An experimental locker contains handheld sonic weapons (along with uniquely tuned earplugs to protect Batman from the effects of these devices), handheld acid sprayers, and even synthetic Kryptonite.

Lockers store Batman's mission-specific equipment. Standard tools that require frequent replacement include Batarangs, smoke grenades, nerve gas ampules, and the cable spools and hooks used in grapnel launchers. Less common items include freeze-spray for shattering locks, thermite paste for burning through metal doors, and chemical capsules loaded with a formulation designed to stimulate the brain's fear center.

CERAMIC-COMPOSITE ARMOR-PLATED EXTERIOR

LENGTH: 36.25 feet

WIDTH: 27.56 feet

HEIGHT: 16.73 feet

WEIGHT: 210 tons

MAXIMUM SPEED: 62 mph

ALL-TERRAIN MILITARY
TANK TREADS

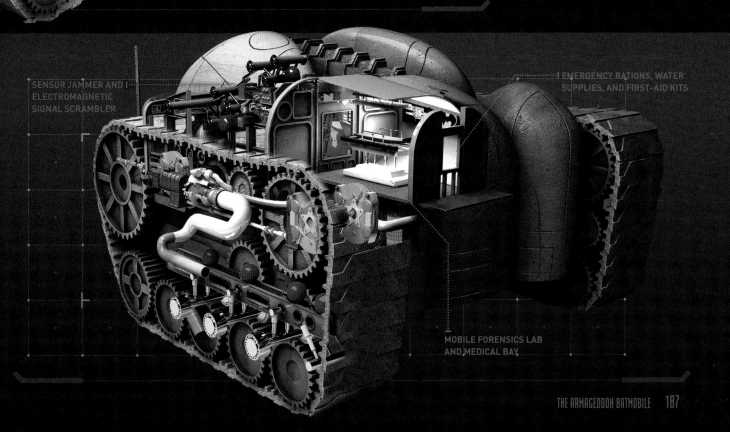

SENSOR JAMMER AND
ELECTROMAGNETIC
SIGNAL SCRAMBLER

EMERGENCY RATIONS, WATER
SUPPLIES, AND FIRST-AID KITS

MOBILE FORENSICS LAB
AND MEDICAL BAY

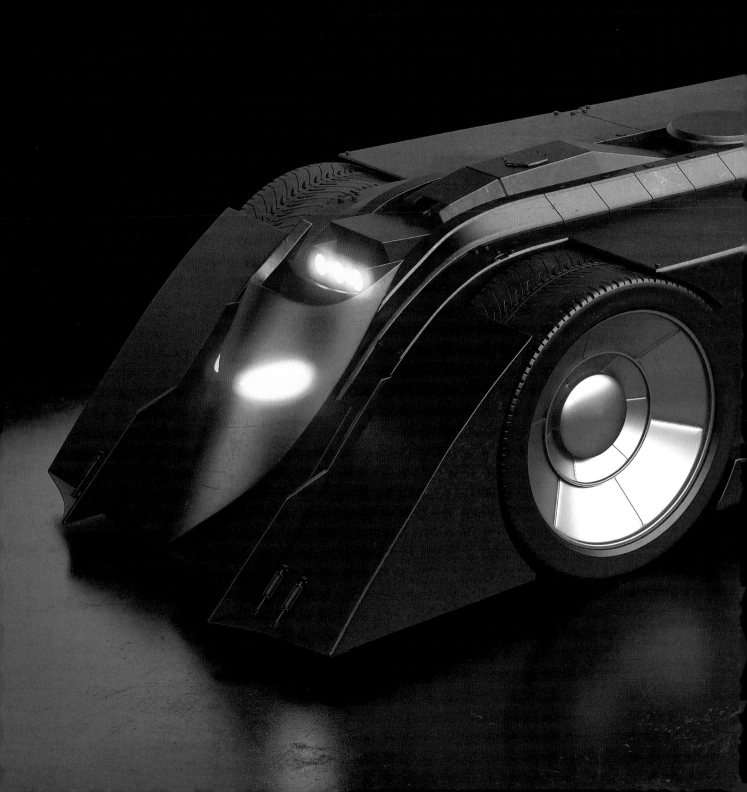

THE MODERN BATMOBILES

— *Batman* and *Detective Comics*, current era —

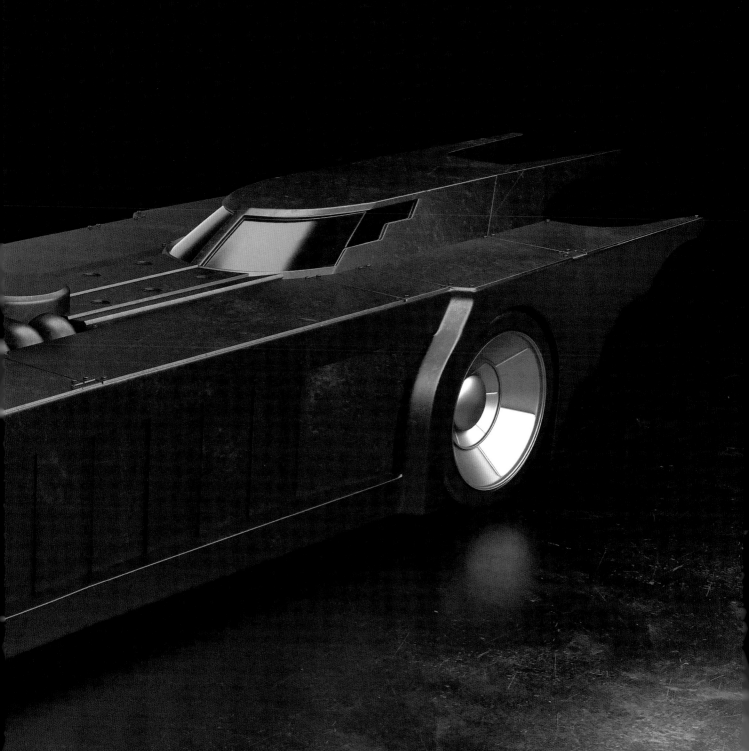

This Batmobile and its variants are the culmination of research gained from myriad rebuilds and tweaks, augmented with bleeding-edge tech breakthroughs borrowed from Justice League technology.

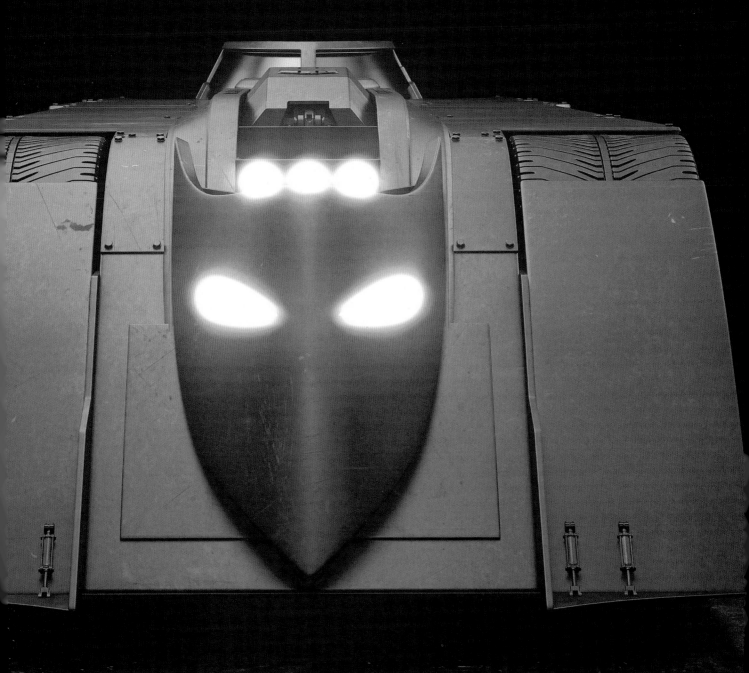

"The low, narrow profile of the Batmobile is optimized for rocketing down narrow alleys and coasting beneath low-hanging bridges."

Batman's war on crime is never-ending, and the Batmobile remains an indispensable weapon in his crusade. The modern Batmobile has been shaped through a ruthless testing regimen and is packed with every innovation imaginable.

The Batmobile sports distinctive front-mounted bodywork in the shape of Batman's mask—a feature first seen on the earliest Batmobile models—and a right-angled, rectangular body that flares outward toward the rear. The low, narrow profile of the Batmobile is optimized for rocketing down narrow alleys and coasting beneath low-hanging bridges. The angled front fenders, combined with the variable control surfaces of its rear stabilizer fins, maximize downforce.

Within the cockpit, Batman sits in a gyro-stabilized driver's seat to operate the steering yoke and touchscreen consoles. Omnidirectional microphones and cameras can record anything in the vehicle's vicinity. The windscreen can become fully opaque (with corresponding cabin sound-proofing) in response to sensory or hypnotic attacks, allowing Batman to steer the car solely using monitoring devices without needing to eyeball his surroundings.

The driver's seat can be ejected with enough force to propel Batman thousands of feet in the air. Shortly after debuting this version of the Batmobile, Batman used the ejection mechanism to intercept a damaged passenger airliner on a collision course with downtown Gotham City.

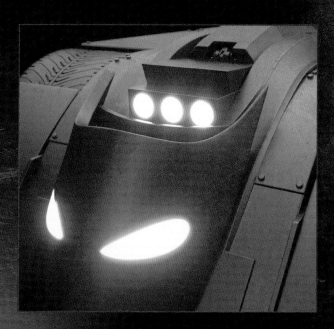

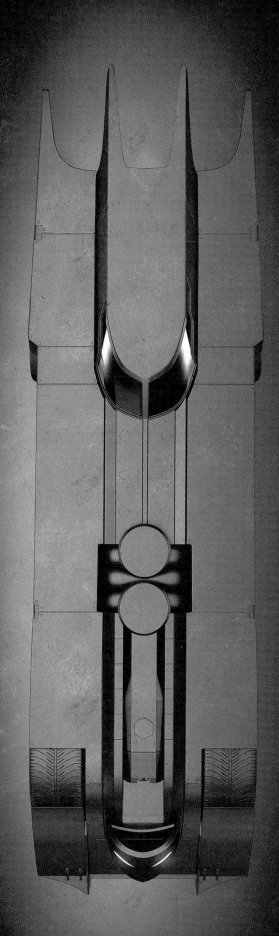

BATMOBILE TESTING

The Batcave is equipped with numerous facilities for improving Batman's and Robin's physical performance, such as a weight room and an obstacle course. The Batmobile receives just as much attention, with the Batcave home to a garage, a machine shop, and a dedicated facility for testing the car's durability and road handling.

The testing chamber is built around a wind tunnel cylinder, with a rolling-road treadmill at ground level for simulating high-speed transit. The wind tunnel's bladed fans can simulate hurricane forces of more than 130 mph, and the flow of air across the vehicle's bodywork can be analyzed for ways to improve aerodynamic streamlining. The treadmill can simulate a variety of road conditions including sheer ice, loose gravel, spiked barricades, and flash flooding.

The walls of the chamber are composed of interlocking panels, each of them concealing a different instrument of structural punishment. Because the Batmobile must withstand a range of attacks, from Firefly's scorching flames to Mr. Freeze's subzero blasts, it is imperative that the vehicle testing phase include a wide array of threat vectors. In addition to flamethrowers and liquid-nitrogen sprayers, the chamber's hidden tools include machine guns, acid jets, ballistic launchers, titanium blades, and high-intensity lasers.

The Batmobile's current ceramic-composite armor has been perfected through these brutal experiments. It provides protection at temperature extremes from 1,100 degrees Fahrenheit (593 degrees Celsius) to –230 degrees Fahrenheit (–146 degrees Celsius) and can withstand the impact of an anti-tank shell.

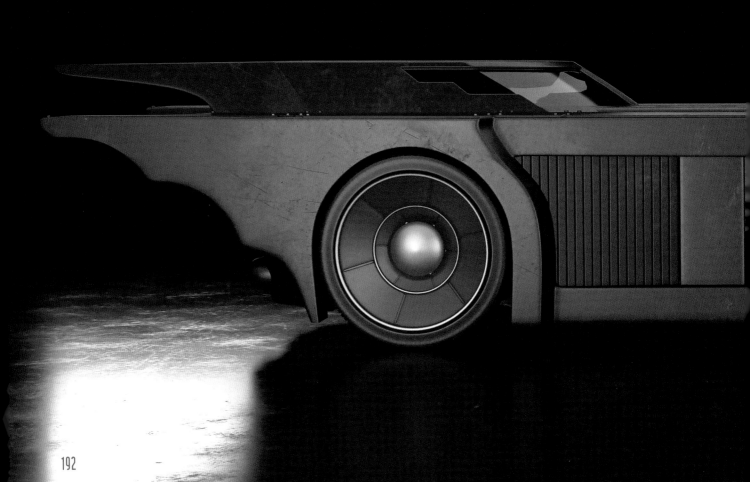

DRIVETRAIN AND WHEELS

The Batmobile uses a WayneTech miniaturized hybrid reactor as its primary power source. This power cell does not require refueling and can operate for years before needing to be replaced. For powered jumps and other feats of acceleration, the Batmobile has a turbo-supercharged jet turbine similar to those used on Air Force stealth fighters. The jet engine combustor can reach temperatures of up to 3,700 degrees Fahrenheit (2,040 degrees Celsius).

The fiber-composite tires of the Batmobile are reinforced with synthetics to resist bullet impacts and can be reinflated via a dashboard switch if they are punctured. The deep grooves of the tire treads are laid out in a stacked-arrow pattern for maximum traction across multiple types of terrain. Extendable studs provide additional purchase under slippery conditions.

For security, a proximity sensor installed beneath the hood will shut down all engine operations if it detects unauthorized tampering.

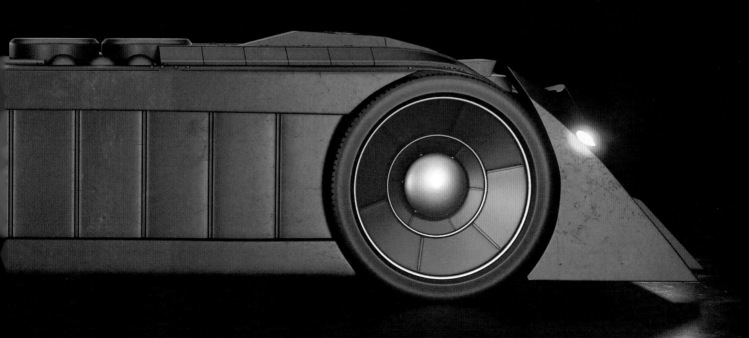

ENCRYPTED COMPUTER LINKUPS WITH THE
BATCAVE, JUSTICE LEAGUE HEADQUARTERS,
AND OTHER TRUSTED NODES

| SOLID-FUEL EJECTION SEATS AND
BREAKAWAY ROOF PANELS

7-SPEED MANUAL
GEARBOX
TRANSMISSION

SPRAYERS LOADE
WITH LUBRICANT
SLICKS AND MACHI
GUMMING ADHESIV

VARIABLE POLARIZATION
COCKPIT WINDOWS

THUMBPRINT-ACTIVATED IGNITION
AND STEERING YOKE

MULTI-SPECTRAL SENSOR CHAMBER

CERAMIC-COMPOSITE

OMNIDIRECTIONAL
FOR STAKEOUTS

SPECS AND
FEATURES

LENGTH: 16 feet
WIDTH: 6.4 feet
HEIGHT: 4.8 feet
MAXIMUM SPEED: 266 mph
ACCELERATION: 0–60 in 2.4 seconds

DEFENSE AND WEAPONS SYSTEMS

Similar to previous models, the modern Batmobile's low stance offers a minimal target for armed assailants, and its composite armor panels can easily be replaced if they are damaged. Layered ballistic glass covers the cockpit windows.

The hubcap of each wheel is equipped with a telescoping tire shredder that can knock attacking vehicles out of commission. The wheel bolts are electromagnetically locked to prevent tampering, and can be turned only with an attuned lug wrench.

A titanium-reinforced hydraulic ram can be extended from the vehicle's nose, and other deployable weapons include smoke grenades, adhesive sprays, and oil slicks. Additionally, a high-intensity floodlight toward the rear of the hood is capable of rapid strobing that causes attackers to feel disoriented and nauseated, and a retractable cable winch on the nose can rip armored doors off their hinges.

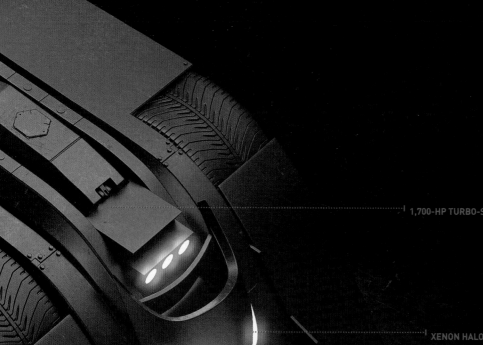

PROPRIETARY WAYNETECH
HYBRID POWER REACTOR

1,700-HP TURBO-SUPERCHARGED TURBINE

XENON HALOGEN HEADLIGHTS
EQUIPPED WITH LASER BEAMS

CO2-FIRED TITANIUM GRAPNEL HOOK WITH
RETRACTABLE CABLE SPOOL

BATCYCLE

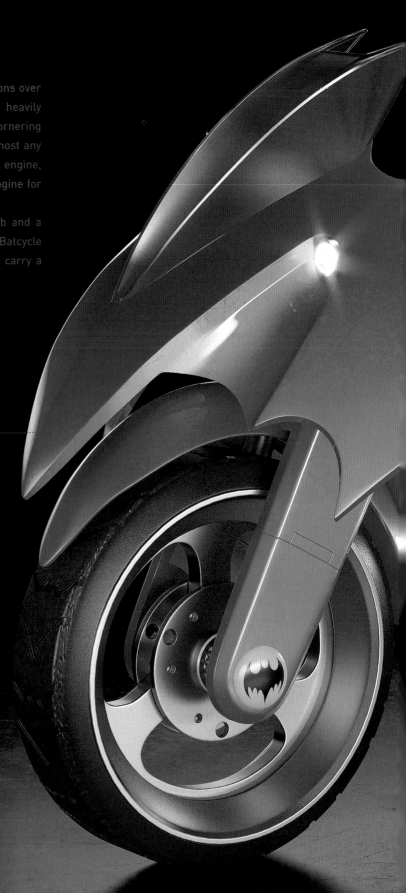

The Batcycle has gone through many evolutions over the years, but its current incarnation is a heavily modified street bike capable of remarkable cornering and a top speed that enables it to overtake almost any vehicle on the road. Powered by a V-4 gasoline engine, the Batcycle can also switch to an electrical engine for silent running and extended range.

Distinctive features include a blue paint job and a bat-symbol mounted on the front fender. The Batcycle is armed with a pair of missile tubes and can carry a passenger in a motorized, ejectable sidecar.

REINFORCED NOSE WITH OBSTACLE-CLEARING CUTTING SURFACES ·····························

SPECS AND FEATURES

TOP SPEED: 200 mph

"RUN SILENT" ELECTRICAL MODE

SIDECAR MOUNT

THE DIY BATMOBILE

— The Batman —

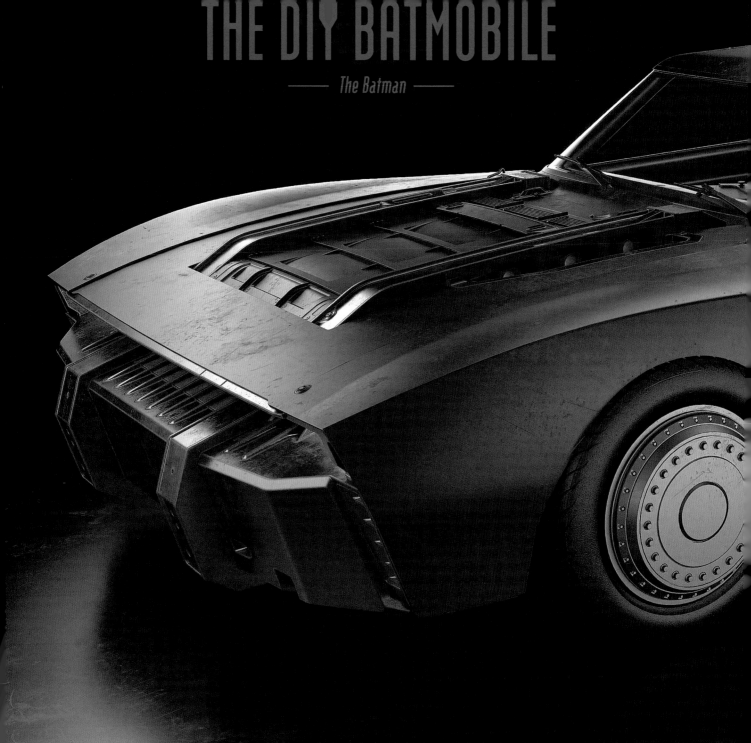

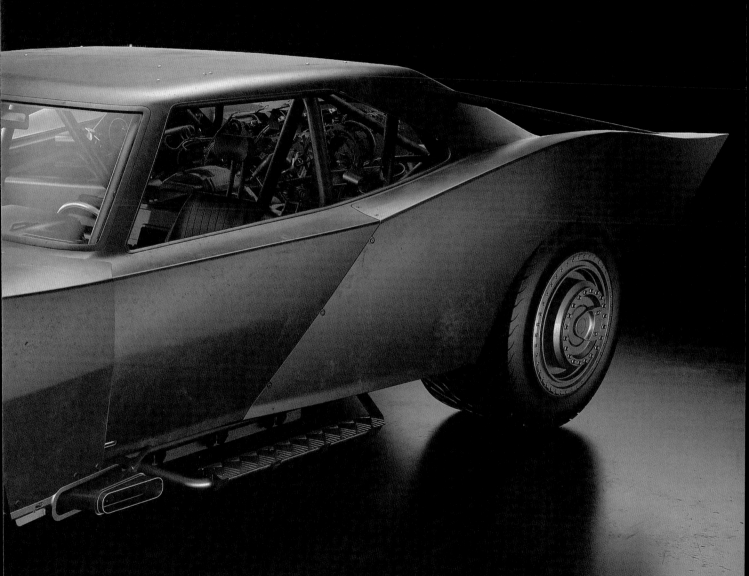

A true speed demon, this Batmobile is a purpose-built muscle car birthed in a grease-stained garage. Though he is still adapting to the role of Batman, Bruce Wayne has applied his history as a street racer to craft a car capable of instilling fear in those who would exacerbate the squalor of Gotham City.

Bruce Wayne grew up in the penthouse of Wayne Tower, looking out over a decaying Gotham City. After the deaths of his parents Thomas and Martha Wayne, Bruce discovered an abandoned train station beneath Wayne Tower that would become his "bat cave." A natural gearhead, Bruce used the space to tinker with classic American muscle cars like the Dodge Charger and the Plymouth Barracuda, eventually building a custom racer and testing his driving skills on Gotham's underground street racing circuit.

"Bruce's do-it-yourself Batmobile is the epitome of function over form, sporting a stripped-down aesthetic and an unpretentious, matte-black finish."

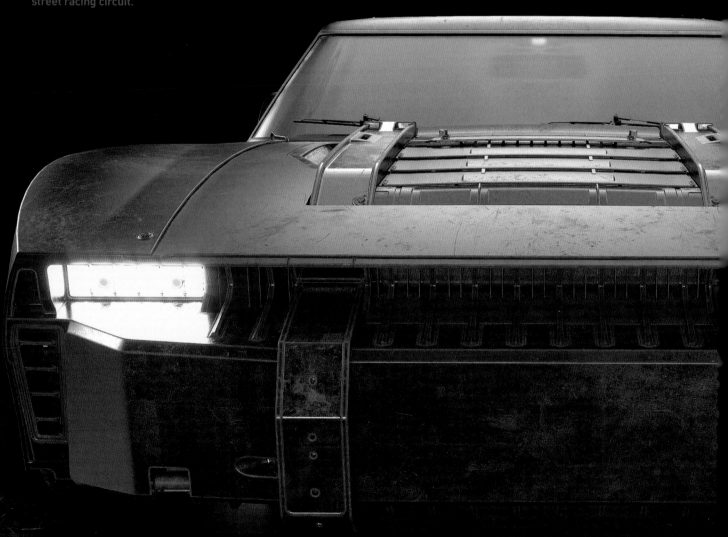

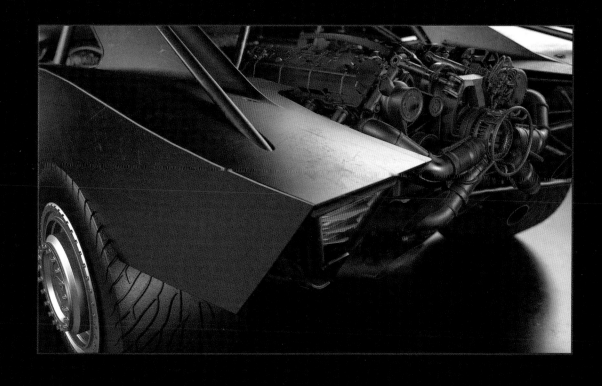

Not long after he assumed the identity of the costumed vigilante Batman, Bruce steered the Batmobile into action against the mysterious serial killer known as The Riddler and Gotham's criminal kingpins—including The Penguin, a top lieutenant of crime boss Carmine Falcone. When The Penguin fled the scene of a busted drug deal, Batman pursued in the Batmobile. The subsequent white-knuckled chase along Gotham's freeways showcased the surprising speed and durability of the Batmobile.

Bruce's do-it-yourself Batmobile is the epitome of function over form, sporting a stripped-down aesthetic and an unpretentious, matte-black finish. The Batmobile's interior follows the same principle. The driver's seat is a standard racing sling that has been bolted to the floor, leaving no room for a passenger. The dashboard gauge cluster provides analog readouts for speed, RPM, oil pressure, and similar essentials. All plastic and vinyl panels have been removed to expose electrical fuses and wire clusters.

DRIVETRAIN AND WHEELS

The trunk space of the Batmobile has been refitted to house a massive 650-hp V8 turbocharged engine. An afterburner for the rear exhaust provides a power boost when needed, emitting a high-pitched whine that combines with the rumble of the V8 for a uniquely intimidating sonic signature. A rally-car gearbox allows Batman to transfer power between the front and rear wheels on the fly, allowing for tighter turn radiuses when cornering and similar precision maneuvers. A lifted suspension helps the Batmobile bounce back from hard landings after high-speed jumps.

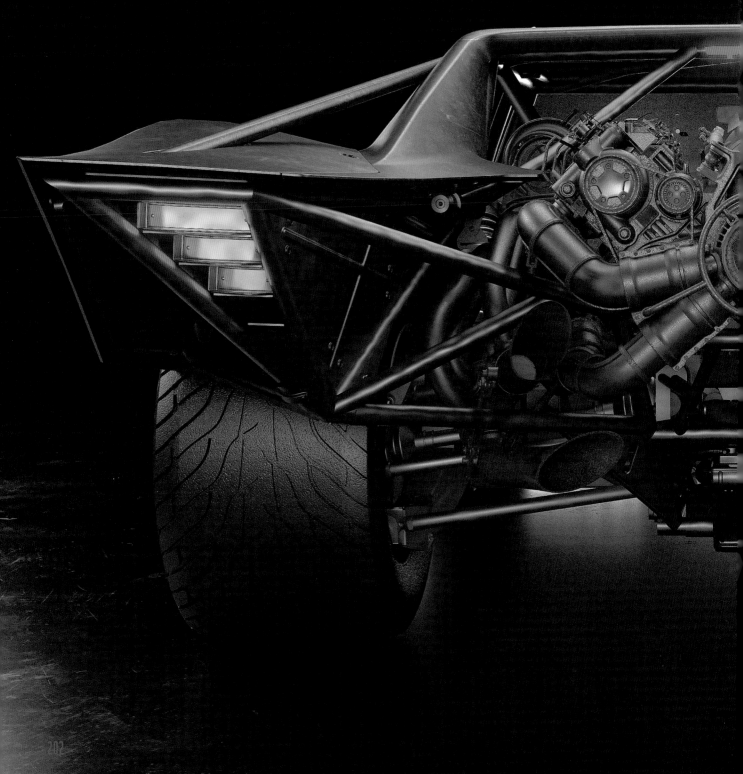

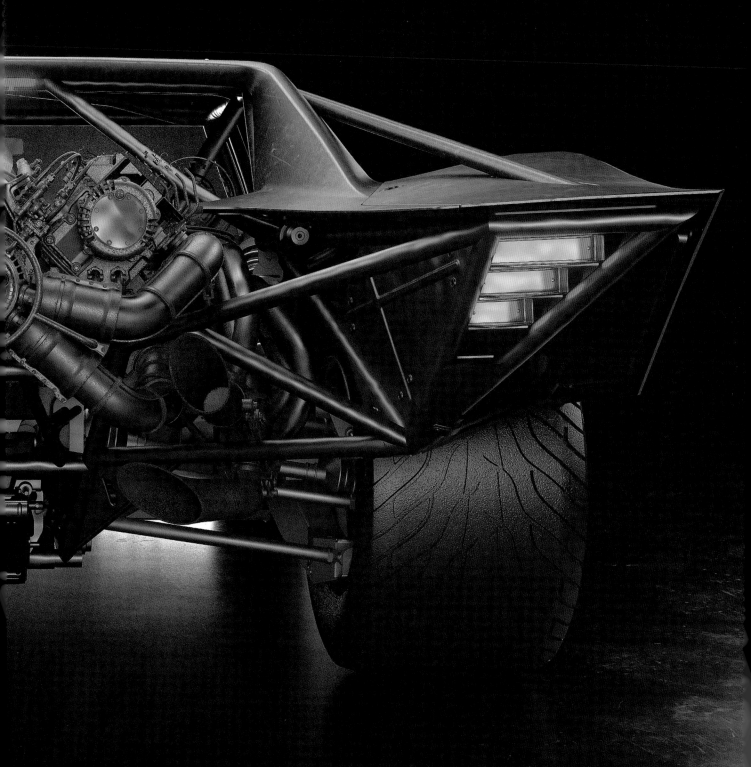

ARMOR

The Batmobile is built for speed, and no obstacle can stand in its way at full throttle. Batman has also installed a solid steel frame and a reinforced steel bumper on the front end, allowing the Batmobile to ram barricades or to shove slower cars off the road. By contrast, the rear of the vehicle (including the engine) is almost completely exposed, a practical consideration to reduce the Batmobile's overall weight and raise its rate of acceleration. The rear fenders terminate in upward flares that resemble the tucked-back wings of a diving bat.

"Batman has also installed a solid steel frame and a reinforced steel bumper on the front end, allowing the Batmobile to ram barricades or to shove slower cars off the road."

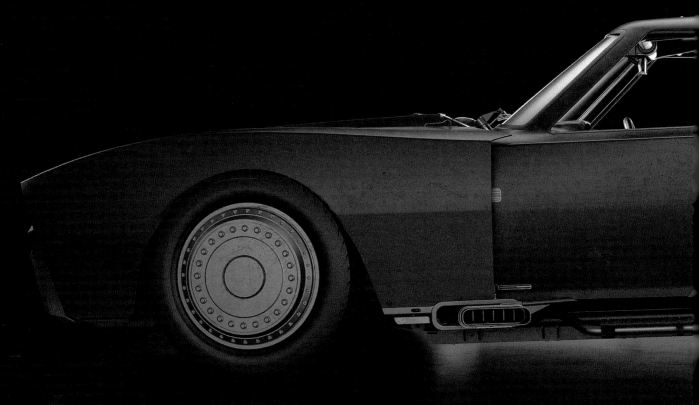

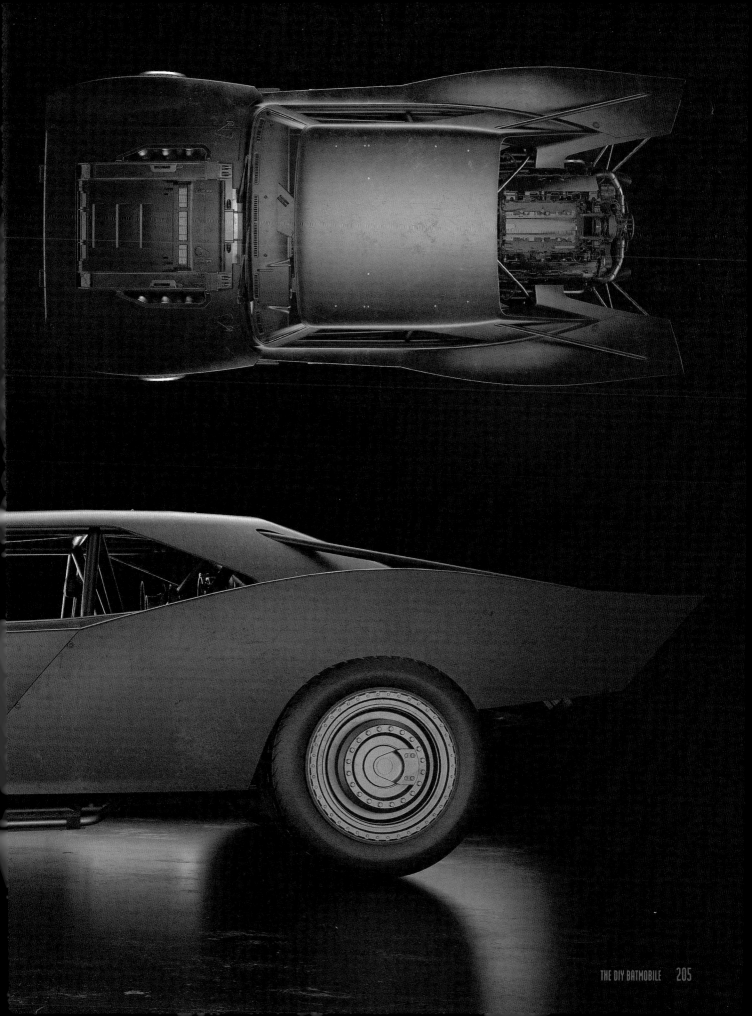

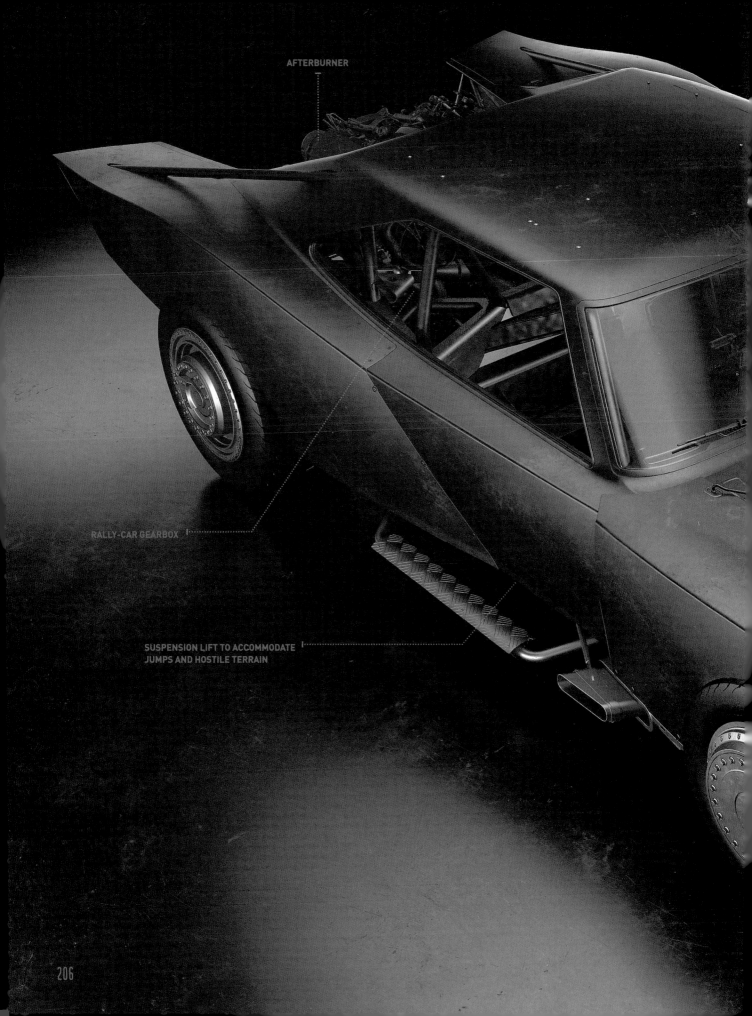

AFTERBURNER

RALLY-CAR GEARBOX

SUSPENSION LIFT TO ACCOMMODATE
JUMPS AND HOSTILE TERRAIN

SPECS AND
FEATURES

LENGTH: 17 feet, 4 inches
WIDTH: 6 feet, 5 inches
ENGINE: 650-hp turbocharged V8
with afterburner

MINIMALIST RACING COCKPIT

INSIGHT
EDITIONS

PO Box 3088
San Rafael, CA 94912
www.insighteditions.com

Find us on Facebook: www.facebook.com/InsightEditions
Follow us on Twitter: @insighteditions

US Trade ISBN: 978-1-64722-329-8
CE ISBN: 979-8-88663-033-6

Publisher: Raoul Goff
VP of Licensing and Partnerships: Vanessa Lopez
VP of Creative: Chrissy Kwasnik
VP of Manufacturing: Alix Nicholaeff
VP, Editorial Director: Vicki Jaeger
Designer: Amazing 15
Executive Editor: Chris Prince
Editorial Assistant: Savannah Jensen
Managing Editor: Maria Spano
Production Manager: Joshua Smith
Senior Production Manager: Greg Steffen
Senior Production Manager, Subsidiary Rights: Lina s Palma-Temena

Original art by Łukasz Liszko.
Additional art from the Warner Bros. archives.

Insight Editions, in association with Roots of Peace, will plant two trees for each tree used in the
manufacturing of this book. Roots of Peace is an internationally renowned humanitarian organization
dedicated to eradicating land mines worldwide and converting war-torn lands into productive farms
and wildlife habitats. Roots of Peace will plant two million fruit and nut trees in Afghanistan and
provide farmers there with the skills and support necessary for sustainable land use.

Manufactured in China by Insight Editions

10 9 8 7 6 5 4 3 2 1